FRITZ SCHIDER

AN ATLAS OF
ANATOMY
FOR ARTISTS

REVISED BY PROFESSOR DR. M. AUERBACH

AND TRANSLATED BY BERNARD WOLF, M.D.

NEW BIBLIOGRAPHY BY ADOLF K. PLACZEK,
COLUMBIA UNIVERSITY

ADDITIONAL ILLUSTRATIONS FROM THE
OLD MASTERS AND HISTORICAL SOURCES

WITH A NEW SECTION ON HANDS SELECTED BY
HEIDI LENSSEN

THIRD AMERICAN EDITION

DOVER PUBLICATIONS, INC.
NEW YORK

Published in Canada by General Publishing Company, Ltd., 30 Lesmill Road, Don Mills, Toronto, Ontario.
Published in the United Kingdom by Constable and Company, Ltd., 10 Orange Street, London WC 2.

An Atlas of Anatomy for Artists is a new English translation of the sixth (1929) edition of *Plastisch-Anatomischer Handatlas für Akademien, Kunstschulen und zum Selbstunterricht 5. Aufl.* published by E. A. Seeman.

Standard Book Number: 486-20241-0
Library of Congress Catalog Card Number: 58-3622

Manufactured in the United States of America
Dover Publications, Inc.
180 Varick Street
New York, N. Y. 10014

PREFACE

TO THE THIRD AMERICAN EDITION

This third revised American edition is augmented by 10 illustrations from Jules Cloquet's *Anatomie de l'Homme* (plates 157-166), 16 illustrations from Jeno Barcsay's *Anatomy for the Artist* (plates 171-176), and a new section on hands selected by Heidi Lenssen (plates 97-106).

1957 Dover Publications, Inc.

PREFACE

TO THE SECOND AMERICAN EDITION

In this second revised American edition, the publishers have aimed to increase the usefulness of a book that has been standard for many years. The book has been expanded by the addition of the following material:

(1) A new bibliography.

(2) A wide selection of illustrations from historical sources: Vesalius, Leonardo, Goya, Degas, and others.

(3) Photographic illustrations of interest to the artist which are reproduced for the first time in this book: the Nancy Bayley photographs of growing children and the Muybridge action studies.

Although Schider has always been a valuable book for the study of anatomy, it is hoped that the added sections will encourage the student to study life drawing from the rich repository of material that is readily available in the great libraries and museums of the world. Rimmer and Muybridge, for example, were great teachers and students of the human figure during the nineteenth century; yet, their books are out of print at the present time. If this book introduces to the student such works as these and encourages him to investigate the artistic and photographic resources that are available, much of the purpose of the book will have been achieved.

Schider has been particularly useful in that he has never encouraged the student to follow any style other than his own. He has concentrated primarily on presenting the essential facts of anatomy in a straightforward manner leaving the student in less danger of imitating particular styles or mannerisms. This aspect of the book has not been altered; rather, the introduction of the historical material should make the student continuously aware of the variety of style and approach that is possible.

1954 Dover Publications, Inc.

INTRODUCTION

PLATES 1 and 2. The Skeleton.

PLATES 1 and 2 show the skeleton of a young man from the front, side, and back.

NOTE: The female skeleton is clearly differentiated from the male by the small face and skull, the narrow, short thorax, and particularly the more rounded pelvis (compare the drawings).

PLATE 3. The Various Shapes of Bones.

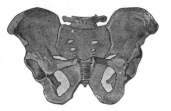

Male Pelvis

Fig. 1 demonstrates the groove between the two tuberosities at the upper end of the humerus, a typical bone groove, and the oval rough area of the humerus (insertion of the deltoid muscle).

Fig. 2 demonstrates the linea aspera, the rough line on the posterior aspect of the femur (origin and insertion of thigh muscles), a typical bone ridge; the head of the femur, the upper cartilage-covered end of the femur, with the femoral neck and the two femoral trochanters.

Fig. 3 demonstrates the crest of the tibia, the upper portion of the S-shaped edge of the tibia, a typical bone edge.

Fig. 4 demonstrates the ischial spine, the pointed process of the ischium, and the acetabulum which serves to receive the head of the femur.

Fig. 5 shows a tubular bone sawn across with its marrow cavity.

PLATE 4. The Types of Joints.

The various joints are classified according to the shape of the articular surfaces.

A. Ball and Socket Joints.

Fig. 1. The ligaments between the humerus and scapula form the joint capsule.

Fig. 2. The ligaments between the femur and pelvis.

The ball and socket joint consists of a spherical head which fits into a cavity, the acetabulum, and which allows motion in all directions. Flexion, extension, adduction, and circumduction are possible in this type of joint.

B. Hinge Joints.

Fig. 3. The joints of the fingers, the interphalangeal joints, are shown as examples of this type.

In a hinge joint, one bone has a transverse convex cylindrical surface and the other bone shows the reciprocal contour. Only flexion and

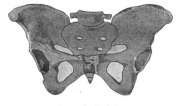

Female Pelvis

extension are possible in such a joint.

C. Combination Type of Joint.

Fig. 4. The elbow joint is shown as an example of this type of joint. Three or more articular surfaces with various shapes are involved: the joint between the ulna and the humerus forms a hinge joint while the joint between the radius and the humerus is of the ball and socket type. In addition, there is a special joint between the ulna and radius. In this combined joint, pronation and supination, flexion and extension are possible. (Pronation refers to the motion of rotating the palm of the hand inwards towards the body; the pronated posi-

tion of the forearm and hand is the position assumed after maximum inward rotation—the palm then faces outwards. Supination refers to the opposite motion, i.e. rotating the palm outwards away from the body; the supinated position is the position assumed after maximum outward rotation—the palm faces forward and slightly outwards.)

D. Immobile Type of Joint.

Fig. 5. The joints between the individual wrist (carpal) and ankle (tarsal) bones and between the carpal and metacarpal, tarsal and metatarsal bones are examples of this type.

PLATE 5. Schematic Cross-section Through a Joint.

The important features are clearly labeled on the plate.

THE BONES OF THE HUMAN BODY
I. The Bones of the Skull.
PLATES 6 and 7.

PLATE 6, Fig. 1 is a view of the skull from below; Fig. 2, from the front.

In Fig. 1, note:

A. The two occipital condyles with joint surfaces which articulate with concave facets on the first cervical vertebra.

B. The two mandibular fossae in which the articular processes of the mandible move.

C. The occipital protuberance to which the ligamentum nuchae ("ligament of the neck") is attached.

D. The mastoid processes, the styloid processes, and the external occipital crest which serve for the origin or insertion of muscles.

E. The foramen magnum is the connection between the cranial cavity and the vertebral (spinal) canal.

PLATE 6, Fig. 2. In this drawing, significant features as far as external appearance is concerned are:

A. The two frontal prominences — rounded protuberances more definitely marked in children and women than in men;

B. The two superciliary arches — slender ridges above the orbits more distinctly marked in men than in women or children;

C. The glabella — a small, flat surface between the superciliary arches;

D. The temporal lines — characteristically individual lines which form the lateral margins of the forehead;

E. The nasal bones;

F. The zygomatic bones with their very prominent zygomatic processes forming the anterior portions of the zygomatic arches;

G. The chin formed by the central part of the mandible.

PLATE 7, Figs. 1 and 2 show the skull of the newborn, viewed from above and from the left side. Sutural lines have not formed as yet. Instead, membrane-covered spaces are present between bones concerned. The frontal bone consists of two portions, unfused as yet.

Fig. 3 demonstrates the senile skull. As a result of the teeth falling out, the mandible is thinned, the angle of the mandible obtuse, the mandible extends beyond the maxilla, and the chin protrudes.

Figs. 4 to 6 demonstrate the contours of three different skulls with their sutures.

II. The Bones of the Trunk.
PLATES 8, 9, and 10.

These plates include the bones of the trunk consisting of the spinal column and the thoracic cage.

A. The spinal column of the adult consists of 24 distinct (true) vertebrae, the sacrum, and the coccyx. The 24 true vertebrae are made up of 7 cervical vertebrae, 12 thoracic vertebrae, and 5 lumbar vertebrae. The sacrum consists of 5 fused (false) vertebrae; the coccyx, 4 fused vertebrae.

B. The thoracic cage includes the sternum and 12 pairs of ribs. The upper 7 ribs (true ribs) are directly connected to the sternum by their costal cartilages; of the lower 5 ribs (false ribs), the eighth, ninth, and tenth are attached by their costal cartilages to the costal cartilage of the seventh rib, forming thereby the inferior thoracic margin, clearly indicated in the living. The eleventh and twelfth ribs lie within the posterior abdominal wall with their anterior ends unattached ("floating" ribs).

PLATE 11. Types of Vertebrae.

Fig. 1. The first cervical vertebra (atlas); note the concave articular facets into which the occipital condyles fit.

Fig. 2. The second cervical vertebra (axis); note the tooth-shaped process (the dens).

Fig. 3. The first and second cervical vertebrae, articulated.

iv

Fig. 4. The seventh cervical vertebra; note a bifurcated spinous process and perforated transverse process.

(N.B. the spinous process of the seventh cervical vertebra is rarely bifurcated but usually presents a single tubercle easily palpable beneath the skin, as indicated by the name "vertebra prominens" sometimes used for this vertebra.)

Figs. 5 and 6. The first thoracic vertebra; note the articular facets for the ribs.

Fig. 7. The fifth lumbar vertebra; note the massive body and strong spinous process.

PLATES 12 and 13. Movements of the Spinal Column.

The nodding motion between the head and first cervical vertebra and the rotatory motion between first and second cervical vertebrae are not shown. Only the movements of the spinal column from the third cervical vertebra to the sacrum are illustrated: forward and backward flexion, lateral (right and left) flexion, and rotation about the longitudinal axis.

Forward and backward flexion are performed predominantly in the cervical and lumbar portions. For this purpose, the thoracic portion of the spine with the thorax may be considered as fixed. Also, lateral flexion occurs in the main in the cervical and lumbar portions. Rotation about the longitudinal axis occurs, on the other hand, predominantly in the thoracic portion of the spine and particularly in its lower part. Rotation from the eighth to the twelfth thoracic vertebrae may be as much as 28 degrees. Total amount of rotation from the third cervical vertebrae to the sacrum is about 47 degrees.

III. The Bones of the Upper Extremity. PLATES 14 and 15.

The bones of the upper extremity may be said to include:
A. The clavicle and the scapula which together form the shoulder girdle;
B. The humerus;
C. The two bones of the forearm (ulna and radius);
D. The bones of the wrist;
E. The bones of the palm and fingers.
Subdivisions B, C, D, E together make up the upper extremity proper or the "free" portion of the upper extremity.

PLATE 14, Fig. 1 illustrates the bones of the upper extremity as seen from the front with the forearm hanging down at the side naturally.
NOTE: This position of the forearm is midway between supination and pronation. For purposes of strict anatomical description, the "anterior view" of the forearm is the anterior aspect of the supinated forearm with palm facing directly forward. The outer aspect of the forearm and hand in this position is also called the lateral or radial side. The inner aspect is also called the medial or ulnar side. "Radial" and "ulnar" refer to the two bones of the forearm.

Note the S-shaped clavicle, the apex of the shoulder formed by the acromion process of the scapula, the coracoid process of the scapula, the humerus with its characteristic joint surfaces, the bones of the forearm articulating with the humerus, and finally, below the forearm, the bones of the wrist, palm, and fingers (carpal bones, metacarpal bones and phalanges).

PLATE 14, Fig. 2 illustrates the bones of the upper extremity, with pronated forearm, as seen from the medial (or inner) side. Note the foreshortened clavicle and acromion process, the medial epicondyle of the humerus, the crossed bones of the forearm, and the lateral aspect of the wrist and hand.

PLATE 15, Fig. 1 illustrates the bones of the upper extremity with forearm pronated, as seen from the lateral (or outer) side. Note the axillary border of the scapula, the foreshortened clavicle, the clearly demonstrated head of the humerus and lateral epicondyle of the humerus, the adjacent S-shaped bones of the forearm, and the side view of the wrist and hand.

PLATE 15, Fig. 2 shows the bones of the upper extremity, forearm pronated, as seen from behind. Note that the scapula is seen in its entire extent and that both epicondyles of the humerus are well demonstrated. (Extensor muscles are attached to the lateral epicondyle; flexor muscles to the medial epicondyle.) The ulna is well seen, especially its upper end or olecranon, and its lower end, the styloid process and the head which form a prominence just above the wrist.

IV. The Bones of the Lower Extremity. PLATES 16 and 17.

The bones of the lower extremity consist of:
A. The two innominate bones (Each innominate

bone is made up of three bones distinct in development but fused in the adult — the pubis, ischium, and ilium. The innominate bones, the sacrum, and coccyx, together, form the pelvis, sometimes called the pelvic girdle.);

B. The femur;

C. The leg bones (tibia and fibula);

D. The bony structure of the foot.

Subdivisions B, C, and D make up the lower extremity proper or "free" lower extremity.

PLATE 16, Fig. 1 shows the bones of the lower extremity as seen from the front. Note the half-pelvis, the innominate bone with well-marked anterior superior and inferior spines, the femur with its well-developed ends, the patella, the two leg bones, and the bones of the foot viewed from above and in front. The bones of the foot consist of the tarsal bones, the metatarsal bones, and the bones of the toes (phalanges).

PLATE 16, Fig. 2 shows the bones of the lower extremity as seen from behind. Note the half-pelvis, the innominate bones with well-marked posterior superior and inferior spines, the ischium with its tuberosity and spine, the femur with the two trochanters at its upper end and the two condyles at its lower end, the tibia articulating with the femur at the knee joint, the fibula, and the bones of the foot.

PLATE 17, Fig. 1 shows the bones of the lower extremity from the medial aspect. Note the fore-shortened pelvis, the medial condyle of the femur, the prominent tibial tuberosity at the upper end of the tibial crest, and the medial aspect of the bones of the foot.

PLATE 17, Fig. 2 shows the lateral view of the bones of the lower extremity. Note the half-pelvis with prominent iliac crest, the femur and patella, the tibia with its tuberosity, the fibula with the fibular head at its upper end, and the lateral aspect of the bones of the foot.

V. The Articulations of the Human Body.
PLATES 18 and 19.

PLATE 18 shows the ligamentous capsule of the hip joint and the ligaments of the elbow joint.

PLATE 19 shows the knee joint with and without its capsule. The capsule is re-enforced by accessory ligaments, not only on the outside of the joint but also within the joint as cruciate ligaments. Note the position of the two fat pads below the patella. These fat pads determine to a considerable extent the external appearance of the knee.

THE MUSCLES OF THE HUMAN BODY
I. General Considerations on the Types of Muscles and Tendons.
PLATE 20.

A typical muscle may be said to consist of a central, red, fleshy or "muscular" portion (the belly) which changes its length and a tendon which does not alter its length but is stretched when the muscular portion is shortened.

PLATE 20, Fig. 1 is a schematic representation of a muscle to clarify the terminology used. In general, the "origin" of a muscle is the uppermost muscle attachment or the muscle attachment nearest the midline of the body, while the opposite muscle attachment is called the "insertion." Some muscles are subdivided into a "head," any expanded portion at the origin, a central portion (the muscle belly), and a terminal portion or tail. Tendons appear in several forms:

A. As terminal tendons, attached at the end of the muscle, e.g. the gastrocnemius muscle and the Achilles' tendon (Fig. 3).

B. As interstitial tendons, inserted in the substance of the muscle belly, e.g. the tendinous "inscriptions" of the rectus abdominis muscle Fig. 4).

C. As sheets, bands, or strands which frequently extend from the origin or insertion deep into the muscle substance, e.g. the tendinous strands in the extensor carpi ulnaris muscle (Fig. 2).

D. As aponeuroses—the term used for broad extensive tendon sheets, e.g. the aponeurosis of the external oblique muscles (overlying the right rectus abdominis muscle in Fig. 4).

E. As tendinous sheets or bands which cover a portion of the muscle belly, e.g. the tendons of the gastrocnemius muscle (Fig. 3).

It is also possible to distinguish several types of muscle bellies:

A. Muscles with two, three, or more heads which arise at different sites and fuse into one belly, e.g. the biceps muscle and the triceps muscle of the arm and the quadriceps muscle of the thigh.

B. Muscles with a single belly which divides into several slips which insert independently, e.g. the flexors and extensors of the fingers and toe.

C. Broad muscles which, besides contracting, serve also to cover or protect body cavities, e.g. the pectoralis major muscle, and the external oblique abdominal muscle.

D. Ring-shaped muscles, e.g. the circular muscles surrounding the eyes and mouth.

E. "Skin" muscles which arise from some deeper site but insert into the skin, e.g. the platysma muscle in the neck.

NOTE: The term fascia is applied to a membranous connective tissue sheet which surrounds a muscle or muscle group.

II. The Muscles of the Head.
PLATES 21 through 24.

The muscles of the head may be divided into:

A. The muscles associated with the lids;
B. The muscles associated with the mouth;
C. The muscles for the nose;
D. The muscles over the top of the skull;
E. The muscles associated with the lower jaw.

A. Muscles associated with the lids. Orbicularis oculi muscle (PLATE 21).

Origin: Medial angle of the eye, lachrymal bone and medial ligament of the lid.
Insertion: Interdigitates with fibers at origin.
Action: Closes the eyelids.

B. Muscles associated with the mouth.

1. Orbicularis oris muscle (PLATES 21, 22, Fig. 2, and PLATE 24).
Origin and insertion: Consists of prolongations from all of the adjacent muscles on each side of the face.
Action: Closes the mouth.

Insertion: Corner of the mouth.
Action: Depresses the corner of the mouth.

4. Caninus muscle (levator anguli oris muscle).
Origin: Canine fossa of the maxilla.
Insertion: Into the orbicularis oris muscle.
Action: Elevates the corner of the mouth.

5. Risorius muscle.
Origin: Subcutaneous tissue and as a prolongation of the platysma muscle, overlying the masseter muscles.
Insertion: Skin and mucous membrane at the corner of the mouth.
Action: Pulls the corner of the mouth laterally, producing a dimple in the cheek.

6. Quadratus labii superioris muscle, infraorbital head.
Origin: Lower margin of the orbit.
Insertion: Skin of the upper lip.
Action: Raises the upper lip.

7. Quadratus labii superioris, angular head.
Origin: Medial angle of the eye and nasal process of the maxilla.
Insertion: Anterior limb inserts into skin and alar cartilage of nose; posterior limb inserts into the skin of the upper lip.
Action: Raises the nasal alar cartilage and upper lip.

8. Zygomaticus muscle (zygomaticus major mus-

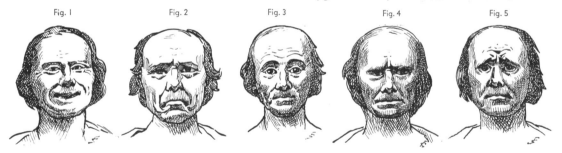

Fig. I Fig. 2 Fig. 3 Fig. 4 Fig. 5

Physiognomy (after Duchenne)

2. Buccinator muscle (PLATES 21, 22, Fig. 2, and PLATE 24).
Origin: External surface of the maxilla and external oblique line of the mandible.
Insertion: The muscle bundles cross at the corners of the mouth and extend into the orbicularis oris muscle.
Action: Draws the corner of the mouth laterally.

3. Triangularis muscle (depressor anguli oris muscle) (PLATES 21, 22, Fig. 3).
Origin: External surface of mandible.

cle) (PLATE 21).
Origin: External surface of zygomatic bone.
Insertion: Corner of the mouth.
Action: Pulls the corner of the mouth upward and laterally.

9. Quadratus labii superioris muscle, zygomatic head (zygomaticus minor muscle) (PLATE 21).
Origin: External surface of zygomatic bone.
Insertion: Lateral portion of the upper lip.
Action: Pulls the corner of the mouth upward and laterally.

10. Quadratus labii inferioris muscle (depressor

labii inferioris muscle) (PLATE 21).

Origin: Border of mandible between mental foramen and mental tubercle.

Insertion: Skin of lower lip.

Action: Pulls the lower lip downward and laterally.

11. Mentalis muscle.

Origin: From mandible between the canine teeth.

Insertion: Skin of the chin.

Action: Draws up the skin of the chin and causes lower lip to protrude.

C. Muscles for the nose.

Procerus muscle (pyramidalis nasi muscle) (PLATES 21 and 24).

Origin: Root of the nose.

Insertion: Skin over the bridge of the nose.

Action: Draws the skin of the nose upward and assists in widening the nostril.

The other nasal muscles are: transverse portion of the nasalis muscle (compressor naris muscle); alar portion of the nasalis muscle (depressor alae nasi muscle); the depressor septi nasi and the dilator naris muscles.

D. The muscles over the top of the skull.

1. Occipitalis muscle.

Origin: Occipital bone, above the superior nuchal line.

Insertion: Into the galea aponeurotica, i.e. the aponeurosis covering the top of the skull.

Action: Draws backward the skin over the head.

2. Frontalis muscle.

Origin: Root of the nose and superciliary arches.

Insertion: Anterior margin of the galea aponeurotica (cranial aponeurosis).

Action: Draws forward the skin over the head, elevates the eyebrows and wrinkles the forehead.

E. Muscles associated with the mandible.

1. Masseter muscle (PLATE 22, Figs. 1 and 2).

Origin: Lower border of the zygomatic arch.

Insertion: Angle of the mandible.

Action: Elevates the mandible and presses the lower and upper teeth together.

2. Temporalis muscle (PLATE 22, Figs. 1 and 2).

Origin: Superior temporal line, external surface of the temporal bone and anterior border of the temporal fossa.

Insertion: Through a strong tendon, which passes deep to the zygomatic arch, into the coronoid process of the mandible.

Action: Pulls the mandible upward.

NOTE 1. Correlation of muscular action and facial expressions: The muscles noted above are those which alter the facial expression in accordance with the emotions, e.g. (see illustrations):

Happiness, laughter—zygomaticus muscle.

Contempt, discontent—triangularis muscle.

Attention, astonishment—frontalis muscle.

Meditation—upper portion of orbicularis oculi muscle.

Pain—corrugator (supercilii) muscle.

PLATE 23 shows the eye, nose, and (external) ear from the front and side with detailed features labeled.

III. The Muscles of the Trunk.
PLATES 22 through 27.

The muscles of the trunk may be divided into:

A. The neck muscles;

B. The thoracic muscles;

C. The muscles of the abdominal wall;

D. The muscles of the back.

A. The neck muscles.

1. Platysma muscle (PLATE 22, Fig. 3).

Origin: Fascia covering the pectoral and deltoid muscles.

Insertion: Lower border of mandible and the skin of the face.

Action: Stretches the skin of the neck.

2. Sternocleidomastoid muscle (PLATES 21 and 22, Fig. 3).

Origin: The medial head arises from the anterior surface of the manubrium sterni; the lateral head arises from the medial third of the clavicle.

Insertion: Wide portion of the mastoid process and the superior nuchal line.

Action: If the muscle of one side contracts, the head is rotated to the opposite side. If the muscles of each side contract simultaneously, the chin is raised.

3. Sternothyroid muscle (PLATE 21).

Origin: Posterior surface of the manubrium sterni.

Insertion: Body of the hyoid bone.

Action: Pulls the hyoid bone down.

4. Omohyoid muscle (PLATE 21).

Origin: Superior border of the scapula.

Insertion: Body of the hyoid bone.

Action: Pulls the hyoid bone down and back.

In addition, this group of muscles includes the sternothyroid muscle and the thyrohyoid muscle (Deep layer of the neck muscles).

5. Scalene muscles; three in number, the anterior, middle, and posterior.

Origin of scalenus anterior muscle: From the anterior tubercles of the transverse processes of the third to sixth cervical vertebrae. *Origin of scalenus medius muscle:* From the posterior tubercles of the transverse processes of all of the cervical vertebrae. *Origin of scalenus posterior muscle:* From the posterior tubercles of the transverse processes of the three lower cervical vertebrae.

Insertion of scalenus anterior and medius muscles: On the superior surface of the first rib. *Insertion of scalenus posterior muscle:* On the external surface of the second rib.

Action: Elevate the first two ribs.

6. Digastric muscle (PLATE 24).

Origin: From the inner surface of the mastoid process.

Insertion: On the superior border of the hyoid bone and the posterior aspect of the chin.

Action: With fixed hyoid bone, pulls the mandible down.

In the study from life, PLATE 25, the following structures are well seen: the contour of the anterior portion of the digastric muscle, and, below this, the anterior surface of the hyoid bone, the laryngeal prominence (Adam's apple), and the inferior cervical fossa or jugular notch just above the manubrium sterni. The lateral view shows the sternocleidomastoid muscle with its two sites of origin, the sternum and the clavicle.

PLATE 24 shows the muscles of the trunk as seen from the front.

B. The thoracic muscles.

1. Pectoralis major muscle.

Origin: The clavicle and the entire anterior surface of the sternum down to the level of the sixth costal cartilage.

Insertion: The bony ridge below the greater tuberosity of the humerus.

Action: Pulls the humerus toward the anterior aspect of the thorax and rotates it inward.

2. Pectoralis minor muscle (PLATES 21 and 28, Fig. 2).

This muscle is almost entirely covered by the pectoralis major muscle.

Origin: From the third, fourth, and fifth ribs.

Insertion: Coracoid process of the scapula.

Action: Pulls the scapula down.

3. Serratus anterior muscle (PLATE 28, Fig. 1).

Origin: Through nine slips (digitations) from the external surface of the eight upper ribs.

Insertion: Vertebral border of the scapula.

Action: Pulls the scapula forward and pulls it tightly against the trunk.

The deep layer of thoracic muscles, covered for the most part by the muscles noted above, includes the intercostal muscles (PLATE 28, Fig. 1), the subclavius muscle, and the intertransverse muscles.

C. Muscles of the abdominal wall.

1. External oblique abdominal muscle.

Origin: Through eight fleshy slips or digitations from the eight lower ribs.

Insertion: The three last digitations extend to the iliac crest; the other slips end in a broad but thin aponeurosis which inserts partly into the inguinal ligament and, in the midline, fuses with the corresponding aponeurosis of the opposite side to form the "linea alba" or white line.

Action: Decreases the size of the abdominal cavity, increasing the intra-abdominal pressure.

2. Internal oblique abdominal muscle-covered by the external oblique muscle. PLATE 24 shows its appearance after removal of the external oblique muscle.

Origin: Anterior superior iliac spine and iliac crest.

Insertion: On the last three ribs and in the region of the linea alba.

Action: Same as the external oblique muscle.

3. Transversus abdominis muscle-covered by both the external and internal oblique muscles.

Origin: From the lower costal cartilages and the crest of the ilium.

Insertion: Into the linea alba.

Action: Same as external and internal oblique muscles.

4. Rectus abdominis muscle.

Origin: Pubis, from pubic spine to symphysis.

Insertion: External surface and lower border of the fifth to seventh costal cartilages.

Action: Same as the other abdominal muscles.

PLATE 25 is a study from life of the surface anatomy of the human body, demonstrating the entire course of the left clavicle below the skin, the depression between the two major pectoral muscles corresponding to the sternum, the inferior thoracic margin, the jugular notch above the manubrium sterni between the two sternocleidomastoid muscles, and the delto-pectoral or inferior clavicular fossa between the deltoid muscle and the pectoralis major muscle. The pectoralis major muscles form prominent masses. The tendinous inscriptions of the rectus abdominis muscle above the navel de-

lineate six, approximately quadrilateral areas; below the navel, the external oblique muscle is recognizable. The inguinal (Poupart's) ligament, with its graceful curved course, is well delineated and forms the boundary between trunk and thigh.

D. Muscles of the back (PLATES 29 and 47).

1. Trapezius muscle.
 Origin: Superior nuchal line of the occipital bone, spinous processes of all cervical and thoracic vertebrae.
 Insertion: Superior surfaces of the outer third of the clavicle and the spine of the scapula.
 Action: Pulls the scapula backward and assists in raising the arm by raising the scapula.

2. Latissimus dorsi muscle.
 Origin: From the spinous processes of the lower six or seven thoracic vertebrae and the spinous processes of all lumbar and sacral vertebrae; also three or four slips arise from the lower three or four ribs as digitations between those of the external oblique muscle.
 Insertion: Crest of lesser tubercle of humerus and intertubercular (bicipital) groove.
 Action: Pulls the arm back and down and rotates it medially.

3. The rhomboid muscles (PLATE 47, Fig. 1).
 Origin: The spinous processes of the two lower cervical and four upper thoracic vertebrae.
 Insertion: Vertebral border of the scapula.
 Action: Pulls the scapula upward and toward the spine.

4. Levator scapulae muscle (PLATE 47, Fig. 1).
 Origin: Through four slips from the posterior tubercles of the transverse processes of the four upper cervical vertebrae.
 Insertion: Superior angle of the scapula.
 Action: Raises the scapula.

5. Sacrospinalis muscle (erector spinae muscle) (PLATE 47, Fig. 2).
 Origin: The lateral portion of this combined muscle, the iliocostalis lumborum muscle, arises from the posterior portion of the iliac crest; the medial portion, lying next to the midline, the longissimus dorsi muscle, arises from the sacrum.
 Insertion: The iliocostalis lumborum muscle inserts through 12 slips on the lower border of the 12 ribs at their angles and another slip goes to the transverse process of the seventh cervical vertebra. The lateral portions of the longissimus dorsi muscle insert on the transverse processes of the lumbar vertebrae and the lower borders of the lower ten ribs; the medial portion inserts on the lumbar and thoracic vertebrae.
 Action: Straightens and extends the spinal column.

This group of muscles also includes several other muscles adjacent to the spine as well as muscles extending between the occipital bone and the first cervical vertebra.

PLATE 30, the study from life of the surface anatomy, shows the prominent spinous process of the seventh cervical vertebra, the spine of the scapula, and the iliac crest. The tendinous area of the trapezius muscle about the seventh cervical spine appears as a flat, moderately depressed area. The triangular tendon of origin of the trapezius muscle from the spine of the scapula produces a small fossa. The course of the trapezius muscle below the skin is well delineated as well as that of the latissimus dorsi muscle. Below the lower border of the latter muscle is seen the inferior angle of the scapula. Below, the sacrospinalis muscle of each side forms a prominent mass next to the midline.

PLATE 31 shows a cross-section through the neck of a 20-year-old male. The positions and relationships of the bones and muscles as well as the large blood vessels and nerves, the larynx and esophagus, are clearly seen.

PLATES 32 and 33 show a lateral view of the bone and muscle relationships in "The Fighter" by Borghese. The work of Salvage, "Le Gladiateur Combattant," Folie, 1812, Paris, was used to obtain the general outlines.

PLATES 35, 37, and 39-44 are photographs of a splendidly developed male body. Surface anatomical features are clarified by the accompanying sketches.

PLATES 36 and 38 serve as examples of the "Hercules" type athlete. Accompanying diagrams sketch the muscles demonstrated. In the anterior view may be seen the clavicle, iliac crest, sternum (as a deep longitudinal depression in the midline of the chest) with adjacent prominent pectoral muscles, and the triangular delto-pectoral fossae. Below the elevated right arm, five digitations of the serratus anterior muscle may be identified. The portion of the oblique abdominal muscles which inserts into the iliac crest is clearly delineated. The inferior thoracic border is well marked as well as the grooves due to the three tendinous inscriptions of the rectus abdominis muscle above the navel. In the posterior view, one can identify the two borders of the scapula, and in the midline, about the seventh cervical spinous process, the somewhat tri-

angular tendinou~ area of the trapezius muscle. Below is seen the curved line due to the iliac crest. The trapezius tendon attached to the scapular spine produces a deep triangular fossa. The inferior angle of the scapula is visible below the prominent border of the latissimus dorsi muscle. The well-developed sacrospinalis muscle can be followed some distance upward from the sacrum and ilium.

PLATES 45 and 46 show anatomical demonstrations of the human body in various positions as seen from the front, side, and back.

IV. The Muscles of the Upper Extremity. PLATES 48-69.

These muscles may be divided into:
 A. The shoulder muscles (PLATES 48-53);
 B. The muscles of the (upper) arm (PLATES 48-53);
 C. The muscles of the forearm (PLATE 54);
 D. The muscles of the hand (PLATES 56-59).
A. The shoulder muscles.
 1. Deltoid muscles.
 Origin: Lower border of the scapular spine, outer border of the acromion and lower border of the clavicle.
 Insertion: The triangular rough area on the lateral side at the middle of the shaft of the humerous.
 Action: Elevates the arm.
 2. Infraspinatus muscle.
 Origin: From the entire extent of the infraspinous fossa with exception of the axillary border and inferior angle of the scapula.
 Insertion: Greater tuberosity of the humerus.
 Action: Elevates the arm.
 3. Teres minor muscle.
 Origin: Middle portion of the axillary border of the scapula.
 Insertion: Greater tuberosity of the humerus.
 Action: Rotates the arm outward.
 4. Teres major muscle.
 Origin: Inferior angle of the scapula.
 Insertion: Medial lip of intertubercular groove.
 Action: Depresses the arm and rotates it inward.
B. The muscles of the arm.
 1. Anterior arm muscles.
 a. Biceps muscle.
 Origin: Short head arises from the coracoid process of the scapula; long head arises from the superior border of the glenoid cavity.

Insertion: Radial tuberosity.
 Action: Flexes the forearm at the elbow joint and is the strongest supinator of the forearm.
 b. Coracobrachialis muscle.
 Origin: Coracoid process of the scapula.
 Insertion: Middle of the shaft of the humerus.
 Action: Elevates the arm.
 c. Brachialis muscle.
 Origin: Anterior surface of humerus, surrounding the site of insertion of the deltoid muscle.
 Insertion: Ulnar tuberosity.
 Action: Flexes the forearm and puts tension on the medial portion of the capsule of the elbow joint.
 2. Posterior arm muscles.
 a. Triceps muscle.
 Origin of long head: Axillary border of scapula.
 Origin of lateral head: Along a line which extends from the site of insertion of the infraspinatus muscle to the lower third of the humerus.
 Origin of medial head: Below the site of insertion of the teres major muscle.
 Insertion: Upper part of olecranon.
 Action: Extends the arm.
 b. Anconeus muscle.
 Origin: Lateral epicondyle of the humerus.
 Insertion: Lateral aspect of olecranon.
 Action: Extends the forearm.
C. Muscles of the forearm.
 1. Muscles on the flexor aspect.
 a. Superficial layer.
 1.) Pronator teres muscle.
 Origin: Medial epicondyle of the humerus.
 Insertion: Rough area in middle of shaft of radius.
 Action: Pronates and flexes the forearm.
 2.) Flexor carpi radialis muscle.
 Origin: Medial epicondyle of the humerus.
 Insertion: Anterior surface of base of second metacarpal.
 Action: Flexes the hand at the wrist.
 3.) Palmaris longus muscle.
 Origin: Medial epicondyle of humerus.
 Insertion: Into palmar fascia.
 Action: Flexes forearm and hand.
 4.) Flexor carpi ulnaris muscle.
 Origin: Medial epicondyle of humerus.

Insertion: Pisiform bone.

Action: Flexes the forearm and hand.

5.) Flexor digitorum sublimis muscle.

Origin: Medial epicondyle of humerus.

Insertion: Through four strong tendons on the middle phalanges of the second to fifth fingers.

Action: Flexes the middle phalanges.

b. Deep layer (PLATE 54, Fig. 2).

1.) Flexor digitorum profundus muscle.

Origin: Medial and anterior surfaces of the ulna and the interosseous membrane.

Insertion: Through four tendons on the terminal phalanges of the second to fifth fingers.

Action: Flexes the fingers, particularly the terminal phalanges.

2.) Flexor pollicis longus muscle.

Origin: Anterior surface of radius.

Insertion: Terminal phalanx of thumb.

Action: Flexes the terminal phalanx of the thumb.

3.) Pronator quadratus muscle.

Origin: Lower fourth of the ulna.

Insertion: On the radius at the same level as origin from ulna.

Action: Pronates the forearm.

2. Muscles on the extensor aspect of the forearm.

a. Superficial layer.

1.) Brachioradialis (supinator radii longus).

Origin: Bony ridge on the lateral epicondyle of the humerus.

Insertion: Lateral side of base of styloid process of radius.

Action: Flexes the forearm. Acts as supinator only when forearm is extended and pronated.

2.) Extensor carpi radialis longus muscle.

Origin: Below the brachioradialis muscle.

Insertion: Base of second metacarpal bone.

Action: Extends and abducts the hand.

3.) Extensor carpi radialis brevis muscle.

Origin: Lateral epicondyle of the humerus.

Insertion: Metacarpal of middle finger.

Action: Extends the hand radialward.

4.) Extensor digitorum communis muscle.

Origin: Lateral epicondyle of the humerus.

Insertion: By four tendons on the bases of the phalanges of the fingers.

Action: Extends the fingers.

5.) Extensor carpi ulnaris muscle.

Origin: Lateral epicondyle of the humerus.

Insertion: Base of fifth metacarpal bone.

Action: Extends and abducts the hand ulnarward.

6.) Supinator (brevis) muscle (lies deeply concealed under the brachioradialis muscle).

Origin: Lateral epicondyle of the humerus.

Insertion: Medial surface of the radius.

Action: Supinates the forearm.

7.) Abductor pollicis longus muscle.

Origin: Lateral surface of the ulna, the interosseous membrane, and the radius.

Insertion: Base of first metacarpal bone.

Action: Abducts the thumb.

8.) Extensor pollicis brevis muscle.

Origin: Below the abductor pollicis longus muscle.

Insertion: On first phalanx of thumb.

Action: Extends the first phalanx of the thumb.

9.) Extensor pollicis longus muscle.

Origin: Interosseous membrane and ulna.

Insertion: The tendon of this muscle fuses with the tendon of the extensor pollicis brevis muscle.

Action: Extends both phalanges of the thumb.

10.) Extensor indicis proprius muscle.

Origin: Ulna and interosseous membrane.

Insertion: The tendon of this muscle fuses on the dorsal surface of the hand with the tendon to the index finger from the extensor digitorum communis muscle.

Action: Extends the finger.

V. Life Study of the Upper Extremity. PLATES 48, 50-55.

GENERAL NOTE: In these plates, a markedly well-developed upper extremity of a middle-aged man is drawn from life. The muscular prominences are natural, but the transitions from muscles to tendons are in many places accentuated.

PLATE 48 shows the anterior view of the upper extremity with forearm pronated. In this position, the bones of the forearm are crossed due to the rotation of the radius about the fixed ulna.

Above the deltoid muscle, the clavicle and acromion are clearly seen. Comparison with the accompanying figures, showing the superficial muscles of the upper extremity, will clarify the drawings. The site of crossing of the extensor carpi radialis longus and the brachioradialis muscles is of importance in determining the lateral contour of the forearm. The same is true of the crossing of the pronator teres and the brachialis muscles in relation to the medial contour. The biceps muscle extends with its tendon into the depths of the bend of the elbow.

The veins of the upper extremity are very prominent, particularly the cephalic vein over the biceps.

PLATE 50 shows the medial view of the upper extremity.

Of the bony parts, the medial epicondyle of the humerus is very prominent at about the center of the figure near the bend of the elbow and below the head of the ulna at the wrist.

On the lateral contour, the deltoid muscle is seen crossing the biceps. The biceps is crossed also lower down above the bend of the elbow by the brachioradialis muscle.

The venous network of the flexor side of the upper extremity is clearest in this view. A large vein is seen crossing the bend of the elbow obliquely, the so-called median vein. The continuation of this vein on the medial aspect of the arm is called the basilic vein which empties above the elbow joint into the deep veins of the arm. These, along with the brachial artery and nerves, extend in a bundle in a groove between the biceps and triceps muscles to the axilla. In the middle of the arm, these vessels lie almost directly beneath the skin.

PLATE 51 shows the lateral view of the upper extremity. Of the bony structures, the olecranon and the head of the ulna are most prominent. The bones of the arm and forearm are covered with muscles. The lateral epicondyle of the humerus, emphasized in the figures demonstrating the muscles, is covered by the brachioradialis and extensor carpi radialis longus muscles. The acromion and clavicle are clearly seen.

Note how the deltoid muscle is inserted between the biceps and brachialis muscles. Characteristic features of the medial contour are the transition of the triceps muscle into its tendon, the attachment of the lateral head of this muscle to the olecranon, and the crossing of the brachioradialis and extensor carpi radialis longus muscles over the brachialis and biceps muscles. Between the extensor carpi ulnaris and flexor carpi ulnaris muscles, which form the gently curved external contour from olecranon to ulnar head, can be noted the ulna through-

out its entire length forming a well-marked boundary between flexors and extensors.

The anconeus muscle presents a well-demarcated triangular elevation and crosses the extensor carpi ulnaris muscle, below the bend of the elbow. Of importance in determining the external contour above the wrist is the crossing of the long muscles of the thumb over the extensor carpi radialis brevis muscle.

PLATE 52 shows the posterior view of the upper extremity. Of the bony structures, the olecranon, the medial epicondyle of the humerus, and the head of the ulna are most prominent.

The spine of the scapula forms a depression between the trapezius and deltoid muscles. Clearly seen is the transition of the triceps muscle into its tendon.

PLATE 53 shows the muscles which form the axilla and the deep layer of muscles of the arm.

PLATE 54 shows the deep layer of the muscles of the forearm.

PLATE 55 shows the ulna on the medial side of the arm.

D. The muscles of the hand (PLATES 56-59).

1. The muscles of the ball of the thumb.

 a. Abductor pollicis brevis muscle.
 Origin: Transverse carpal (anterior annular) ligament and the greater multangular bone (trapezium).
 Insertion: Basal phalanx of the thumb.
 Action: Abducts the thumb.

 b. Flexor pollicis brevis muscle.
 Origin: Superficial portion from the transverse carpal ligament and greater multangular bone; deep portion from the os multangulum minus (trapezoid) and the os capitatum (magnum).
 Insertion: Base of the first phalanx of the thumb.
 Action: Flexes the proximal phalanx of the thumb.

 c. Opponens pollicis muscle.
 Origin: Transverse carpal ligament and greater multangular bone (trapezium).
 Insertion: Along the entire length of the lateral border of the first metacarpal bone.
 Action: Flexes, adducts, and rotates medialward the first metacarpal bone. The volar surface of the thumb is thus brought in apposition with the volar surfaces of the other fingers.

 d. Adductor pollicis muscle.

Origin: Second and third metacarpal bones and deep carpal ligaments.

Insertion: Medial side of base of first phalanx of the thumb.

Action: Adducts the thumb.

2. The muscles of the ball of the little finger.

 a. Abductor digiti quinti muscle.

 Origin: Pisiform bone.

 Insertion: Ulnar surface of the first phalanx of the little finger.

 Action: Abducts the little finger.

 b. Flexor digiti quiti brevis muscle.

 Origin: Transverse carpal ligament.

 Insertion: Ulnar surface of the first phalanx of the little finger.

 Action: Flexes the little finger.

 c. Opponens digiti quiti muscle.

 Origin: Transverse carpal ligament.

 Insertion: Ulnar border of fifth metacarpal bone.

 Action: Brings the fifth finger into apposition with the thumb.

3. The muscles of the palm.

 a. Interosseous muscles (dorsal).

 Origin: Borders of the metacarpal bones.

 Insertion: The first of these muscles goes to the radial side of the basal phalanx of the index finger; the second, similarly to the middle finger; the third, to the ulnar side of the middle finger; and the fourth, to the ulnar side of the ring finger.

 b. Interosseous muscles (volar).

 Origin: The ulnar side of the index finger and the radial sides of the fourth and fifth fingers.

 Insertion: On the borders of the basal phalanges.

 Action: Adduct the fingers toward the middle finger.

4. Lumbrical muscles.

Origin: In the palm, from the tendons of the deep flexors.

Insertion: Cross on the radial side of the four fingers from the palm to the back of the fingers.

Action: Flex the fingers at the basal phalanges.

VI. Life Study of the Hand.
PLATES 56-60.

For this purpose, the hand of an old individual is chosen, since the various structures are more distinctly seen.

PLATE 56 shows the dorsal surface of the hand.

Note the prominent head of the ulna on the external contour. The heads of the metacarpal bones protrude as the "knuckles." Characteristic dimples are formed about the knuckles by collections of fat in the female and in children. Of the hand muscles, note the abductor digiti quinti muscle forming the graceful curve on the medial border of the hand and the prominence on the lateral border of the hand formed by the interosseous muscle of the index finger.

The tendons of the extensor digitorum communis muscle and the veins are clearly seen in this view.

The skin on the back of the fingers is stretched and shows over the joints between the first and second phalanges three characteristic folds: the central fold is straight, the proximal fold (toward the wrist) is convex upward, and the distal fold is convex downward. These folds are particularly well-marked in the thumb.

PLATE 57 shows the hand as seen from the radial side. Again, the heads of the metacarpals and phalanges are clearly seen.

The tendons of the long and short extensors of the thumb form a characteristic triangle before joining one another distally.

In hyperextension, a well-marked depression is formed between the stretched tendons—the "tabatière" or snuff-box.

Of the hand muscles, the interosseous muscle of the index finger and the abductor pollicis brevis muscle are important features of the external contour. Another muscle, the adductor pollicis, clearly demonstrates its triangular shape in this view. Small veins which join proximally to form larger vessels, are present over the radial side of the hand.

Between the abducted thumb and the index finger, the skin forms a prominent fold called the "web."

PLATE 58 shows the palm. Of the bony parts, note the styloid process of the radius on the lateral contour just above the wrist, the pisiform bone as a small prominent elevation, and the very prominent head of the first metacarpal bone.

The muscles of the ball of the thumb form a well-marked egg-shaped elevation, considerably more prominent than the muscles of the ball of the little finger.

Three tendons of muscles of the forearm are clearly seen above the wrist: medially, the tendon of the flexor carpi ulnaris muscle; in the center, more prominent than the others, the tendon of the palmaris longus; finally, immediately deep to the palmaris longus tendon, the tendon of the flexor

carpi radialis muscle. The palmaris longus tendon passes over the transverse carpal ligament and joins the palmar fascia. The tendons and muscles of the palm are poorly seen because of surrounding collections of fat and are covered by the palmar fascia.

In the figure demonstrating the muscles, the palmar fascia is removed. Above the transverse carpal ligament, there is a vein which can always be seen if the skin is thin enough. The skin of the palm covers a layer of fibrous fat. Small fat pads are present immediately over the basal phalanges of the fingers.

The skin of the palm shows three prominent creases, and the fingers and thumb are crossed by three transverse folds.

PLATE 59 shows the hand as seen from the ulnar side. Most prominent of the bony structures is the head of the ulna. In thin individuals, the ligaments about the phalangeal joints and the pisiform bone may be seen, the latter, as a small rounded elevation.

On the external contour, the abductor and adductor of the thumb and abductor of the little finger can be identified. The thin palmaris brevis muscle, arising from the palmar fascia, passes transversely from its origin to the abductor digiti quinti muscle which it partially covers.

PLATE 60 shows the veins of the hand which are prominent in the surface anatomy (PLATE 56).

VII. Demonstrations.
PLATES 61-69.

PLATES 61-63 are drawings of various positions of the flexed upper extremity with corresponding studies from life of the surface anatomy. The purpose of these plates is to demonstrate the anatomy of the upper extremity held in various positions. The drawings are, therefore, not meant to be of artistic value but rather to indicate the anatomical relationships.

PLATE 64 shows movements of the elbow joint. Since the movements at the elbow joint have great influence on the appearance of the upper extremity, Plate 64 illustrates various positions of the arm in relation to the forearm.

This combined joint is made up of three joints: articulation between ulna and humerus, articulation between radius and humerus, articulation between ulna and radius—the radio-ulnar joint.

PLATES 65-66 demonstrate various movements at the shoulder and elbow joints. In raising the arms, the inferior angle of the scapula moves outward, the clavicle moves up and out. In crossing the arms over the chest, the scapulae move toward the sides of the thorax. In crossing the arms over the back, the scapulae approach each other.

Of the elbow joint movements, the most important is rotation of the radius about the ulna, i.e. pronation. This produces marked alterations in the appearance of the forearm. When the palm faces forwards, the ulna and radius lie in the same vertical plane adjacent to each other, i.e. the forearm is in the position of supination and the external shape of the forearm appears flattened from front to back. As the radius rotates about the ulna, the shafts of the bones cross each other, i.e. the forearm assumes the position of pronation in which its external shape is rounded. (See also Plates 45 and 46.)

PLATES 67-69 are demonstrations of hand photographs. In the male, joints and extensor tendons are prominent. In the female and in children, dimples produced by collections of fat about the knuckles are characteristic.

VIII. The Muscles of the Lower Extremity.
PLATES 70-81.

These muscles are divided into:

A. The muscles of the hip and buttock;

B. The thigh muscles;

C. The leg muscles;

D. The foot muscles.

A. The muscles of the hip and buttock.

1. Superficial layer.

a. Gluteus maximus muscle.

Origin: From the outer surface of the ilium in the region of the posterior superior iliac spine, from the sacrum and coccyx, and from the ischial tuberosity.

Insertion: On the gluteal tuberosity of the femur and the iliotibial band.

Action: Most powerful extensor of the thigh.

b. Gluteus medius muscle.

Origin: Outer surface of ilium between the anterior and posterior gluteal lines and the anterior three-fourths of the iliac crest.

Insertion: Anterior border of the great trochanter.

Action: Abducts the thigh.

c. Tensor fasciae latae muscle.

Origin: Anterior superior iliac spine.

Insertion: Inserts into iliotibial band and thereby indirectly into the lateral femoral condyle.

Action: Rotates medially, flexes, and abducts the thigh.

2. Deep layer.
 a. Gluteus minimus muscle.
 Origin: External surface of ilium.
 Insertion: Anterior border of great trochanter.
 Action: Abducts the thigh and rotates it medialward.
 b. Piriformis muscle.
 Origin: Anterior surface of sacrum.
 Insertion: Apex of great trochanter.
 Action: Extends, abducts, and rotates the thigh laterally.
 c. Obturator internus muscle.
 Origin: Inner surface of ischium and pubis.
 Insertion: Great trochanter.
 Action: Rotates the thigh laterally.
 d. Quadratus femoris muscle.
 Origin: Tuberosity of ischium.
 Insertion: On vertical ridge below the great trochanter.
 Action: Rotates the thigh laterally.
 e. Psoas major muscle.
 Origin: Twelfth thoracic and lumbar vertebrae.
 Insertion: Lesser trochanter.
 Action: Flexes the thigh.
 f. Iliacus muscle.
 Origin: Inner surface of the ilium.
 Insertion: Lesser trochanter.
 Action: Flexor of thigh.

B. The muscles of the thigh.
 1. Anterior group.
 a. Sartorius muscle.
 Origin: Ilium below the anterior superior iliac spine.
 Insertion: Medial surface of tibia near tuberosity.
 Action: Rotates leg medially when knee is flexed.
 b. Quadriceps femoris muscle. This muscle is composed of four large separate muscles (heads), three of which are partially united to each other.
 1.) Rectus femoris muscle.
 Origin: Anterior inferior iliac spine.
 2.) Vastus lateralis muscle.
 Origin: Great trochanter and lateral lip of linea aspera.
 3.) Vastus medialis muscle.
 Origin: Medial lip of linea aspera.
 4.) Vastus intermedius (crureus) muscle.
 Origin: Anterior surface of femoral shaft.

Insertion: Through a tendon arising from the four muscles into the tibial tuberosity. The patella is a sesamoid bone in the substance of this tendon.
Action: Extends the leg.
 2. Muscles on the medial aspect of the thigh.
 a. Gracilis muscle.
 Origin: Symphysis pubis.
 Insertion: Into tibia below the medial condyle.
 Action: Adducts and flexes the thigh; flexes the leg.
 b. Adductor longus muscle.
 Origin: Superior border of symphysis pubis.
 Insertion: Middle third of femoral shaft.
 Action: Adducts the femur and crosses one thigh over the other.
 c. Adductor brevis muscle.
 Origin: Inferior ramus of pubis.
 Insertion: Upper third of linea aspera.
 Action: Adducts the femur.
 d. Pectineus muscle.
 Origin: Crest of pubic bone.
 Insertion: Behind lesser trochanter.
 Action: Flexes and adducts the thigh.
 e. Adductor magnus muscle.
 Origin: Inferior ramus of pubis and superior ramus of ischium.
 Insertion: Femoral shaft from lesser trochanter to medial condyle.
 Action: Strongest of the adductor muscles.
When the thigh is fixed, the adductor muscles and the pectineus muscle assist in maintaining the erect position of the trunk and may incline the trunk forward.
 3. Muscles on the posterior aspect of the thigh.
 a. Semitendinosus muscle.
 Origin: Ischial tuberosity.
 Insertion: Below the medial condyle of the tibia.
 Action: Flexes the knee.
 b. Semimembranosus muscle.
 Origin: Ischial tuberosity.
 Insertion: Posterior surface of medial condyle of tibia.
 Action: Flexes the leg.
 c. Biceps femoris muscle.
 1.) Long head.
 Origin: Ischial tuberosity.
 2.) Short head.
 Origin: Linea aspera.
 Insertion: Head of the fibula.
 Action: Flexes the knee.

C. The muscles of the leg.
 1. Anterior group.
 a. Tibialis anterior muscle.
 Origin: Lateral condyle and lateral surface of tibia and the interosseous membrane.
 Insertion: First cuneiform bone and metatarsal of the great toe.
 Action: Flexes the foot and elevates the inner border of the foot.
 b. Extensor digitorum longus muscle.
 Origin: Lateral condyle of the tibia, interosseous membrane, head and anterior border of fibula.
 Insertion: Second to fifth toes.
 Action: Extends the lateral four toes.
 c. Peroneus tertius muscle.
 Origin: Lower third of fibular shaft.
 Insertion: Base of fifth metatarsal bone.
 Action: Flexes the foot and assists in elevating the lateral border of the foot.
 d. Extensor hallucis longus muscle.
 Origin: Anterior portion of medial surface of fibula and interosseous membrane.
 Insertion: Base of second phalanx of big toe.
 Action: Extends big toe.
 2. Muscles on lateral aspect of leg.
 a. Peroneus longus muscle.
 Origin: Head of fibula.
 Insertion: First cuneiform; first and second metatarsal bones.
 Action: Extends the foot and raises its lateral border.
 b. Peroneus brevis muscle.
 Origin: Lower half of fibula.
 Insertion: Tuberosity of fifth metatarsal bone.
 Action: Extends the foot and raises its lateral border.
 3. Muscles on the posterior aspect of the leg.
 a. Gastrocnemius muscle.
 Origin: Lower end of femur.
 Insertion: Through the Achilles' tendon into the calcaneus.
 Action: Extends the foot; also flexes the leg at the knee.
 b. Soleus muscle.
 Origin: Back of the fibular head and upper third of posterior surface of fibular shaft and from the tibia.
 Insertion: By fusion with the Achilles' tendon into the calcaneus.
 Action: Extends the foot.
 c. Plantaris muscle.

Origin: Lowermost portion of lateral lip of linea aspera.
Insertion: Calcaneus.
Action: No known function in man.
 4. Deep layer.
 This group includes:
 a. Tibialis posterior muscle;
 b. Popliteus muscle;
 c. Flexor hallucis longus muscle;
 d. Flexor digitorum longus muscle.
D. The muscles of the foot.
 1. Dorsal group.
 a. Extensor digitorum brevis muscle.
 Origin: Superior surface of the calcaneus (near lateral malleolus).
 Insertion: Through four tendons on the bases of the second phalanges of the lateral four toes.
 Action: Extends the toes.
 b. Dorsal interosseous muscles.
 Origin: Medial surfaces of the four lateral metatarsal bones.
 Insertion: Bases of first phalanges; the second toe has two interosseous muscles, the third and fourth toes only one.
 Action: Spread the toes.
 c. Plantar interosseous muscles.
 Origin: Medial surfaces of the three lateral metatarsal bones.
 Insertion: Medial aspects of bases of first phalanges of second to fourth toes.
 Action: Pull the toes closer to one another.
 2. Muscles on the sole of the foot.
 a. Abductor hallucis muscle.
 Origin: Medial surface of calcaneus, the navicular, the first cuneiform and first metatarsal bones.
 Insertion: Medial side of the base of the proximal phalanx of the big toe and sesamoid bones.
 Action: Abducts the big toe.
 b. Abductor digiti quinti muscle.
 Origin: Posterior portion arises from the calcaneus, the anterior portion from the tubercle of the fifth metatarsal bone.
 Insertion: Lateral side of the bases of the proximal phalanx of the little toe.
 Action: Abducts the little toe.
 3. Deep layer.
 This group includes:
 a. Flexor hallucis brevis muscle;
 b. Adductor hallucis muscle;
 c. Flexor hallucis longus muscle;
 d. Flexor digiti quinti muscle;

e. Flexor digitorum brevis muscle;

f. Flexor digitorum longus muscle;

g. Lumbrical muscles.

These muscles, however, have no influence on the external appearance of the foot.

PLATES 70-73.

PLATE 70 shows the anterior view of the lower extremity.

Bony structures visible: Heart-shaped patella, the head of the fibula; a portion of the medial surface of the tibia covered only by skin and fascia is apparent from the knee to the medial malleolus.

Muscular details: On the lateral contour may be seen the gluteus maximus and medius muscles, the crossing of the gluteus maximus and medius muscles as well as the crossing of the tensor fasciae latae muscle over the vastus lateralis muscle. On the medial contour, the course of the sartorius muscle clearly demarcates the group of extensor muscles on the anterior aspect of the thigh from the adductor muscles on the medial aspect. Above the patella is seen the common tendon of the four heads of the quadriceps femoris muscle which by insertion into the patella and prolongation into the patellar tendon, is inserted into the tibial tuberosity. On each side of the patellar tendon, fat pads are present. The development of these fat pads is related to the amount of pressure transmitted through the knee joint.

From the anterior superior iliac spine, the sartorius muscle may be followed in its medial and downward course to the tibia and the tensor fasciae latae muscle in its lateral and downward course to the lateral condyle of the femur. Both of these muscles at their origins cover the rectus femoris muscle. As they deviate from one another, a small groove is formed.

PLATE 71 shows the lateral view of the lower extremity.

Bony structures visible: The great trochanter, the patella, and the head of the fibula.

The gluteus maximus and medius muscles are clearly evident throughout their entire extent. The position of the tensor fasciae latae muscle on the outer contour as it crosses the vastus lateralis muscle and the continuation of the tensor muscle through the iliotibial band to the lateral condyle of the tibia are evident. Note the demarcation between the biceps femoris muscle on one side and the semitendinosus and semimembraneous muscles on the other as they descend to form the superior

borders of the popliteal fossa. The gastrocnemius muscle forms a marked prominence at the base of the popliteal fossa.

On the lateral aspect of the leg, the individual muscles as well as the triangular uncovered lower end of the fibula with its lateral malleolus are evident.

PLATE 72 shows the posterior view of the lower extremity. Bony structures visible: Great trochanter, the head of the fibula and the two malleoli.

Of the buttock muscles, note particularly the gluteus maximus and medius muscles.

Half of the gluteus maximus muscle goes to the femur and half to the fascia of the thigh. In the living, the lower border of the gluteus maximus is completely covered by fat, so that the buttock is considerably more rounded than the gluteus maximus muscle itself. In addition, while the lower border of the muscle goes obliquely downward and outward, the lower border of the buttock is transverse.

The three flexor muscles—the biceps femoris, the semimembranosus and semitendinosus muscles —form a prominent mass below the gluteal muscles and, as they gradually deviate to either side, form the popliteal fossa behind the knee. In anatomical dissections, the popliteal fossa appears as a deep rhomboid depression, but, in the living, when the leg is extended, the popliteal fossa is made prominent by a collection of fat.

Most prominent of the muscles of the leg is the gastrocnemius muscle. The size of this muscle varies from one individual to another and determines the contour of the leg in this view.

The lateral head is smaller than the medial and does not extend as far distally. The gastrocnemius muscle, along with the soleus muscle, ends in the common Achilles' tendon—the strongest tendon in the body.

PLATE 73 shows the medial view of the lower extremity. Bony structures visible: Profile view of patella, medial surface of tibia from knee to medial malleolus.

The course of the band-like sartorius muscle, from the ilium around the medial margin of the thigh to its insertion on the upper end of the tibia is clearly marked. In the leg, the gastrocnemius and soleus muscles, immediately behind the tibia, form with the flexor digitorum longus muscle an elongated prominence.

The smoothly convex anterior prominence of the leg below the tibial tuberosity is formed by the tibialis anterior muscle. The course of the great saphenous vein is easily followed in the leg.

PLATES 74-77.

These plates are drawings of the musculature from a model of "The Fighter" by Borghese—medial and lateral views of the right lower extremity.

PLATE 76 demonstrates the deep layer of muscles of lower extremity.

PLATE 77 shows cross-sections:
 Fig. 1. Through the thigh.
 Fig. 2. Through the leg.

IX. Drawings From Life.
PLATES 78-81.

PLATE 78 shows the anterior view of the foot.

Bony structures: Note the prominent lateral and medial malleoli: the lateral malleolus is on a lower horizontal plane than the medial.

The lateral border of the extensor digitorum brevis muscle is easily recognizable. It forms the smooth prominence called the arch of the foot and the convex lateral border of the foot immediately below the ankle.

Immediately beneath the skin, the tendons of the extensor digitorum longus and extensor hallucis longus muscles are easily followed to the toes.

The veins of the dorsum of the foot are clearly evident. The largest vein goes upwards to the medial side of the leg.

PLATE 79 shows the posterior view of the foot.

The positions of the malleoli are well seen in this view.

The abductor digiti quinti muscle, particularly when contracted, is of importance in determining the lateral contour of the foot.

The Achilles' tendon is particularly important in determining the appearance of the lower leg and foot in this view. Above, this tendon is broad but it narrows below as it approaches its insertion on the calcaneus.

PLATE 80 shows the lateral view of the foot.

Bony structures: The lateral malleolus, the joints and phalanges of the outer four toes.

Note particularly the curvature of the four outer toes as compared with the straight course of the big toe. This is evident in all three figures.

The exposed triangular surface of the lateral malleolus is bounded posteriorly by the peroneus longus and brevis muscles and anteriorly by the extensor digitorum longus muscle.

The extensor digitorum brevis muscle forms a prominent smooth mass at its origin from the superior surface of the calcaneus in front of the malleoli. The muscle belly decreases in size gradually as it extends forward under the tendons of the extensor digitorum longus muscle.

The abductor digiti quinti muscle forms the elevation along the calcaneus and the second phalanx of the little toe.

The veins of the dorsum of the foot as well as a vein over the lateral malleolus are clearly seen in this view.

PLATE 81 shows the medial view of the foot..

Bony structures: The medial malleolus and the joint between the big toe and the first metatarsal bone.

The abductor hallucis muscle in its course from calcaneus to the first phalanx of the big toe is clearly seen.

Of the tendons, those of the tibialis anterior and the extensor hallucis longus muscles stand out prominently. The posterior contour is formed by the vertical Achilles' tendon. Near the border of the medial malleolus is the great saphenous vein.

PLATE 82 shows the veins of the dorsum of the foot after removal of the skin.

PLATE 83 shows sketches of the knee in various positions. Extension and flexion of the leg produces marked changes in the shape of the knee and its surroundings.

In marked extension, the patella moves proximally, the patellar ligament is stretched, and the fat pads on each side of the quadriceps tendon appear as rounded prominences.

In marked flexion, a cleft appears between the femoral condyles and the upper end of the tibia. The patella is pulled down into this space. The fat pads, capsule, and skin are pressed against the rounded surfaces of the femoral condyles producing the rounded external appearance of the flexed knee.

PLATES 84 and 85 show various motions at the knee joint.

PLATES 86-92.

PLATE 86 shows the relative proportions of the parts of the body of the adult, according to Michelangelo. This divides the total length of the body into eight "head lengths" plus the distance from the malleoli of the ankle to the sole of the foot. In contrast with the older conception, which placed the center of the body at the lower border of the symphysis pubis, the lower extremities are relatively lengthened and the trunk elevated.

PLATE 87. Proportions of the human figure as given by Paul Richer, 1849-1933. *Anatomie Artistique, Description des formes extérieurs du corps*

humain au repos et dans les principaux mouvements. Paris, 1890.

PLATES 88 and 89. Phases in the development of a growing boy. The pictures were taken at approximately two-year intervals under precisely the same conditions — the same distance, standard frame, etc. They are therefore directly comparable for proportions. These photographs, and those of the girl following, were taken at the Institute of Child Welfare at the University of California, and are used through the courtesy of Dr. Nancy Bayley.

PLATES 90 and 91.— Phases in the development of a growing girl. The scale of this series is slightly larger than that of the boy. Within the series, the pictures are again directly comparable.

PLATE 92 shows the proportions of the child according to Kollmann. No general rules can be given since the relative proportions of the body vary markedly with age. On the average, the total body length of a new-born child is equal to four "head lengths"; at the sixth year, about six "head lengths"; at the twelfth year, about seven "head lengths." If one divides the total body length into 100 parts, the relative proportions in children from two to four years according to Kollmann are indicated by the following figures:

From skull to navel (variable).....................................54
From navel to sole of foot.................................46
From skull to perineum (sitting height)................61
Length of the lower extremity...............................39
Thigh length (only the mobile portion)...................16
Leg length ...19
Height of the foot...4
Length of the upper extremity (from acromion
 to the tip of the middle finger)................................42
Arm length ..19
Forearm (elbow-joint to wrist joint)......................13
Hand length ..10
Head length (top of skull to lower border
 of chin) ...22
Widest diameter of head..15
Transverse diameter of the pelvis..........................15

The figures given above vary, of course, between individuals and are only approximate.

PLATE 93. Photographs showing folds and wrinkles around the eyes.

PLATES 94-96.

PLATES 94-96 show various types of breasts. The mature type includes the body of the breast, the areola, and the nipple. In the body of the breast, surrounded by more or less fatty tissue, are found the lobules of the mammary glands which during nursing secrete milk into canaliculi emptying at the nipple. The nipple and the areola are more darkly pigmented than the skin in general.

Normally, the breasts extend from the third to the sixth ribs although they may be above or below this—"high" or "low". In general, "high" breasts are considered much more beautiful. A well-built breast is fixed and tense, not pendant, and its lower margin should join the body without any marked fold. Marked decrease in the fat content of the breast produces a flabby pendant breast.

The breast is not completely developed until some time after adolescence and does not reach full development until the nursing stage.

In girls under seven years, the breast is indistinguishable from the male breast except that the nipple is more prominent. Later the areola becomes prominent and finally the body of the breast itself. In later life, particularly in the white race, the prominence of the areola may become less marked.

A Selection of Hands by Heidi Lenssen.

PLATES 97-98. Hands of the violinist Isaac Stern. Courtesy of S. Hurok.

PLATE 99. Hands of Diego Rivera. Hands of an old laborer (one of the last surviving slaves). Photos by Fritz Henle.

PLATE 100. Fine mechanic at work. Hands of a silversmith. Photos by Fritz Henle.

PLATE 101. Hands of a young man. Greek (*c.* 350 B.C.). Photos by C. W. Huston. Donatello, 1386(?)-1466. "St. John" (detail).

PLATE 102. Andrea del Verrocchio, 1435-1488. Maria and Child" (detail). "St. John and an Angel" (detail).

PLATE 103. Hugo van der Goes, 1452-1482. "Adoration of Jesus" (detail). South German (unknown), *c.* 1470, (detail).

PLATE 104. Giambattista Moroni, 1525(?)-1578. "Gentleman in Adoration" (detail). Jacopa Bassano, 1510-1592, (detail).

PLATE 105. Albrecht Dürer, 1471-1528. "Praying Hands." Courtesy of E. S. Herrmann, Inc.

PLATE 106. El Greco, 1541-1614. "Incognito" (detail). Velázquez, 1599-1660. "Portrait of Innocentius Pope" (detail). Gilbert Stuart, 1755-1828. Portrait (detail).

Illustrations from Historical Sources.
PLATES 107-189.

PLATE 107. Antonio Pollaiuolo, 1432(?)-1498. "Battle of the Naked Men." Pollaiuolo, a pupil of

Donatello, seems to have been the first to dissect bodies in order to make studies of the anatomy for artistic purposes. Vasari tells us that he dissected "many bodies in order to study the action of the muscles." While this statement is open to considerable doubt, it is nevertheless true that this engraving, together with his paintings of subjects such as Hercules, with their exaggerated musculature, had an enormous influence in extending the study of anatomy in Italy and, later, in the rest of Europe.

PLATE 108. Jacopo de'Barbari, c. 1450 - before 1516. "Apollo and Diana." An engraver of German origin, Jacob Walch was called de'Barbari by the Italians. He is of interest to us, at least partly, because of his influence upon Dürer whom he knew in Venice. Dürer's studies of perfect human proportions stem from his enthusiasm for the works of Barbari.

PLATES 109 to 123. Leonardo da Vinci, 1452-1518. It is difficult, if not impossible, properly to evaluate Leonardo's contributions to the study of anatomy without taking into consideration the transitional state of this science in his time and the difficulty of obtaining exact information and of dealing with it in any systematic manner. Leonardo had few opportunities to study cadavers at first hand, and it is not known whether he ever had access to a complete skeleton. Yet, his drawings are remarkably accurate despite minor errors — errors which tend to become more numerous when he deals with deep dissections and inner organs. His far-ranging interests enabled him to understand and to present his material in a new light. His knowledge of mechanics, for example, was applied to the skeleton and the muscles, and he was able to demonstrate many of the facts of their operation. The plates which follow deal entirely with the osteological and myological systems and are arranged in a chronological order, so far as it can be ascertained.

PLATE 109. Bones of the foot. Upper center: Dissection of the shoulder joint.

PLATE 110. Muscles of the trunk.

PLATE 111. Muscles of the trunk and leg. The smaller sketches near the top of the plate, from left to right: thoracic and abdominal cavities, subcostal muscles in respiration, two sketches of the tensor fasciae latae muscle, three small sketches showing nerve and vascular connections, and two more sketches of the tensor fasciae latae muscle.

PLATE 112. Bones of the foot. Muscles of the head, neck, and shoulder.

PLATE 113. Surface anatomy of the shoulder.

PLATES 114-116. Muscles of the shoulder.

PLATE 117. Surface anatomy of the lower extremity. Bottom, center to right: comparative study of the hind leg of a horse with the corresponding region in man.

PLATES 118-123. Muscles of the lower extremity.

PLATE 124. Albrecht Dürer, 1471-1528. "Adam and Eve." Dürer's interests, like those of Leonardo, ranged over a wide variety of subjects including mathematics, chemistry, and physics. In his anatomical studies, he attempted to arrive at a set of ideal proportions for the human figure based upon Italian art. The results were incorporated into four books in which he considered the body to be divided into seven parts, then into eight parts. By manipulating the various proportions according to rules, he produced examples of deformed and distorted figures. The studies were often criticized as being too contrived and academic. The "Adam and Eve" is probably the most successful attempt along these lines. Compare Adam's legs with those of Barbari's Apollo, Plate 108.

PLATES 125-138. Michelangelo Buonarroti, 1474-1564. Michelangelo's efforts to achieve a high degree of realism led him to an extremely careful study of whatever he was about to execute. He is said to have bought fish in the market in order to study their scales. It is also said that he studied cadavers in preparation for a sculpture of Christ. In any event, his interest was centered on the human body to an extent which often excluded other things — landscape and portraiture among others. His anatomical studies cover a period of about twelve years in Florence and Rome. The drawings which follow were done in pen and ink, black and red chalk, and charcoal. The arrangement is chronological. See also Plate 86 for a study of proportions based upon Michelangelo.

PLATE 125. Sketch for the bronze David and arm study for the marble David.

PLATE 126. Studies of the nude.

PLATE 127. Nude seen from the back. Lower right: sketches in black chalk.

PLATE 128. Sketch for the Bruges Madonna. Three nude men.

PLATE 129. Studies for Ignudi of the Sistine Chapel ceiling.

PLATE 130. Studies for the Libyan Sibyl.

PLATE 131. Sketches for the Sistine Chapel ceiling and the tomb of Julius.

PLATE 132. Study for a Pietà.

PLATE 133. Study for a recumbent figure in the Medici Chapel.

PLATE 134. Arm and torso study for a Pietà.

PLATE 135. Study of heads for the Leda.

PLATE 136. Study for a background figure for the "Risen Christ."

PLATE 137. Study for the "Last Judgment." Detail. The spot on the lower head is oil.

PLATE 138. Crucifixion for Vittoria Colonna.

PLATE 139. Domenico del Barbiere (Fiorentino), c. 1506 - after 1565. Design from an anatomy book.

Barbiere was associated at Fontainebleau with Rosso de' Rossi, who was at work on an anatomy book for Francis I. This engraving presumably reproduces one of Rossi's drawings from the book which was never finished. It was, at one time, believed to have been by Michelangelo.

PLATES 140-147. Andreas Vesalius, 1514-1564. Vesalius came from a family of physicians and himself studied medicine at Louvain, Montpellier, and Paris. His later career was divided between teaching at various centers such as Louvain, Padua, Bologna, and Pisa and positions at the courts of Charles V of France and Philip II of Spain. His researches were based upon direct observation of the human body and aimed to counteract the Galenic methods based upon studies of animal anatomy. The direction of his work made him naturally opposed to such anatomists as Eustachio (see Plate 148). He is said to have kept a careful check on his assistants, and the accuracy of his plates would be sufficient to account for their revolutionizing influence if they were not equally prized today for their artistic qualities. The plates reproduced here appeared in Basel in 1543.

PLATES 140 and 141. Male and female nudes from the *Epitome*.

PLATES 142-144. Views of the skeleton from the first book of the *De Humani Corporis Fabrica*.

PLATES 145-147. Three plates showing muscles from the second book of the *De Humani Corporis Fabrica*.

PLATE 148. Bartolomeo Eustachio, (?)-1574. From the *Tabulae Anatomicae*, Rome, 1728. Eustachio's drawings, like those of Vesalius, were based upon direct observation and are characterized by a high degree of accuracy although his Galenic methods place him into a movement in anatomical studies that has been superseded. He is said to have introduced post-mortem examinations into Roman hospitals. While his drawings are exact, they are stiff and uninteresting as compared with those of Vesalius. The parts of the drawing are not labelled directly but may be referred to by the coördinates along the sides and top of the plate.

PLATE 149. Melchior Meier. "Apollo Flaying Marsyas." Not much is known about Meier except that he flourished about 1581. Subjects such as Apollo flaying Marsyas and the martyrdom of St. Sebastian became increasingly popular after the appearance of Vesalius' book of 1543 since they afforded artists the opportunity of combining a display of their anatomical knowledge with a standard artistic subject.

PLATE 150. Orazio Borgioni, died 1616. "The Dead Christ." Following Mantegna's example in his "Dead Christ," Baroque painters perfected the techniques of extreme foreshortening, a skill particu-larly useful in painted ceilings. Mantegna's innovation was brought to the attention of Rembrandt by Borgioni's work reproduced here.

PLATE 151. Hendrik Goltzius, 1558-1616. The "Farnese" Hercules. Just as Baroque writers derived many of the laws of their craft from a study of classical literature, so Baroque painters and sculptors went to classical models for instruction and inspiration. The "Farnese" Hercules in Rome was a favorite subject. Goltzius particularly enjoyed exaggerated muscular development and unusual attitudes and often caricatured Michelangelo in his attempt to emulate his work.

PLATE 152. Lodovico Cardi (Cigoli), 1559-1613. Both Cardi and his teacher Alessandro Allori produced brilliant examples of anatomical sculpture. The *écorché* reproduced here was a particular favorite of Italians in their studies of anatomy.

PLATE 153. Peter Paul Rubens, 1577-1640. "Studies of Venus," *recto*. Rubens' chief anatomical work is a collection of drawings published after his death. They may well have been intended as part of a larger work on anatomy. As it stands, there are forty-four copperplates together with a Latin text on anatomy and some reflections upon astrology and alchemy. The French translation, which omits the non-anatomical passages, appeared in Paris in 1773 under the title of *Théorie de la Figure humaine, considérée dans ses principes, soit en repos ou en mouvement.*

PLATE 154. William Camper, 1666-1709. This study of the hand is reproduced from Camper's book of 1697, the title of which is self-explanatory: *The Anatomy of Humane Bodies, with figures drawn after the life by some of the best masters in Europe, and curiously engraven in one hundred and fourteen copper plates, illustrated with large explications, containing many new anatomical discoveries, and chirurgical observations: to which is added an introduction explaining the animal oeconomy, with a copious index.*

PLATE 155. Francisco de Goya y Lucientes, 1746-1828. "The Giant." This aquatint is one of several which Goya made during the last years of his life. The method is particularly exacting since the picture can be lightened (by scraping) but not darkened.

PLATE 156. John Flaxman, 1755-1826. Views of the thoracic basket. The anatomical studies left by Flaxman were not intended as a textbook for artist, nor were they published during his lifetime. Nineteen plates, together with two by Robertson, were published in London in 1833 under the title of *Anatomical studies of the bones and muscles, for the use of artists, from drawings by the late John Flaxman, engraved by Henry Landseer: with two additional plates and explanatory notes by William Robertson.*

PLATES 157-166. Jules Cloquet. These plates are reproduced from his *Anatomie de l'Homme*. Paris, C. de Lasteyrie. 1821-1832.

PLATE 157. Skeleton of infant.

PLATE 158. Musculature of torso and neck, lateral view.

PLATE 159. Musculature of torso and neck, anterior view.

PLATE 160. Female pelvis, anterior view.

PLATE 161. Female pelvis, anterior view from below.

PLATE 162. Skull, anterior view.

PLATE 163. Bones of the skull, anterior view.

PLATE 164. Lateral view with sagittal section of skull.

PLATE 165. Bones of the hand.

PLATE 166. Bones of the foot, lateral view.

PLATE 167. Jean Auguste Dominique Ingres, 1780-1867. "Studies for the Dead Body of Acron." Classical themes became a favorite subject in the early nineteenth century in painting and sculpture, particularly in France. The emphasis on line rather than on color as the means of creating the illusion of volume, form, and motion led to an extremely high degree of skill in David and in Ingres, who continued the *méthode David*. Huneker spoke of Ingres as "the greatest master of line who ever lived."

PLATES 168-170. William Rimmer, 1816-1879. Rimmer was a physician who gave up his practice in order to teach art—at the Cooper Institute in New York and at the Art Museum in Boston. In 1876, he drew a series of plates in pencil on white paper, published in 1877 as *Art Anatomy*.

PLATE 168. Muscles of the Back.

PLATE 169. Muscles of the torso, solid and unalterable sections.

PLATE 170. The triceps and muscles of the arm.

PLATES 171-176. Jeno Barcsay. *Anatomy for the Artist*. Budapest, Corvina. 1956.

PLATE 171. Trunk in movement.

PLATE 172. Trunk in movement.

PLATE 173. Trunk in movement.

PLATE 174. Foreshortened body.

PLATE 175. Foreshortened body.

PLATE 176. The foot in movement.

PLATE 177. Hilaire Germain Edgar Degas, 1834-1917. "The Bath." Degas' interest in the human body, as demonstrated by his numerous canvases on ballet dancers, is often focused on considerations of balance and displacement of the center of gravity. Although his approach is often said to be intellectual rather than sensual, he compares this woman bather to a cat licking herself.

PLATES 178-189. Eadweard Muybridge. 1830-1904. These studies are reproduced from *The Human Figure in Motion*, 1913, and *Animal Locomotion*, 1887. The pioneering work of Muybridge is especially remarkable in that it was produced before the invention of the motion picture camera. The device used, the zoöpraxiscope, produced a series of transparent photographs on glass which were projected on a screen. The results of the research, carried on chiefly in California and Pennsylvania, were published in eleven volumes under the title of *Animal Locomotion*.

PLATES 178 and 179. Athlete, walking.

PLATES 180 and 181. Athlete, running.

PLATES 182 and 183. Woman, walking.

PLATES 184 and 185. Woman, throwing ball.

PLATES 186 and 187. Child, crawling.

PLATE 188. Child, walking.

PLATE 189. Child, running.

SOURCES OF ILLUSTRATIONS

PLATES 1 and 2—after Lucae, Frankfurt-an-Main.

PLATES 3 and 4—after Spalteholz.

PLATE 5—original.

PLATE 6—after Spalteholz.

PLATE 7—original.

PLATES 8-10—from life.

PLATE 11—after Spalteholz.

PLATES 14-17—from life.

PLATES 18 and 19—original.

PLATE 20—after Spalteholz and original.

PLATE 21—original.

PLATE 22—after Spalteholz.

PLATE 23—original.

PLATE 24—after Duval-Neelsen.

PLATE 25—original.

PLATE 26—after Salvage.

PLATE 27—Kollmann.

PLATE 28—from Spalteholz.

PLATE 29—after Duval-Neelsen.

PLATE 30—from life.

PLATE 31—original.

PLATES 32 and 33—after Salvage.

PLATE 34—Kollmann.

PLATES 35, 37, and 39-44—original.

PLATES 36 and 38—from photographs of van der Weyde.

PLATES 45 and 46—after Richer.

PLATE 47—after Spalteholz.

PLATES 48-52—from life and anatomical preparations.

PLATES 53 and 54—after Spalteholz.

PLATE 55—from anatomical preparation.

PLATES 56-59—from life and anatomical preparations.

PLATE 60—from anatomical preparation.

PLATES 61-63—after a model, A. B'renek in Vienna, and from life.

PLATE 64—from anatomical preparations.

PLATES 65 and 66—after Richer.

PLATES 70-73—from life and anatomical preparations.

PLATES 74 and 75—from plaster models.

PLATE 76—after Spalteholz.

PLATE 77—original.

PLATES 78-81—from life and anatomical preparations.

PLATE 82—after Neelsen and anatomical preparations.

PLATES 83 and 84—after Richer.

PLATE 85—Kollmann.

PLATE 86—after a sketch by Michelangelo.

PLATES 87-189—see Introduction.

PLATES

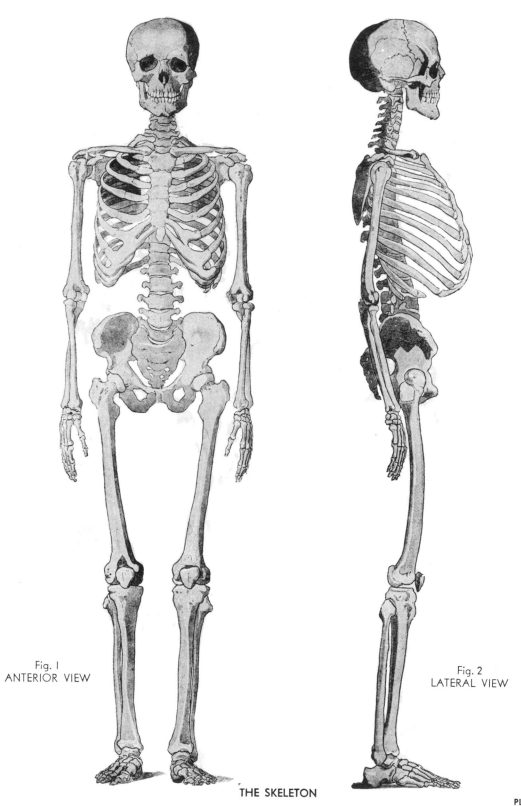

Fig. 1
ANTERIOR VIEW

Fig. 2
LATERAL VIEW

THE SKELETON

PLATE 1

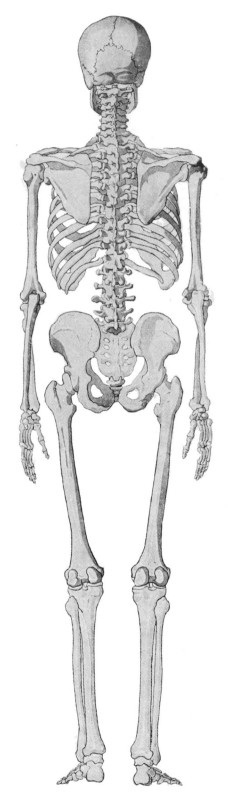

PLATE 2

POSTERIOR VIEW OF THE SKELETON

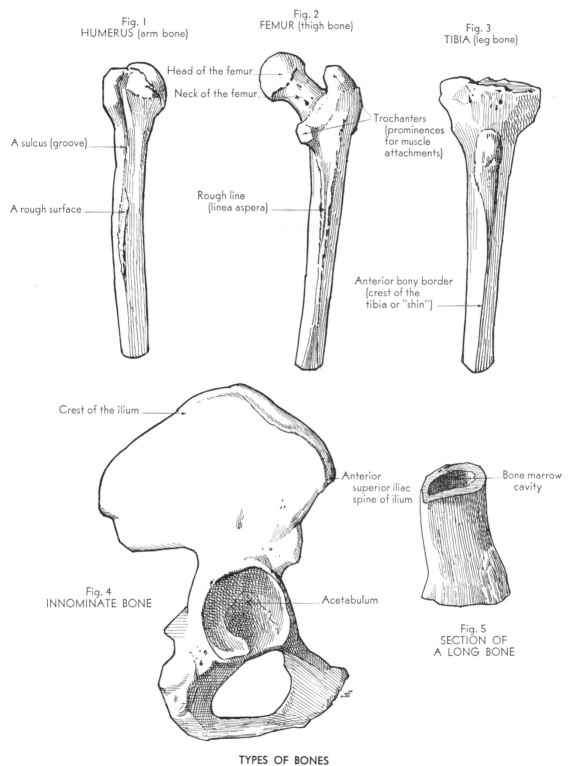

Fig. 1
HUMERUS (arm bone)

Fig. 2
FEMUR (thigh bone)

Fig. 3
TIBIA (leg bone)

Head of the femur

Neck of the femur

Trochanters
(prominences
for muscle
attachments)

A sulcus (groove)

A rough surface

Rough line
(linea aspera)

Anterior bony border
(crest of the
tibia or "shin")

Crest of the ilium

Anterior
superior iliac
spine of ilium

Bone marrow
cavity

Fig. 4
INNOMINATE BONE

Acetabulum

Fig. 5
SECTION OF
A LONG BONE

TYPES OF BONES

PLATE 3

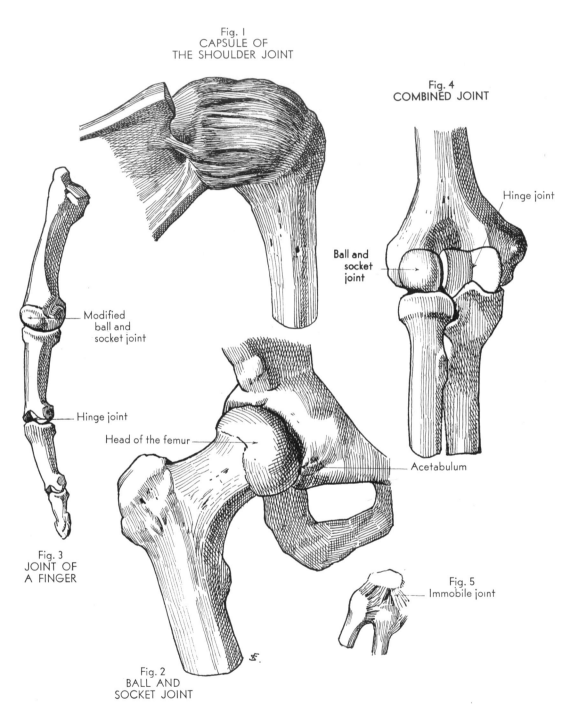

Fig. 1
CAPSULE OF
THE SHOULDER JOINT

Fig. 4
COMBINED JOINT

Hinge joint

Ball and
socket
joint

Modified
ball and
socket joint

Hinge joint

Head of the femur

Acetabulum

Fig. 3
JOINT OF
A FINGER

Fig. 5
Immobile joint

Fig. 2
BALL AND
SOCKET JOINT

TYPES OF JOINTS

PLATE 4

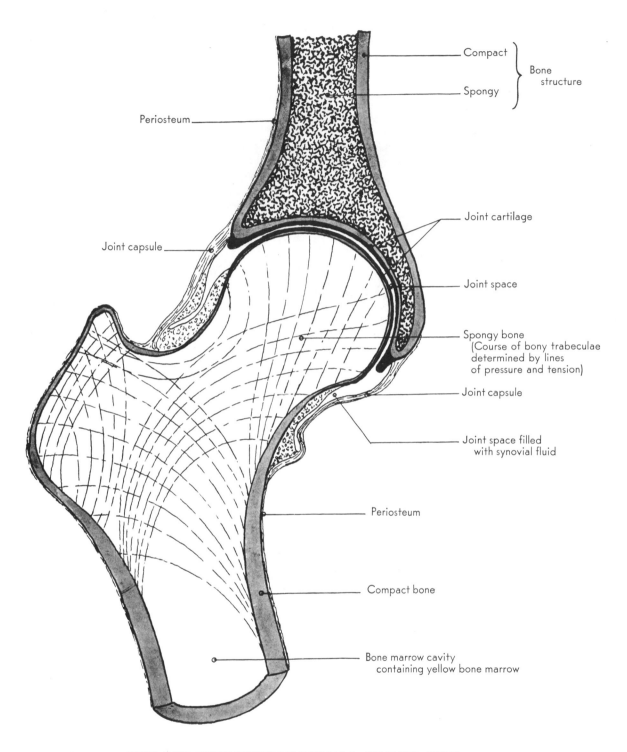

Compact ⎤
 ⎬ Bone structure
Spongy ⎦

Periosteum

Joint cartilage

Joint capsule

Joint space

Spongy bone
(Course of bony trabeculae
determined by lines
of pressure and tension)

Joint capsule

Joint space filled
with synovial fluid

Periosteum

Compact bone

Bone marrow cavity
containing yellow bone marrow

SCHEMATIC CROSS-SECTION THROUGH A JOINT (HIP JOINT)

PLATE 5

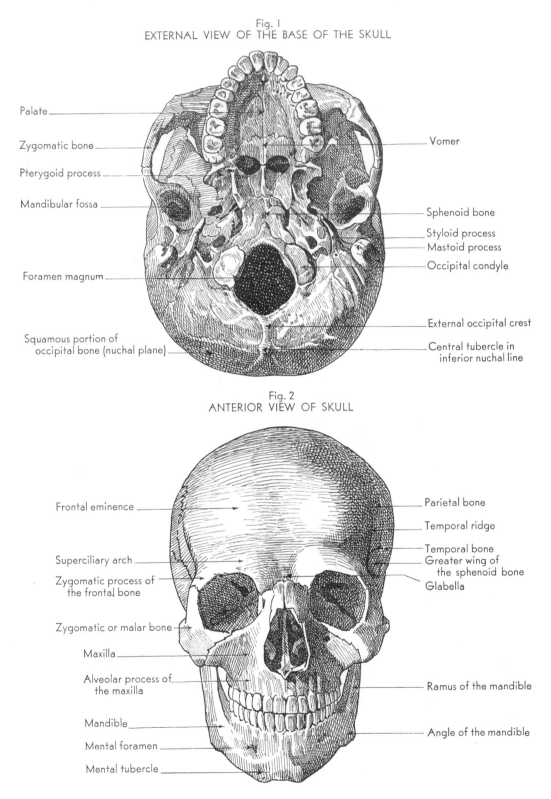

Fig. 1
EXTERNAL VIEW OF THE BASE OF THE SKULL

Palate

Zygomatic bone

Pterygoid process

Mandibular fossa

Foramen magnum

Squamous portion of
occipital bone (nuchal plane)

Vomer

Sphenoid bone
Styloid process
Mastoid process
Occipital condyle

External occipital crest

Central tubercle in
inferior nuchal line

Fig. 2
ANTERIOR VIEW OF SKULL

Frontal eminence

Superciliary arch

Zygomatic process of
the frontal bone

Zygomatic or malar bone

Maxilla

Alveolar process of
the maxilla

Mandible

Mental foramen

Mental tubercle

Parietal bone

Temporal ridge

Temporal bone
Greater wing of
the sphenoid bone
Glabella

Ramus of the mandible

Angle of the mandible

PLATE 6

THE SKULL

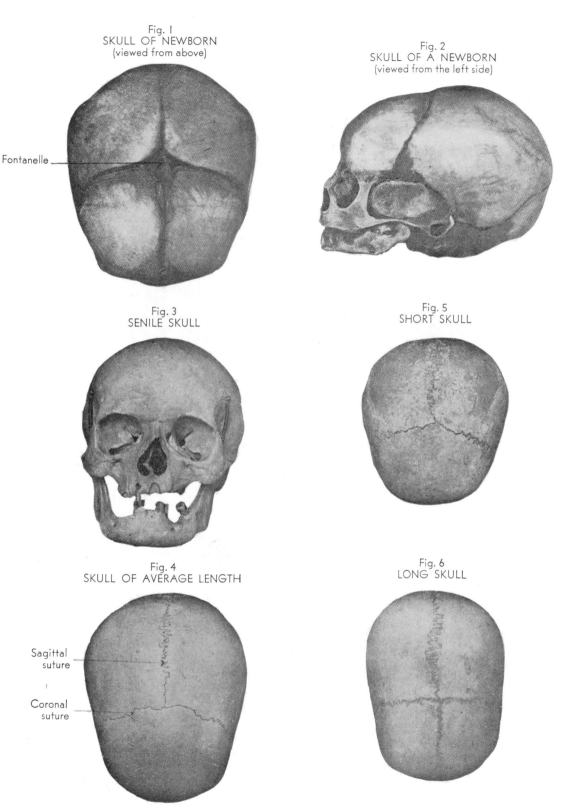

Fig. 1
SKULL OF NEWBORN
(viewed from above)

Fig. 2
SKULL OF A NEWBORN
(viewed from the left side)

Fontanelle

Fig. 3
SENILE SKULL

Fig. 5
SHORT SKULL

Fig. 4
SKULL OF AVERAGE LENGTH

Fig. 6
LONG SKULL

Sagittal
suture

Coronal
suture

TYPES OF SKULLS

PLATE 7

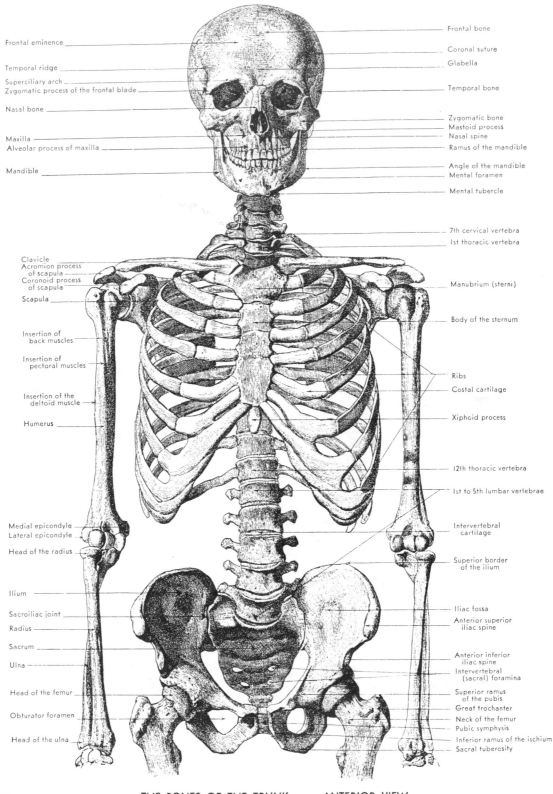

Frontal eminence

Temporal ridge

Superciliary arch
Zygomatic process of the frontal blade

Nasal bone

Maxilla
Alveolar process of maxilla

Mandible

Frontal bone

Coronal suture

Glabella

Temporal bone

Zygomatic bone
Mastoid process
Nasal spine
Ramus of the mandible

Angle of the mandible
Mental foramen

Mental tubercle

7th cervical vertebra
1st thoracic vertebra

Clavicle
Acromion process
of scapula
Coronoid process
of scapula

Scapula

Insertion of
back muscles

Insertion of
pectoral muscles

Insertion of the
deltoid muscle

Humerus

Manubrium (sterni)

Body of the sternum

Ribs

Costal cartilage

Xiphoid process

12th thoracic vertebra

1st to 5th lumbar vertebrae

Medial epicondyle
Lateral epicondyle

Head of the radius

Ilium

Sacroiliac joint

Radius

Sacrum

Ulna

Head of the femur

Obturator foramen

Head of the ulna

Intervertebral
cartilage

Superior border
of the ilium

Iliac fossa

Anterior superior
iliac spine

Anterior inferior
iliac spine

Intervertebral
(sacral) foramina

Superior ramus
of the pubis

Great trochanter

Neck of the femur

Pubic symphysis

Inferior ramus of the ischium

Sacral tuberosity

PLATE 8 THE BONES OF THE TRUNK ANTERIOR VIEW

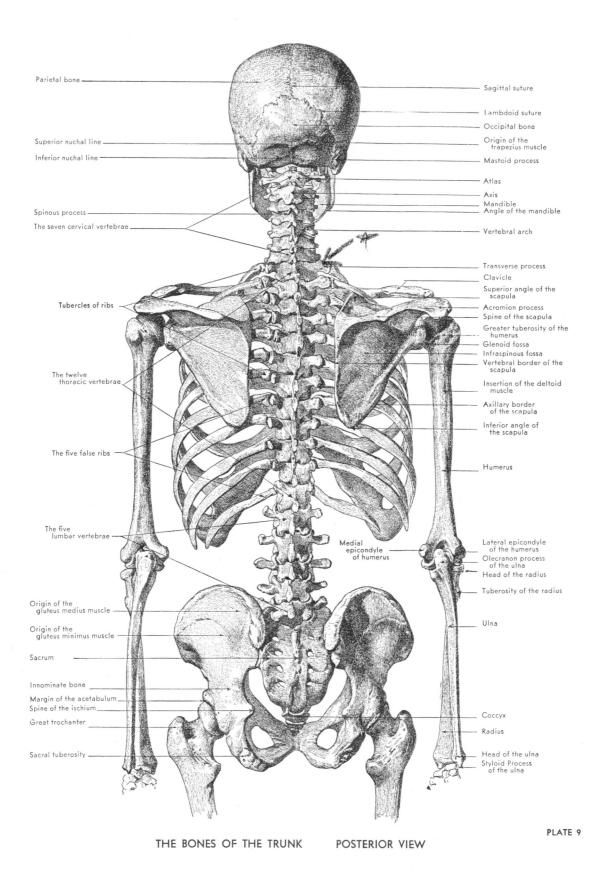

Parietal bone

Superior nuchal line

Inferior nuchal line

Spinous process
The seven cervical vertebrae

Tubercles of ribs

The twelve
thoracic vertebrae

The five false ribs

The five
lumbar vertebrae

Origin of the
gluteus medius muscle

Origin of the
gluteus minimus muscle

Sacrum

Innominate bone

Margin of the acetabulum
Spine of the ischium

Great trochanter

Sacral tuberosity

Sagittal suture

Lambdoid suture

Occipital bone

Origin of the
trapezius muscle

Mastoid process

Atlas

Axis
Mandible
Angle of the mandible

Vertebral arch

Transverse process
Clavicle
Superior angle of the
scapula
Acromion process
Spine of the scapula
Greater tuberosity of the
humerus
Glenoid fossa
Infraspinous fossa
Vertebral border of the
scapula
Insertion of the deltoid
muscle
Axillary border
of the scapula
Inferior angle of
the scapula

Humerus

Medial
epicondyle
of humerus

Lateral epicondyle
of the humerus
Olecranon process
of the ulna
Head of the radius

Tuberosity of the radius

Ulna

Coccyx

Radius

Head of the ulna
Styloid Process
of the ulna

PLATE 9

THE BONES OF THE TRUNK POSTERIOR VIEW

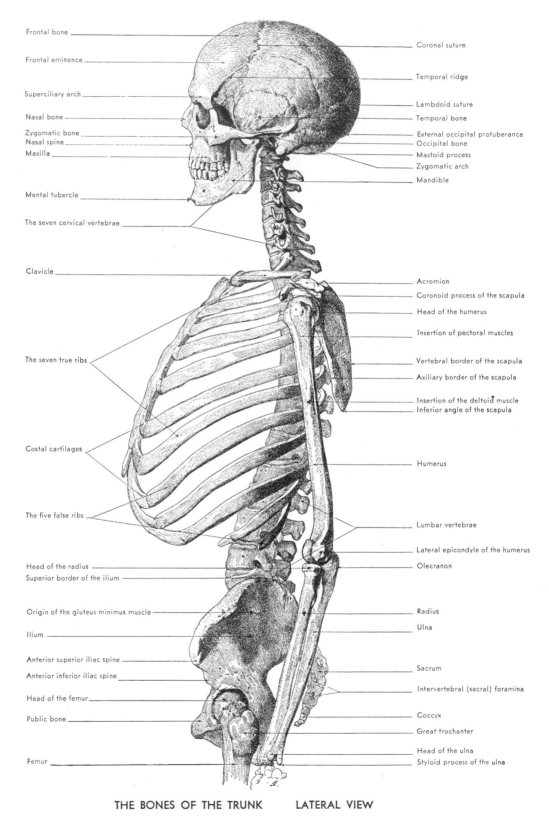

Frontal bone

Frontal eminence

Superciliary arch

Nasal bone

Zygomatic bone
Nasal spine
Maxilla

Mental tubercle

The seven cervical vertebrae

Clavicle

The seven true ribs

Costal cartilages

The five false ribs

Head of the radius
Superior border of the ilium

Origin of the gluteus minimus muscle

Ilium

Anterior superior iliac spine

Anterior inferior iliac spine

Head of the femur

Public bone

Femur

Coronal suture

Temporal ridge

Lambdoid suture

Temporal bone
External occipital protuberance
Occipital bone
Mastoid process
Zygomatic arch
Mandible

Acromion
Coronoid process of the scapula
Head of the humerus
Insertion of pectoral muscles

Vertebral border of the scapula
Axiliary border of the scapula

Insertion of the deltoid muscle
Inferior angle of the scapula

Humerus

Lumbar vertebrae

Lateral epicondyle of the humerus
Olecranon

Radius
Ulna

Sacrum

Intervertebral (sacral) foramina

Coccyx
Great trochanter

Head of the ulna
Styloid process of the ulna

PLATE 10 THE BONES OF THE TRUNK LATERAL VIEW

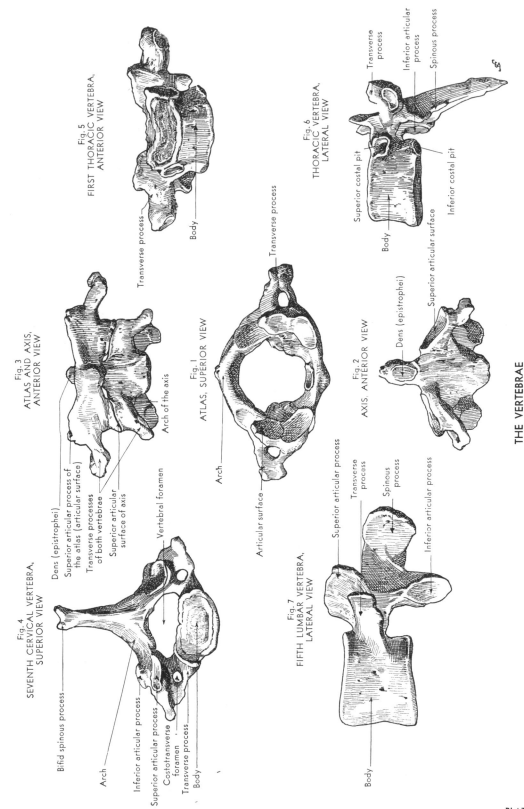

Fig. 5
FIRST THORACIC VERTEBRA,
ANTERIOR VIEW

Transverse process

Body

Fig. 6
THORACIC VERTEBRA,
LATERAL VIEW

Transverse process
Inferior articular process
Spinous process
Superior costal pit
Body
Superior articular surface
Inferior costal pit

Fig. 3
ATLAS AND AXIS,
ANTERIOR VIEW

Transverse process

Fig. 1
ATLAS, SUPERIOR VIEW

Arch
Articular surface

Fig. 2
AXIS, ANTERIOR VIEW

Dens (epistrophei)
Superior articular process of
the atlas (articular surface)
Transverse processes
of both vertebrae
Superior articular
surface of axis
Arch of the axis
Dens (epistrophei)
Vertebral foramen

Fig. 4
SEVENTH CERVICAL VERTEBRA,
SUPERIOR VIEW

Bifid spinous process
Arch
Inferior articular process
Superior articular process
Costotransverse
foramen
Transverse process
Body

Fig. 7
FIFTH LUMBAR VERTEBRA,
LATERAL VIEW

Superior articular process
Transverse process
Spinous process
Inferior articular process
Body

THE VERTEBRAE

PLATE 11

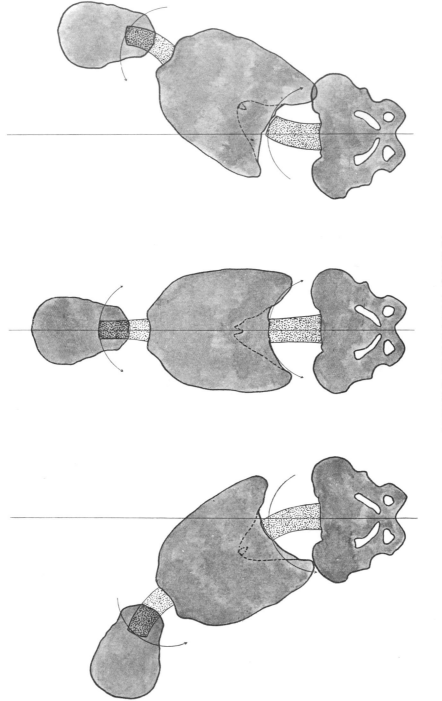

MOTIONS OF THE SPINAL COLUMN

Lateral bending (schematic). Immobile parts shaded: moving parts dotted.

PLATE 12

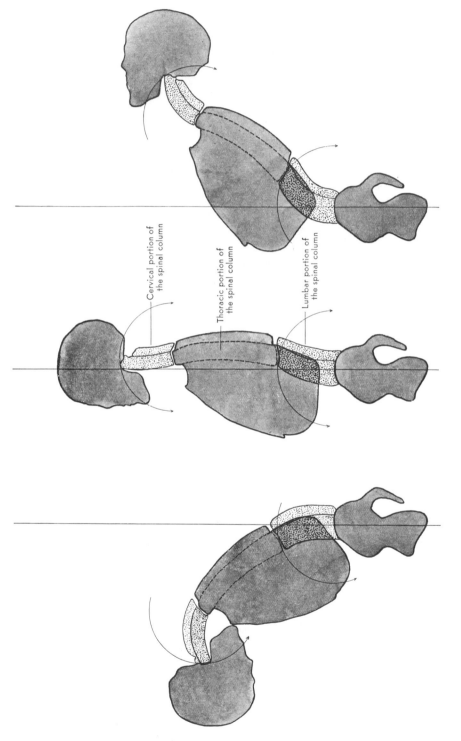

Cervical portion of
the spinal column

Thoracic portion of
the spinal column

Lumbar portion of
the spinal column

MOTIONS OF THE SPINAL COLUMN
Forward and backward bending (schematic). Immobile parts shaded: moving parts dotted.

PLATE 13

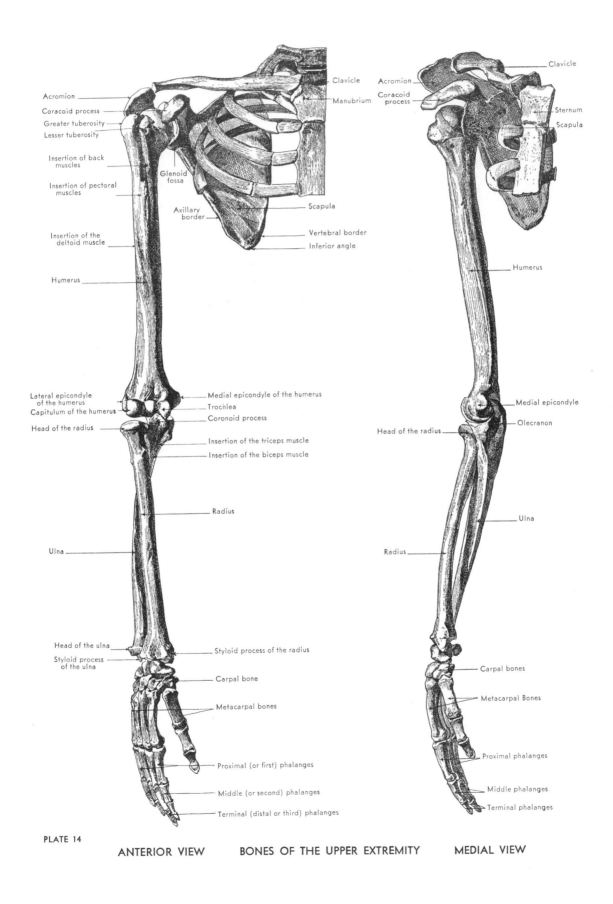

Acromion

Coracoid process

Greater tuberosity

Lesser tuberosity

Insertion of back muscles

Insertion of pectoral muscles

Insertion of the deltoid muscle

Humerus

Lateral epicondyle of the humerus

Capitulum of the humerus

Head of the radius

Ulna

Head of the ulna

Styloid process of the ulna

Clavicle

Manubrium

Glenoid fossa

Axillary border

Scapula

Vertebral border

Inferior angle

Medial epicondyle of the humerus

Trochlea

Coronoid process

Insertion of the triceps muscle

Insertion of the biceps muscle

Radius

Styloid process of the radius

Carpal bone

Metacarpal bones

Proximal (or first) phalanges

Middle (or second) phalanges

Terminal (distal or third) phalanges

Acromion

Coracoid process

Clavicle

Sternum

Scapula

Humerus

Medial epicondyle

Olecranon

Head of the radius

Ulna

Radius

Carpal bones

Metacarpal Bones

Proximal phalanges

Middle phalanges

Terminal phalanges

PLATE 14

ANTERIOR VIEW BONES OF THE UPPER EXTREMITY MEDIAL VIEW

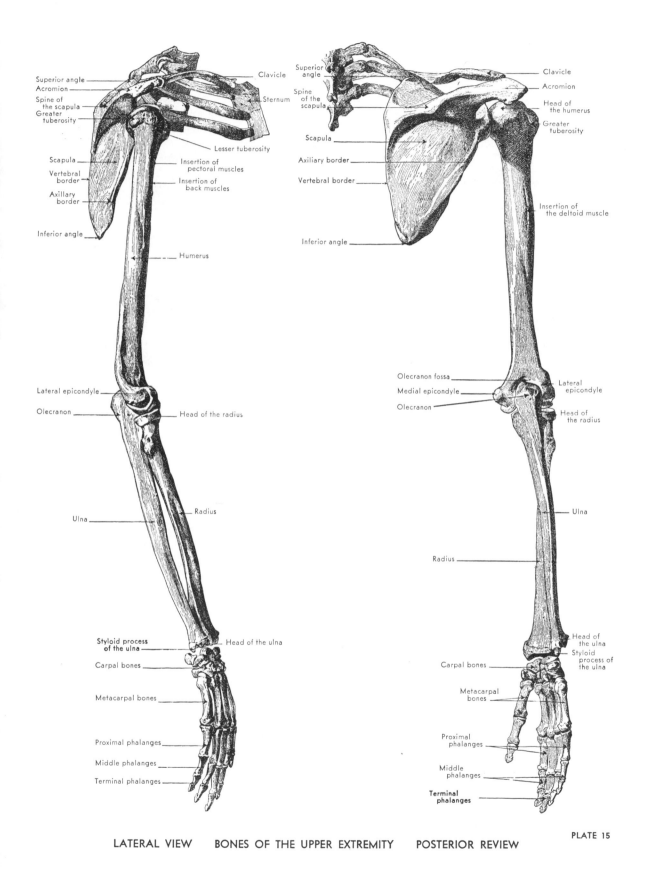

Superior angle
Acromion
Spine of the scapula
Greater tuberosity

Clavicle

Sternum

Lesser tuberosity

Scapula
Vertebral border
Axillary border

Insertion of pectoral muscles
Insertion of back muscles

Inferior angle

Humerus

Lateral epicondyle

Olecranon

Head of the radius

Ulna

Radius

Styloid process of the ulna

Head of the ulna

Carpal bones

Metacarpal bones

Proximal phalanges

Middle phalanges

Terminal phalanges

Superior angle
Spine of the scapula

Clavicle
Acromion
Head of the humerus
Greater tuberosity

Scapula

Axiliary border

Vertebral border

Insertion of the deltoid muscle

Inferior angle

Olecranon fossa
Medial epicondyle
Olecranon

Lateral epicondyle
Head of the radius

Ulna

Radius

Head of the ulna
Styloid process of the ulna

Carpal bones

Metacarpal bones

Proximal phalanges

Middle phalanges

Terminal phalanges

LATERAL VIEW BONES OF THE UPPER EXTREMITY POSTERIOR REVIEW

PLATE 15

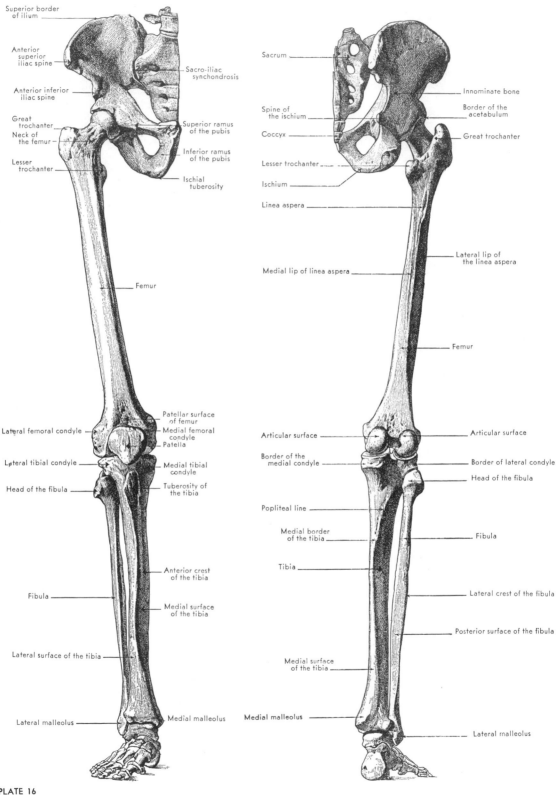

Superior border
of ilium

Anterior
superior
iliac spine

Anterior inferior
iliac spine

Great
trochanter

Neck of
the femur

Lesser
trochanter

Sacro-iliac
synchondrosis

Superior ramus
of the pubis

Inferior ramus
of the pubis

Ischial
tuberosity

Femur

Patellar surface
of femur

Lateral femoral condyle

Medial femoral
condyle

Patella

Lateral tibial condyle

Medial tibial
condyle

Head of the fibula

Tuberosity of
the tibia

Anterior crest
of the tibia

Fibula

Medial surface
of the tibia

Lateral surface of the tibia

Lateral malleolus

Medial malleolus

Sacrum

Spine of
the ischium

Coccyx

Lesser trochanter

Ischium

Linea aspera

Medial lip of linea aspera

Innominate bone

Border of the
acetabulum

Great trochanter

Lateral lip of
the linea aspera

Femur

Articular surface

Border of the
medial condyle

Popliteal line

Medial border
of the tibia

Tibia

Medial surface
of the tibia

Medial malleolus

Articular surface

Border of lateral condyle

Head of the fibula

Fibula

Lateral crest of the fibula

Posterior surface of the fibula

Lateral malleolus

PLATE 16

THE BONES OF THE LOWER EXTREMITY ANTERIOR AND POSTERIOR VIEWS

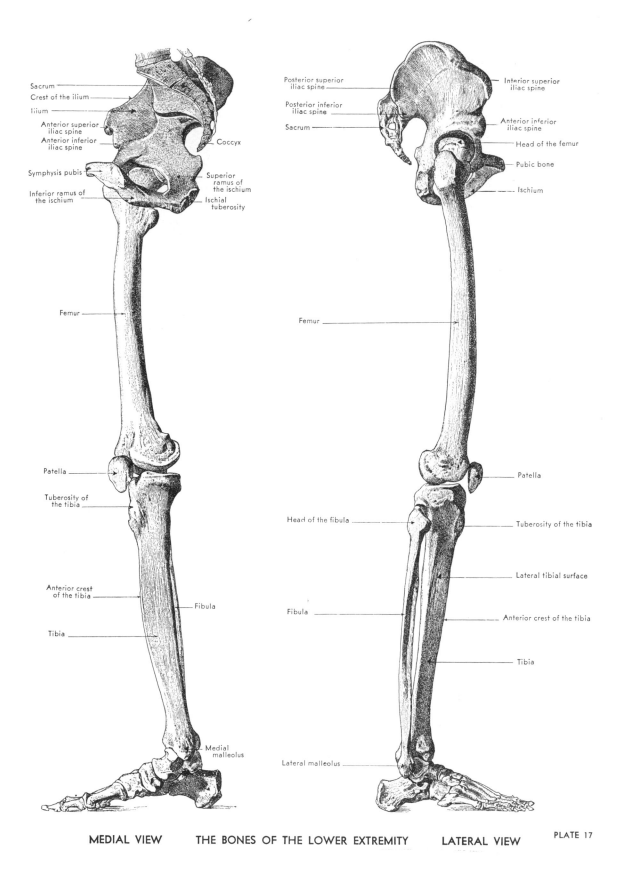

Sacrum

Crest of the ilium

Ilium

Anterior superior
iliac spine

Anterior inferior
iliac spine

Symphysis pubis

Inferior ramus of
the ischium

Coccyx

Superior
ramus of
the ischium

Ischial
tuberosity

Femur

Patella

Tuberosity of
the tibia

Anterior crest
of the tibia

Fibula

Tibia

Medial
malleolus

Posterior superior
iliac spine

Posterior inferior
iliac spine

Sacrum

Interior superior
iliac spine

Anterior inferior
iliac spine

Head of the femur

Pubic bone

Ischium

Femur

Patella

Head of the fibula

Tuberosity of the tibia

Lateral tibial surface

Fibula

Anterior crest of the tibia

Tibia

Lateral malleolus

MEDIAL VIEW THE BONES OF THE LOWER EXTREMITY LATERAL VIEW PLATE 17

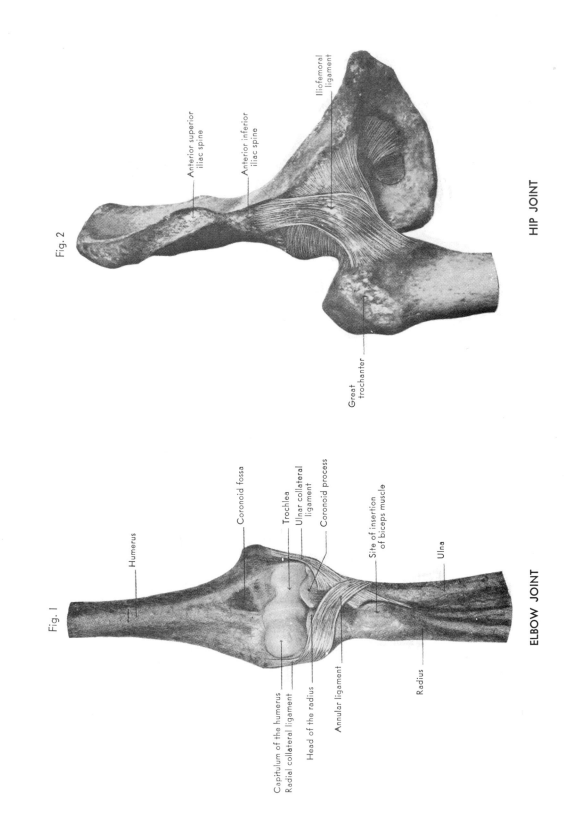

Fig. 2

Anterior superior iliac spine

Anterior inferior iliac spine

Iliofemoral ligament

Great trochanter

HIP JOINT

Fig. 1

Humerus

Coronoid fossa

Trochlea

Ulnar collateral ligament

Coronoid process

Site of insertion of biceps muscle

Ulna

Capitulum of the humerus

Radial collateral ligament

Head of the radius

Annular ligament

Radius

ELBOW JOINT

PLATE 18

Fig. I

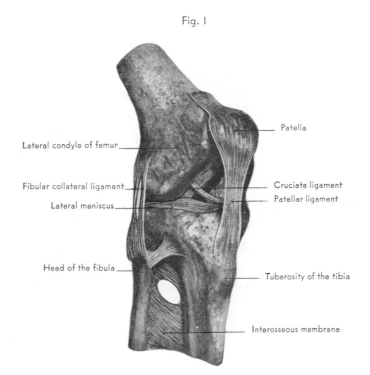

Patella

Lateral condyle of femur

Fibular collateral ligament

Cruciate ligament

Lateral meniscus

Patellar ligament

Head of the fibula

Tuberosity of the tibia

Interosseous membrane

Fig. 2

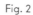
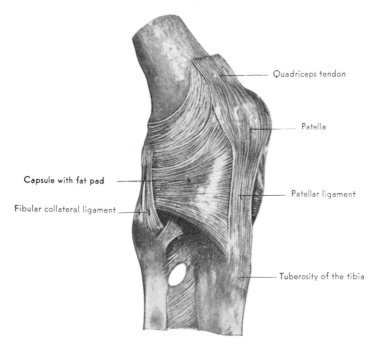

Quadriceps tendon

Patella

Capsule with fat pad

Fibular collateral ligament

Patellar ligament

Tuberosity of the tibia

KNEE JOINT

PLATE 19

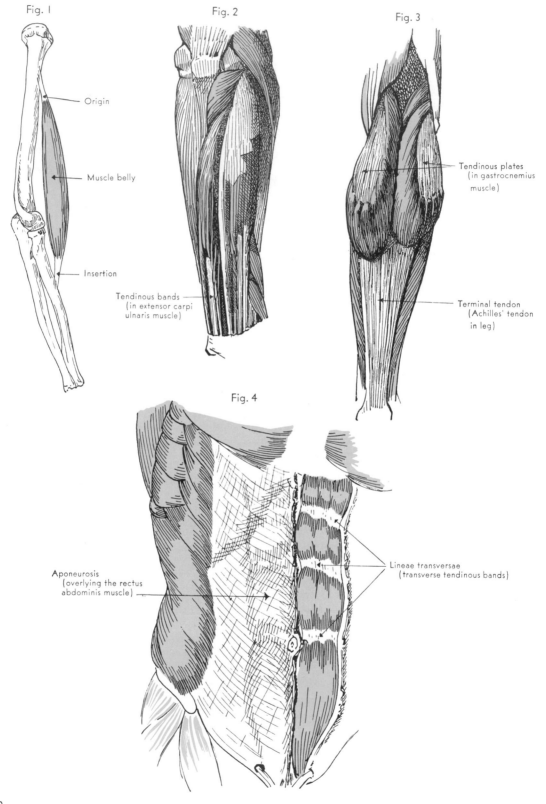

Fig. 1

Origin

Muscle belly

Insertion

Fig. 2

Tendinous bands
(in extensor carpi
ulnaris muscle)

Fig. 3

Tendinous plates
(in gastrocnemius
muscle)

Terminal tendon
(Achilles' tendon
in leg)

Fig. 4

Aponeurosis
(overlying the rectus
abdominis muscle)

Lineae transversae
(transverse tendinous bands)

PLATE 20

TYPES OF TENDONS AND MUSCLES

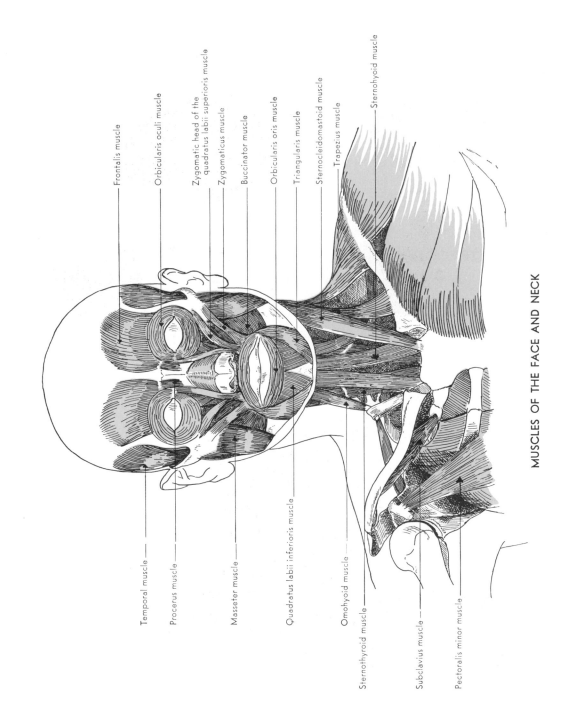

Frontalis muscle

Orbicularis oculi muscle

Zygomatic head of the
quadratus labii superioris muscle

Zygomaticus muscle

Buccinator muscle

Orbicularis oris muscle

Triangularis muscle

Sternocleidomastoid muscle

Trapezius muscle

Sternohyoid muscle

Temporal muscle

Procerus muscle

Masseter muscle

Quadratus labii inferioris muscle

Omohyoid muscle

Sternothyroid muscle

Subclavius muscle

Pectoralis minor muscle

MUSCLES OF THE FACE AND NECK

PLATE 21

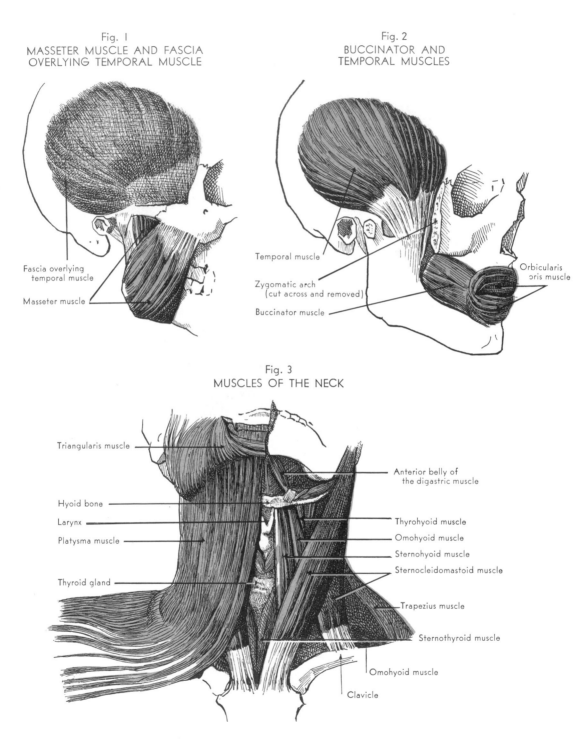

Fig. 1
MASSETER MUSCLE AND FASCIA
OVERLYING TEMPORAL MUSCLE

Fascia overlying
temporal muscle

Masseter muscle

Fig. 2
BUCCINATOR AND
TEMPORAL MUSCLES

Temporal muscle

Zygomatic arch
(cut across and removed)

Buccinator muscle

Orbicularis
oris muscle

Fig. 3
MUSCLES OF THE NECK

Triangularis muscle

Hyoid bone

Larynx

Platysma muscle

Thyroid gland

Anterior belly of
the digastric muscle

Thyrohyoid muscle

Omohyoid muscle

Sternohyoid muscle

Sternocleidomastoid muscle

Trapezius muscle

Sternothyroid muscle

Omohyoid muscle

Clavicle

MUSCLES OF THE HEAD AND NECK

PLATE 22

Fig. 1

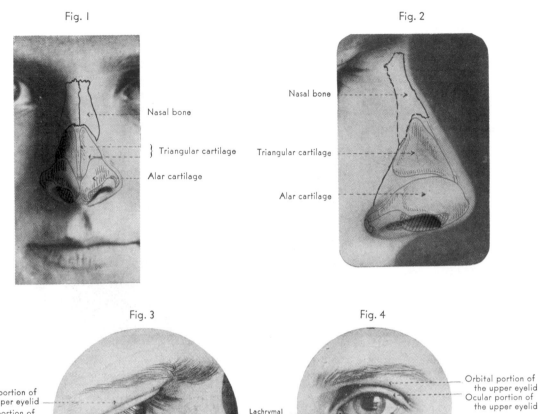

Nasal bone

} Triangular cartilage

Alar cartilage

Fig. 2

Nasal bone

Triangular cartilage

Alar cartilage

Fig. 3

Orbital portion of
the upper eyelid
Ocular portion of
the upper eyelid

Ocular portion of
the lower eyelid
Orbital portion of
the lower eyelid

Fig. 4

Orbital portion of
the upper eyelid
Ocular portion of
the upper eyelid

Lachrymal
caruncle

Ocular portion of
the lower eyelid
Orbital portion of
the lower eyelid

Fig. 5

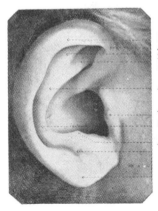

Helix of the ear
Anterior branch of the helix
Superior branch } of the anti-helix
Inferior branch

Anti-helix

Tragus
Posterior branch of the anti-helix

Anti-tragus
Lower end of the anti-helix

Lobule of the ear

Fig. 4

NOSE, EYE, AND EAR

PLATE 23

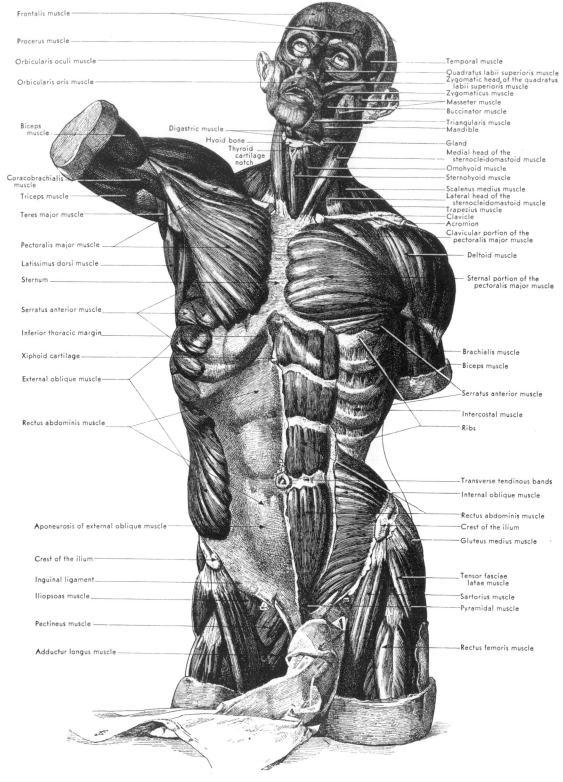

Frontalis muscle

Procerus muscle

Orbicularis oculi muscle

Orbicularis oris muscle

Biceps muscle

Coracobrachialis muscle

Triceps muscle

Teres major muscle

Pectoralis major muscle

Latissimus dorsi muscle

Sternum

Serratus anterior muscle

Inferior thoracic margin

Xiphoid cartilage

External oblique muscle

Rectus abdominis muscle

Aponeurosis of external oblique muscle

Crest of the ilium

Inguinal ligament

Iliopsoas muscle

Pectineus muscle

Adductur longus muscle

Digastric muscle

Hyoid bone
Thyroid cartilage notch

Temporal muscle
Quadratus labii superioris muscle
Zygomatic head of the quadratus labii superioris muscle
Zygomaticus muscle
Masseter muscle
Buccinator muscle
Triangularis muscle
Mandible
Gland
Medial head of the sternocleidomastoid muscle
Omohyoid muscle
Sternohyoid muscle
Scalenus medius muscle
Lateral head of the sternocleidomastoid muscle
Trapezius muscle
Clavicle
Acromion
Clavicular portion of the pectoralis major muscle

Deltoid muscle

Sternal portion of the pectoralis major muscle

Brachialis muscle

Biceps muscle

Serratus anterior muscle

Intercostal muscle

Ribs

Transverse tendinous bands

Internal oblique muscle

Rectus abdominis muscle
Crest of the ilium
Gluteus medius muscle

Tensor fasciae latae muscle

Sartorius muscle
Pyramidal muscle

Rectus femoris muscle

PLATE 24 MUSCLES OF THE TRUNK ANTERIOR VIEW

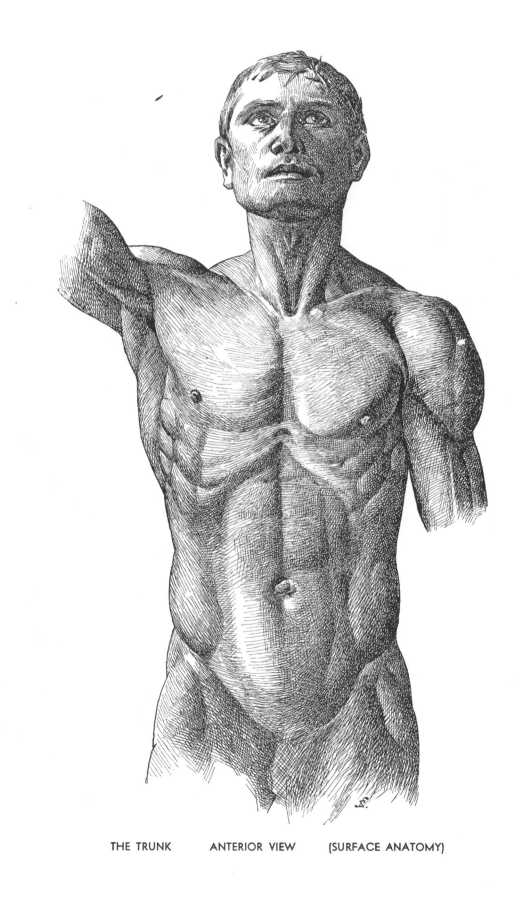

THE TRUNK ANTERIOR VIEW (SURFACE ANATOMY) PLATE 25

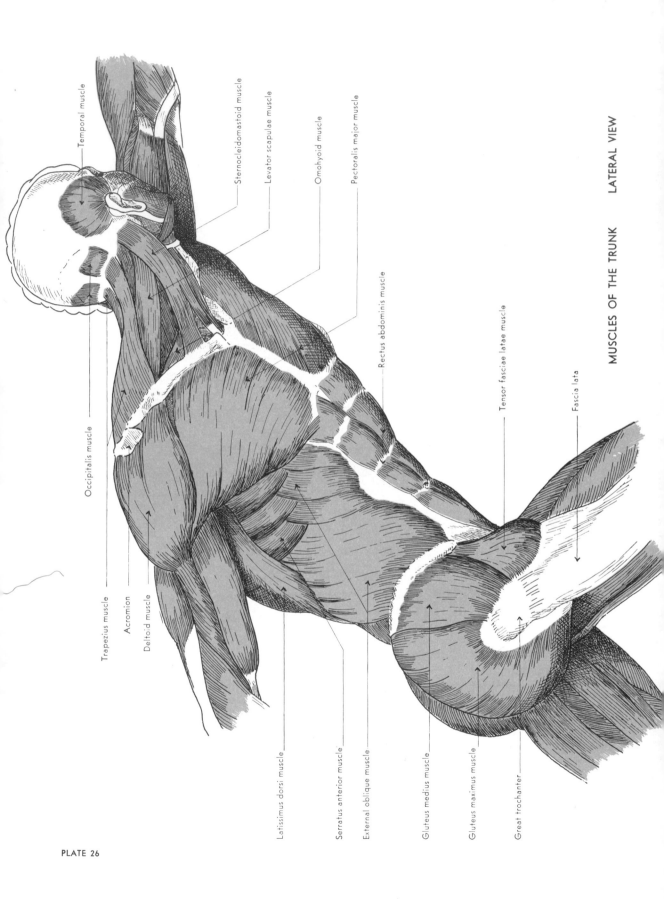

Temporal muscle

Sternocleidomastoid muscle

Levator scapulae muscle

Omohyoid muscle

Pectoralis major muscle

Rectus abdominis muscle

Tensor fasciae latae muscle

Fascia lata

Occipitalis muscle

Trapezius muscle

Acromion

Deltoid muscle

Latissimus dorsi muscle

Serratus anterior muscle

External oblique muscle

Gluteus medius muscle

Gluteus maximus muscle

Great trochanter

MUSCLES OF THE TRUNK LATERAL VIEW

PLATE 26

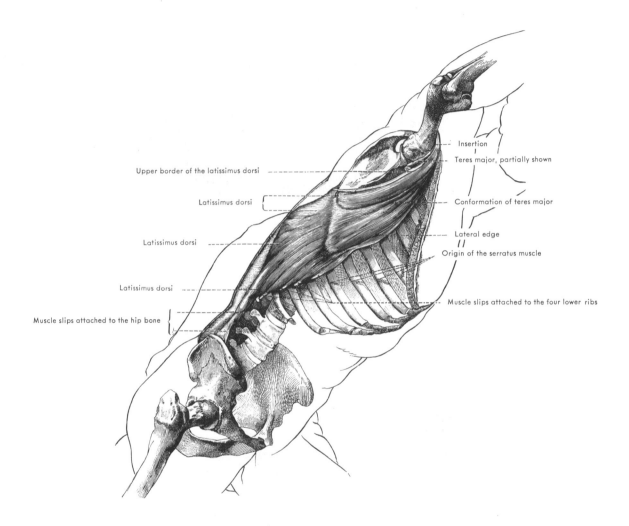

Insertion

Teres major, partially shown

Upper border of the latissimus dorsi

Latissimus dorsi

Conformation of teres major

Latissimus dorsi

Lateral edge

Origin of the serratus muscle

Latissimus dorsi

Muscle slips attached to the hip bone

Muscle slips attached to the four lower ribs

KOLLMANN, THE LATISSIMUS DORSI, WITH ARM RAISED

PLATE 27

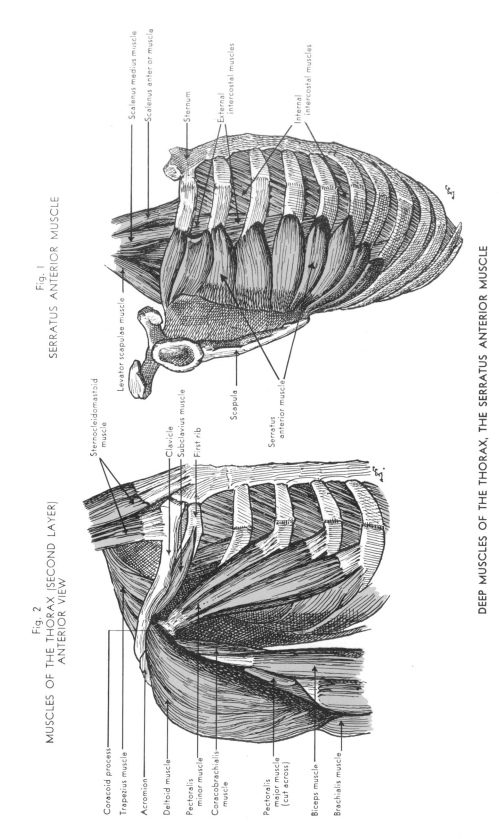

Fig. I
SERRATUS ANTERIOR MUSCLE

Fig. 2
MUSCLES OF THE THORAX (SECOND LAYER)
ANTERIOR VIEW

Scalenus medius muscle
Scalenus anter or muscle
Sternum
External intercostal muscles
Internal intercostal muscles

Levator scapulae muscle

Sternocleidomastoid muscle

Clavicle
Subclavius muscle
First rib

Scapula

Serratus anterior muscle

Coracoid process
Trapezius muscle
Acromion
Deltoid muscle
Pectoralis minor muscle
Coracobrachialis muscle
Pectoralis major muscle (cut across)
Biceps muscle
Brachialis muscle

DEEP MUSCLES OF THE THORAX, THE SERRATUS ANTERIOR MUSCLE

PLATE 28

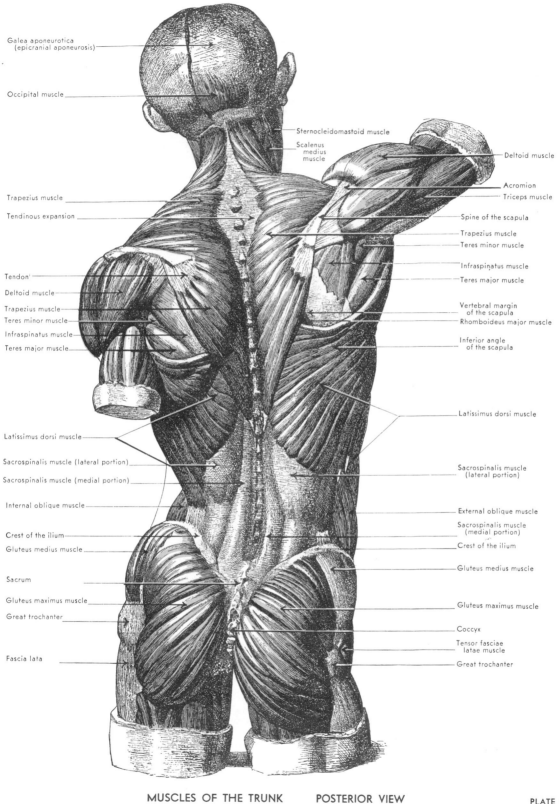

Galea aponeurotica
(epicranial aponeurosis)

Occipital muscle

Sternocleidomastoid muscle

Scalenus
medius
muscle

Deltoid muscle

Acromion
Triceps muscle

Trapezius muscle

Tendinous expansion

Spine of the scapula

Trapezius muscle
Teres minor muscle

Infraspinatus muscle
Teres major muscle

Tendon

Deltoid muscle

Trapezius muscle

Teres minor muscle

Infraspinatus muscle

Teres major muscle

Vertebral margin
of the scapula
Rhomboideus major muscle

Inferior angle
of the scapula

Latissimus dorsi muscle

Latissimus dorsi muscle

Sacrospinalis muscle (lateral portion)

Sacrospinalis muscle (medial portion)

Sacrospinalis muscle
(lateral portion)

Internal oblique muscle

External oblique muscle
Sacrospinalis muscle
(medial portion)

Crest of the ilium

Gluteus medius muscle

Crest of the ilium

Gluteus medius muscle

Sacrum

Gluteus maximus muscle

Great trochanter

Gluteus maximus muscle

Coccyx

Tensor fasciae
latae muscle

Great trochanter

Fascia lata

MUSCLES OF THE TRUNK POSTERIOR VIEW

PLATE 29

PLATE 30 THE TRUNK POSTERIOR VIEW (SURFACE ANATOMY)

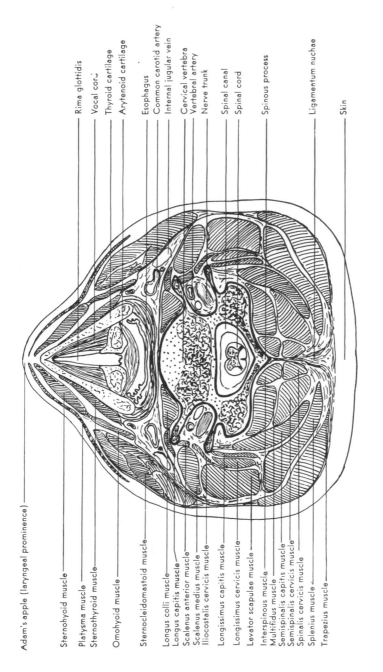

Adam's apple (laryngeal prominence)

Sternohyoid muscle

Platysma muscle
Sternothyroid muscle

Omohyoid muscle

Sternocleidomastoid muscle

Longus colli muscle
Longus capitis muscle
Scalenus anterior muscle
Scalenus medius muscle
Iliocostalis cervicis muscle

Longissimus capitis muscle

Longissimus cervicis muscle
Levator scapulae muscle

Interspinous muscle
Multifidus muscle
Semispinalis capitis muscle
Semispinalis cervicis muscle
Spinalis cervicis muscle
Splenius muscle
Trapezius muscle

Rima glottidis

Vocal cord
Thyroid cartilage
Arytenoid cartilage

Esophagus
Common carotid artery
Internal jugular vein
Cervical vertebra
Vertebral artery
Nerve trunk

Spinal canal
Spinal cord

Spinous process

Ligamentum nuchae

Skin

CROSS-SECTION THROUGH THE NECK OF AN ADULT

PLATE 31

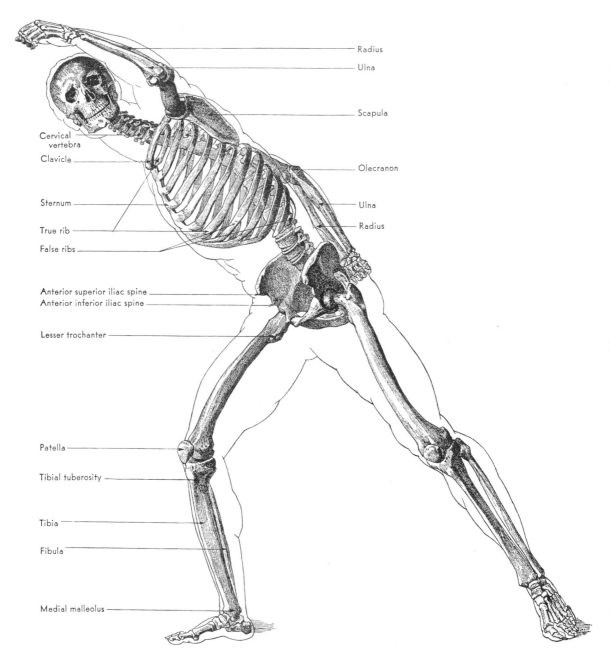

Radius

Ulna

Scapula

Cervical
vertebra

Clavicle

Olecranon

Sternum

Ulna

True rib

Radius

False ribs

Anterior superior iliac spine
Anterior inferior iliac spine

Lesser trochanter

Patella

Tibial tuberosity

Tibia

Fibula

Medial malleolus

SKELETON IN POSITION OF "THE FIGHTER" BY BORGHESE

PLATE 32

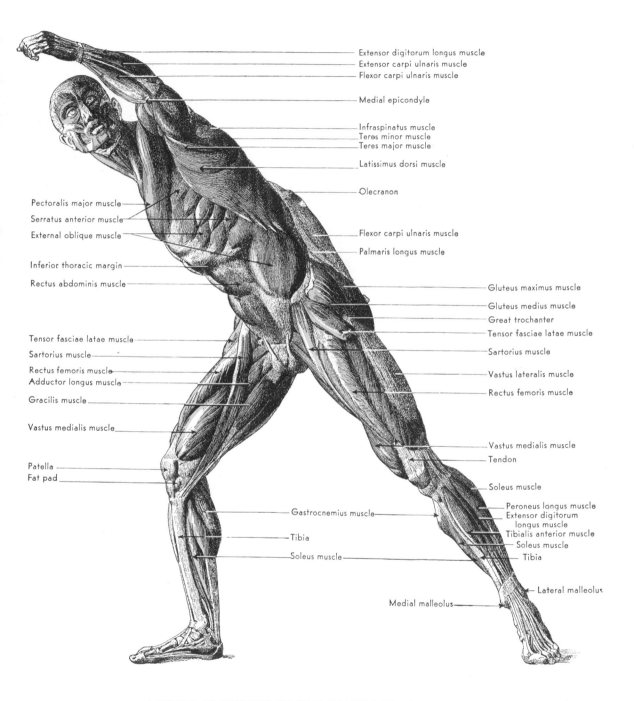

Extensor digitorum longus muscle
Extensor carpi ulnaris muscle
Flexor carpi ulnaris muscle

Medial epicondyle

Infraspinatus muscle
Teres minor muscle
Teres major muscle

Latissimus dorsi muscle

Olecranon

Pectoralis major muscle
Serratus anterior muscle
External oblique muscle

Flexor carpi ulnaris muscle
Palmaris longus muscle

Inferior thoracic margin
Rectus abdominis muscle

Gluteus maximus muscle
Gluteus medius muscle
Great trochanter
Tensor fasciae latae muscle

Tensor fasciae latae muscle
Sartorius muscle
Rectus femoris muscle
Adductor longus muscle
Gracilis muscle

Sartorius muscle
Vastus lateralis muscle
Rectus femoris muscle

Vastus medialis muscle

Vastus medialis muscle
Tendon

Patella
Fat pad

Soleus muscle

Peroneus longus muscle
Extensor digitorum longus muscle
Tibialis anterior muscle
Soleus muscle
Tibia

Gastrocnemius muscle

Tibia

Soleus muscle

Lateral malleolus

Medial malleolus

MUSCLES IN POSITION OF "THE FIGHTER" BY BORGHESE

PLATE 33

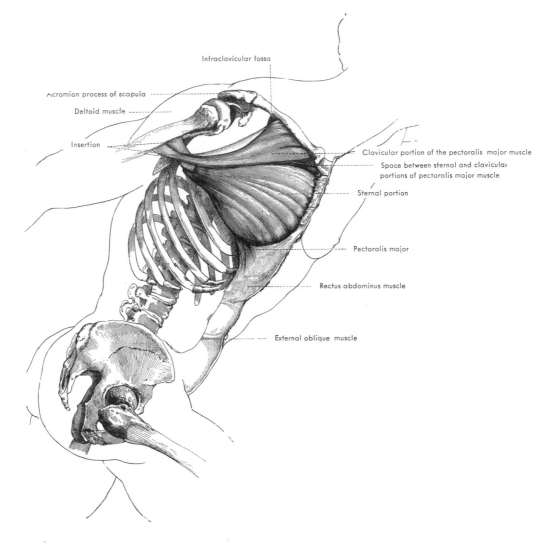

Infraclavicular fossa

Acromion process of scapula

Deltoid muscle

Insertion

Clavicular portion of the pectoralis major muscle

Space between sternal and clavicular portions of pectoralis major muscle

Sternal portion

Pectoralis major

Rectus abdominus muscle

External oblique muscle

KOLLMANN, THE PECTORALIS MAJOR, BASED ON THE
BORGHESE "FIGHTER"

PLATE 34

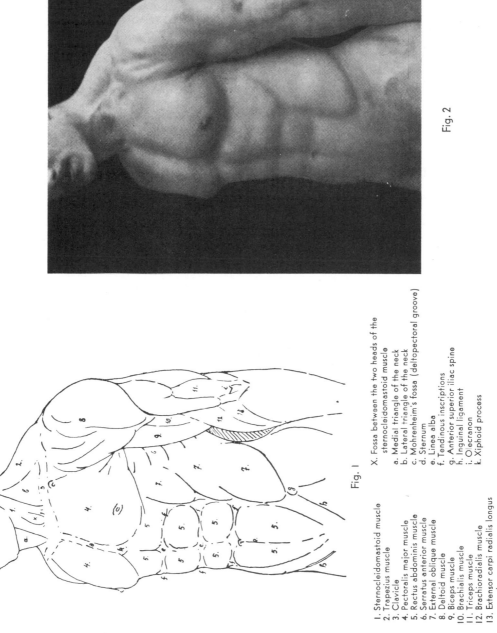

Fig. 2

Fig. 1

1. Sternocleidomastoid muscle
2. Trapezius muscle
3. Clavicle
4. Pectoralis major muscle
5. Rectus abdominis muscle
6. Serratus anterior muscle
7. External oblique muscle
8. Deltoid muscle
9. Biceps muscle
10. Brachialis muscle
11. Triceps muscle
12. Brachioradialis muscle
13. Extensor carpi radialis longus
 muscle

X. Fossa between the two heads of the
 sternocleidomastoid muscle
a. Medial triangle of the neck
b. Lateral triangle of the neck
c. Mohrenheim's fossa (deltopectoral groove)
d. Sternum
e. Linea alba
f. Tendinous inscriptions
g. Anterior superior iliac spine
h. Inguinal ligament
i. Olecranon
k. Xiphoid process

ATHLETE THORAX I

PLATE 35

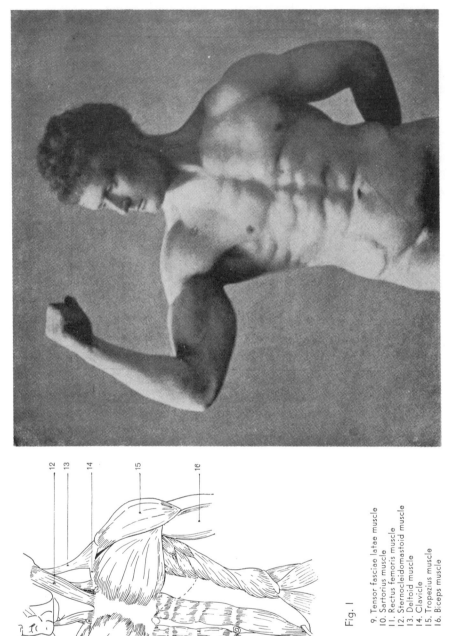

Fig. 1

Fig. 2

ATHLETE ANTERIOR VIEW

1. Pectoralis major muscle
2. Latissimus dorsi muscle
3. Serratus anterior muscle
4. Inferior thoracic margin
5. External oblique muscle
6. Rectus abdominis muscle
7. Gluteus medius muscle
8. Crest of the ilium

9. Tensor fasciae latae muscle
10. Sartorius muscle
11. Rectus femoris muscle
12. Sternocleidomastoid muscle
13. Deltoid muscle
14. Clavicle
15. Tropezius muscle
16. Biceps muscle

PLATE 36

Fig. 2

Fig. I

1. Sternocleidomastoid muscle
2. Trapezius muscle
3. Clavicle
4. Pectoralis major muscle
5. Rectus abdominis muscle
6. Serratus anterior muscle
7. External oblique muscle
8. Deltoid muscle
X. Fossa between the two heads of
 the sternocleidomastoid muscle
a. Medial triangle of the neck

b. Lateral triangle of the neck
c. Mohrenheim's fossa (deltopectoral
 groove)
d. Sternum
e. Linea alba
f. Tendinous inscriptions
g. Anterior superior iliac
 spine
h. Inguinal ligament
i. Acromion
k. Xiphoid process

ATHLETE THORAX II

PLATE 37

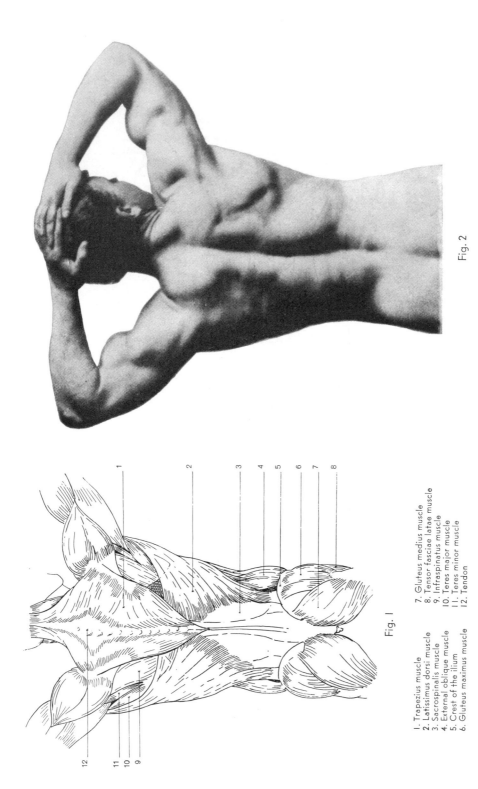

Fig. 2

Fig. 1

1. Trapezius muscle
2. Latissimus dorsi muscle
3. Sacrospinalis muscle
4. External oblique muscle
5. Crest of the ilium
6. Gluteus maximus muscle

7. Gluteus medius muscle
8. Tensor fasciae latae muscle
9. Infraspinatus muscle
10. Teres major muscle
11. Teres minor muscle
12. Tendon

ATHLETE POSTERIOR VIEW

PLATE 38

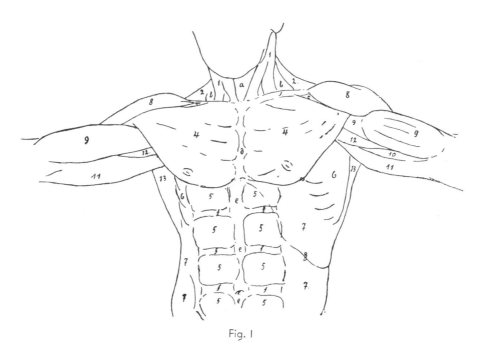

Fig. I

1. Sternocleidomastoid muscle
2. Trapezius muscle
3. Clavicle
4. Pectoralis major muscle
5. Rectus abdominis muscle
6. Serratus anterior muscle
7. External oblique muscle
8. Deltoid muscle
9. Biceps muscle
10. Brachialis muscle
11. Triceps muscle
12. Coracobrachialis muscle

13. Latissimus dorsi muscle
X. Fossa between the two heads of
 the sternocleidomastoid muscle
a. Medial triangle of the neck
b. Lateral triangle of the neck
c. Mohrenheim's fossa (deltopectoral
 groove)
d. Sternum
e. Linea alba
f. Tendinous inscriptions
g. Inferior thoracic margin

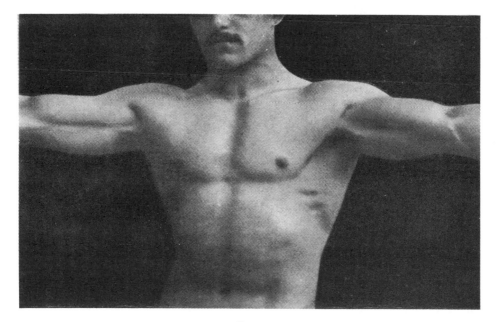

Fig. 2

ATHLETE THORAX III PLATE 39

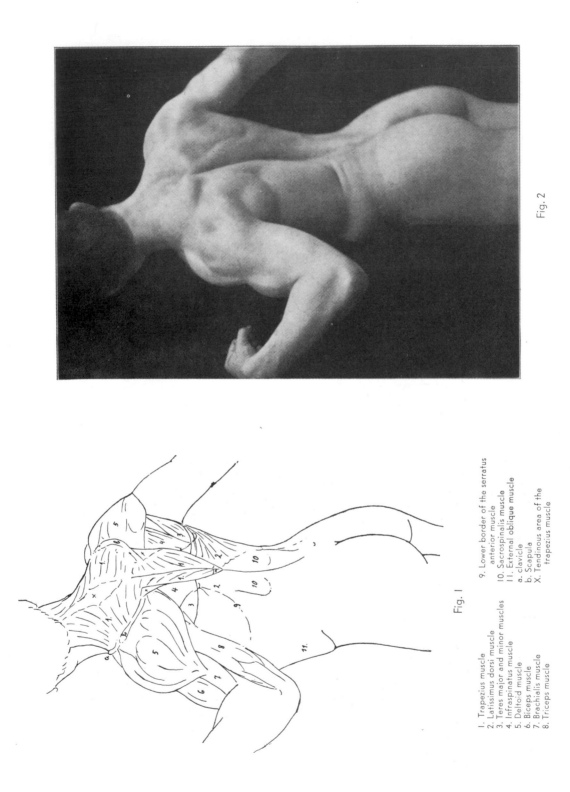

Fig. 2

Fig. 1

1. Trapezius muscle
2. Latissimus dorsi muscle
3. Teres major and minor muscles
4. Infraspinatus muscle
5. Deltoid muscle
6. Biceps muscle
7. Brachialis muscle
8. Triceps muscle

9. Lower border of the serratus
 anterior muscle
10. Sacrospinalis muscle
11. External oblique muscle
a. clavicle
b. Scapula
X. Tendinous area of the
 trapezius muscle

ATHLETE BACK I

PLATE 40

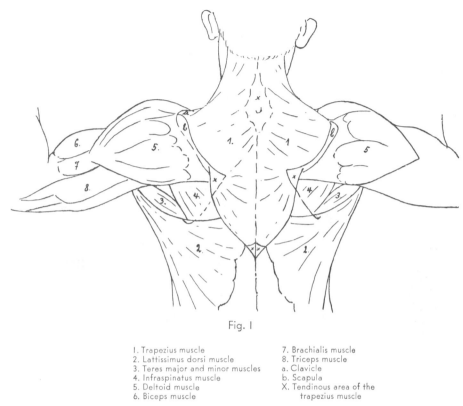

Fig. I

1. Trapezius muscle
2. Lattissimus dorsi muscle
3. Teres major and minor muscles
4. Infraspinatus muscle
5. Deltoid muscle
6. Biceps muscle
7. Brachialis muscle
8. Triceps muscle
a. Clavicle
b. Scapula
X. Tendinous area of the
 trapezius muscle

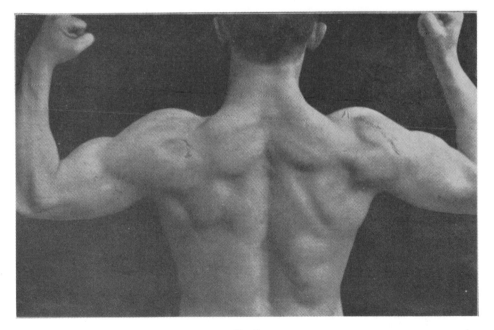

Fig. 2

ATHLETE BACK II PLATE 41

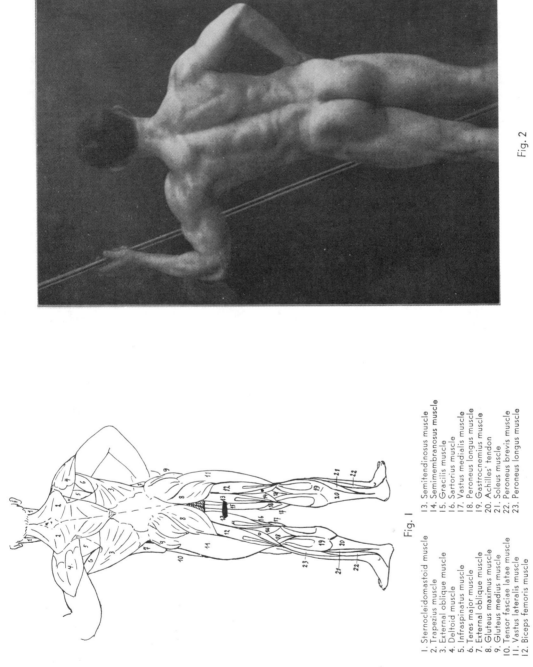

Fig. 2

Fig. I

1. Sternocleidomastoid muscle
2. Trapezius muscle
3. External oblique muscle
4. Deltoid muscle
5. Infraspinatus muscle
6. Teres major muscle
7. External oblique muscle
8. Gluteus maximus muscle
9. Gluteus medius muscle
10. Tensor fasciae latae muscle
11. Vastus lateralis muscle
12. Biceps femoris muscle

13. Semitendinosus muscle
14. Semimembranosus muscle
15. Gracilis muscle
16. Sartorius muscle
17. Vastus medialis muscle
18. Peroneus longus muscle
19. Gastrocnemius muscle
20. Achilles' tendon
21. Soleus muscle
22. Peroneus brevis muscle
23. Peroneus longus muscle

ATHLETE BACK III

PLATE 42

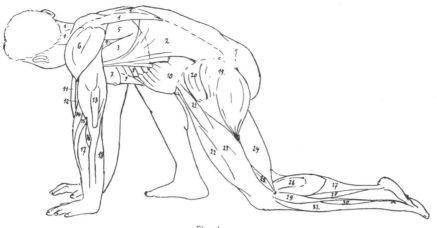

Fig. 1

1. Trapzius muscle
2. Latissimus dorsi muscle
3. Teres major muscle
4. Teres minor muscle
5. Infraspinatus muscle
6. Deltoid muscle
7. Pectoralis major muscle
8. Serratus anterior muscle
9. Rectus abdominis muscle
10. External oblique muscle
11. Biceps muscle
12. Brachialis muscle

13. Triceps muscle
14. Brachioradialis muscle
15. Extensor carpi radialis longus muscle
16. Anconeus muscle
17. Extensor carpi radialis brevis muscle
18. Extensor carpi ulnaris muscle
19. Gluteus maximus muscle
20. Gluteus medius muscle
21. Tensor fasciae latae muscle
22. Rectus femoris muscle

23. Vastus lateralis muscle
24. Biceps femoris muscle, long head
25. Biceps femoris muscle, short head
26. Gastrocnemius muscle
27. Achilles' tendon
28. Soleus muscle
29. Peroneus longus muscle
30. Peroneus brevis muscle
31. Extensor digitorum longus muscle

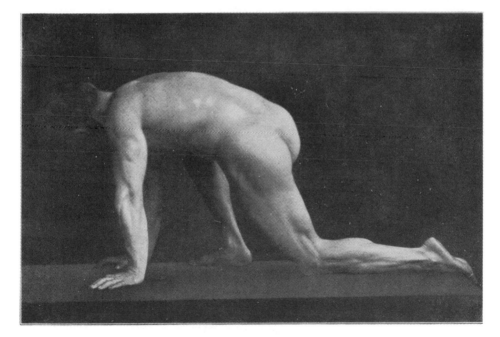

Fig. 2

ATHLETE KNEELING

PLATE 43

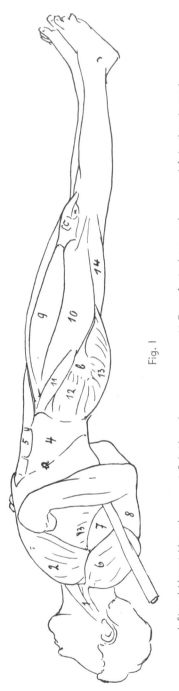

Fig. I

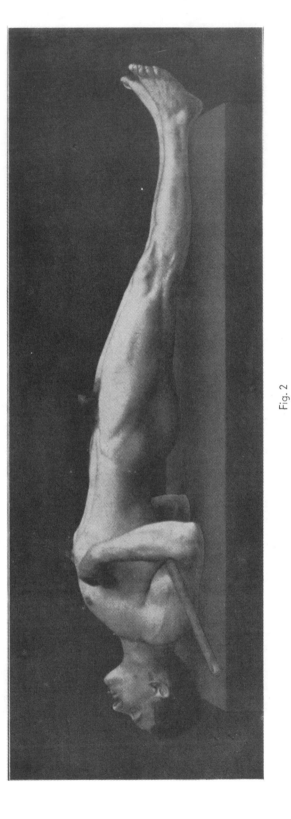

Fig. 2

1. Sternocleidomastoid muscle
2. Pectoralis major muscle
3. Serratus anterior muscle
4. External oblique muscle
5. Rectus abdominis muscle

6. Deltoid muscle
7. Biceps muscle
8. Triceps muscle
9. Rectus femoris muscle
10. Vastus lateralis muscle

11. Tensor fasciae latae muscle
12. Gluteus medius muscle
13. Gluteus maximus muscle
14. Biceps femoris muscle

a. Inferior thoracic margin
b. Tendinous insertion of the
 gluteus maximus muscle
c. Patella
X. Fat pad of knee joint

ATHLETE SUPINE

PLATE 44

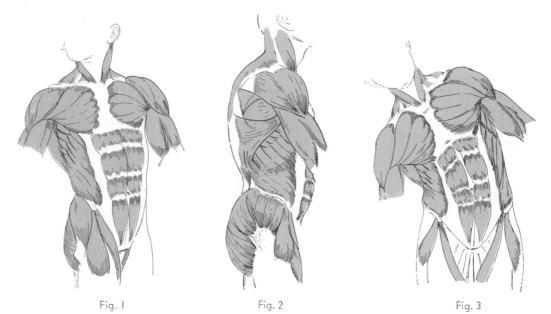

Fig. 1 Fig. 2 Fig. 3

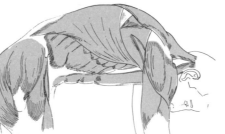

Fig. 4

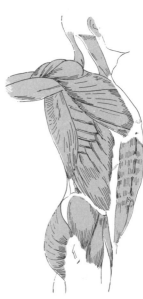

Fig. 5 Fig. 6

POSITIONS OF THE TRUNK 1 PLATE 45

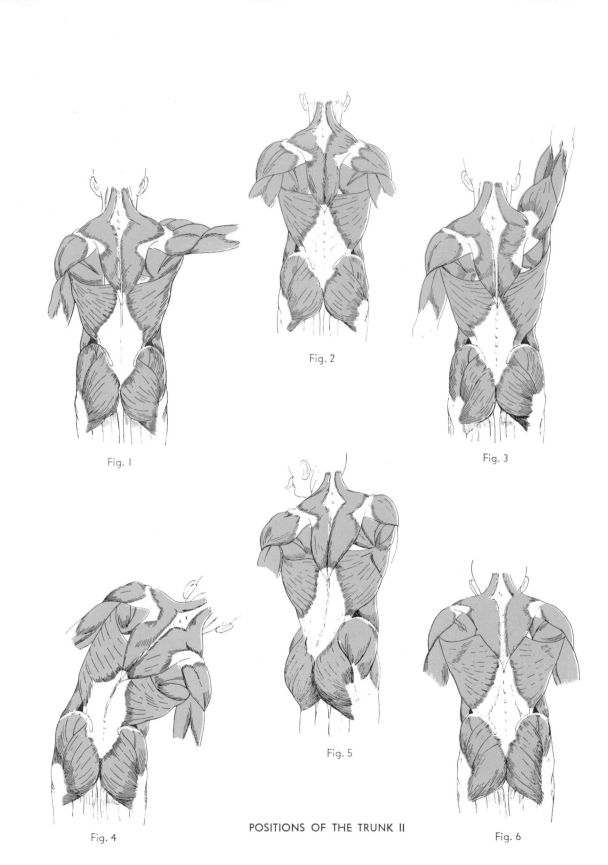

Fig. 1

Fig. 2

Fig. 3

Fig. 4

Fig. 5

Fig. 6

POSITIONS OF THE TRUNK II

PLATE 46

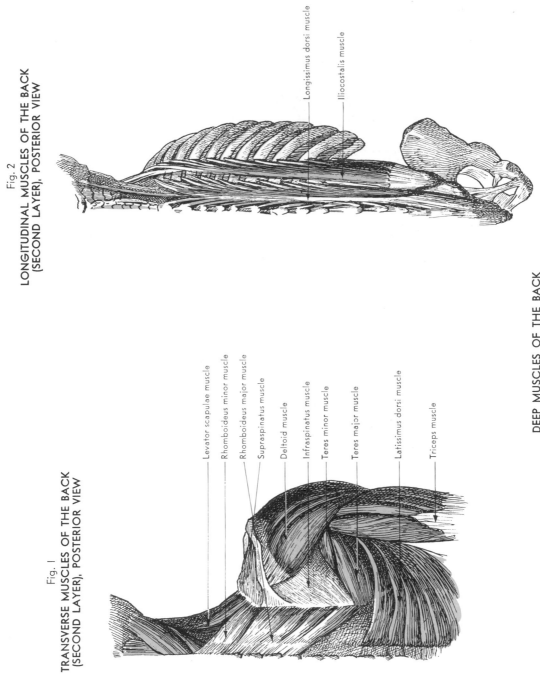

Fig. 2
LONGITUDINAL MUSCLES OF THE BACK
(SECOND LAYER), POSTERIOR VIEW

Longissimus dorsi muscle

Iliocostalis muscle

Fig. 1
TRANSVERSE MUSCLES OF THE BACK
(SECOND LAYER), POSTERIOR VIEW

Levator scapulae muscle

Rhomboideus minor muscle

Rhomboideus major muscle

Supraspinatus muscle

Deltoid muscle

Infraspinatus muscle

Teres minor muscle

Teres major muscle

Latissimus dorsi muscle

Triceps muscle

DEEP MUSCLES OF THE BACK

PLATE 47

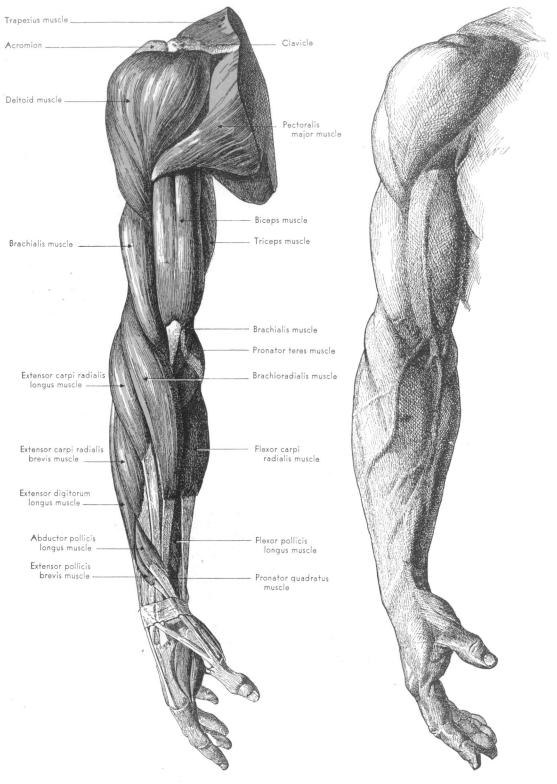

Trapezius muscle

Acromion

Clavicle

Deltoid muscle

Pectoralis
major muscle

Biceps muscle

Triceps muscle

Brachialis muscle

Brachialis muscle

Pronator teres muscle

Extensor carpi radialis
longus muscle

Brachioradialis muscle

Extensor carpi radialis
brevis muscle

Flexor carpi
radialis muscle

Extensor digitorum
longus muscle

Abductor pollicis
longus muscle

Flexor pollicis
longus muscle

Extensor pollicis
brevis muscle

Pronator quadratus
muscle

PLATE 48

ANTERIOR VIEW FOR COMPARISON WITH SURFACE ANATOMY
THE MUSCLES OF THE UPPER EXTREMITY,

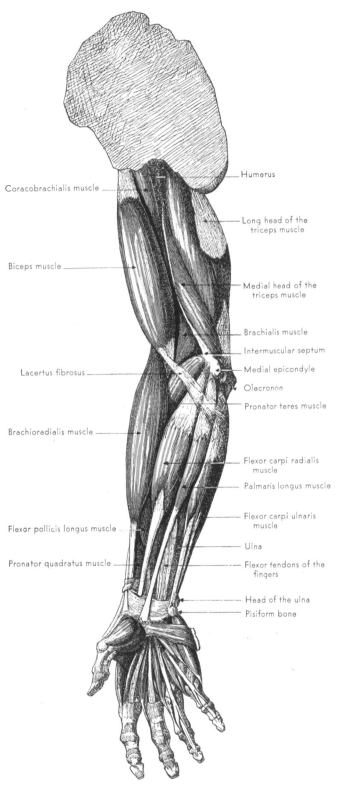

Coracobrachialis muscle

Biceps muscle

Lacertus fibrosus

Brachioradialis muscle

Flexor pollicis longus muscle

Pronator quadratus muscle

Humerus

Long head of the triceps muscle

Medial head of the triceps muscle

Brachialis muscle

Intermuscular septum

Medial epicondyle

Olecronon

Pronator teres muscle

Flexor carpi radialis muscle

Palmaris longus muscle

Flexor carpi ulnaris muscle

Ulna

Flexor tendons of the fingers

Head of the ulna

Pisiform bone

THE MUSCLES OF THE UPPER EXTREMITY, MEDIAL VIEW

PLATE 49

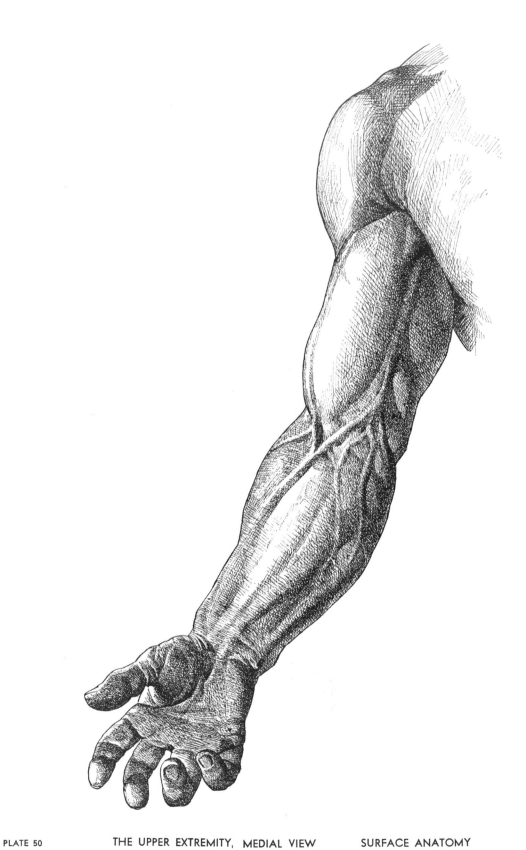

PLATE 50 THE UPPER EXTREMITY, MEDIAL VIEW SURFACE ANATOMY

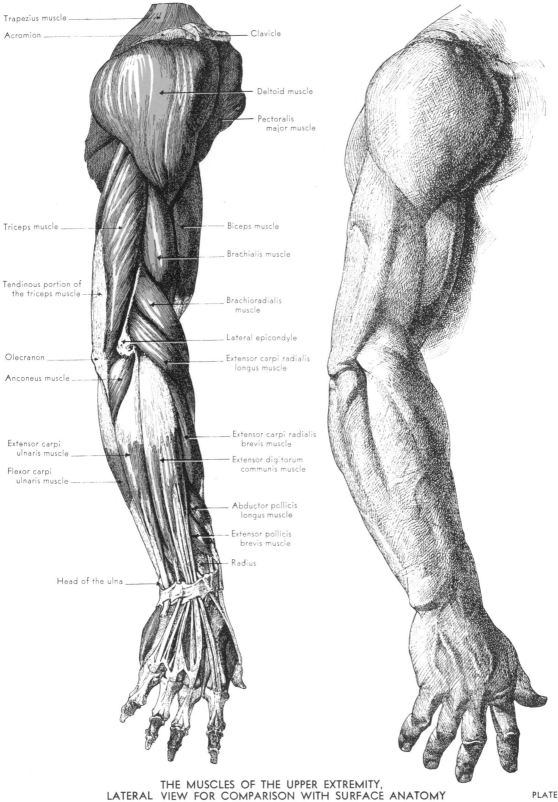

Trapezius muscle

Acromion

Clavicle

Deltoid muscle

Pectoralis
major muscle

Triceps muscle

Biceps muscle

Brachialis muscle

Tendinous portion of
the triceps muscle

Brachioradialis
muscle

Lateral epicondyle

Olecranon

Extensor carpi radialis
longus muscle

Anconeus muscle

Extensor carpi
ulnaris muscle

Extensor carpi radialis
brevis muscle

Flexor carpi
ulnaris muscle

Extensor digitorum
communis muscle

Abductor pollicis
longus muscle

Extensor pollicis
brevis muscle

Radius

Head of the ulna

THE MUSCLES OF THE UPPER EXTREMITY,
LATERAL VIEW FOR COMPARISON WITH SURFACE ANATOMY

PLATE 51

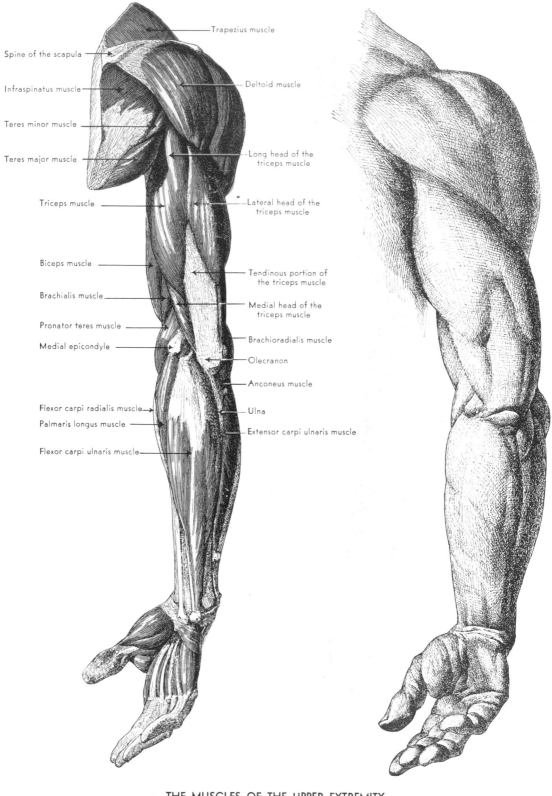

Trapezius muscle

Spine of the scapula

Infraspinatus muscle

Teres minor muscle

Teres major muscle

Triceps muscle

Biceps muscle

Brachialis muscle

Pronator teres muscle

Medial epicondyle

Flexor carpi radialis muscle

Palmaris longus muscle

Flexor carpi ulnaris muscle

Deltoid muscle

Long head of the triceps muscle

Lateral head of the triceps muscle

Tendinous portion of the triceps muscle

Medial head of the triceps muscle

Brachioradialis muscle

Olecranon

Anconeus muscle

Ulna

Extensor carpi ulnaris muscle

PLATE 52

THE MUSCLES OF THE UPPER EXTREMITY,
POSTERIOR VIEW FOR COMPARISON WITH SURFACE ANATOMY

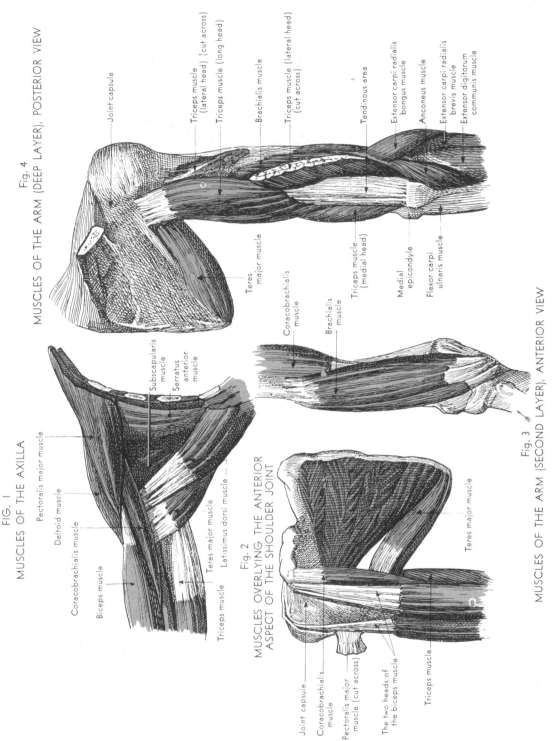

FIG. I

MUSCLES OF THE AXILLA

Pectoralis major muscle

Deltoid muscle

Coracobrachialis muscle

Biceps muscle

Triceps muscle

Teres major muscle

Latissimus dorsi muscle

Subscapularis muscle

Serratus anterior muscle

Fig. 2

MUSCLES OVERLYING THE ANTERIOR ASPECT OF THE SHOULDER JOINT

Joint capsule

Coracobrachialis muscle

Pectoralis major muscle (cut across)

The two heads of the biceps muscle

Triceps muscle

Teres major muscle

MUSCLES OF THE ARM (SECOND LAYER), ANTERIOR VIEW

Fig. 3

Coracobrachialis muscle

Brachialis muscle

MUSCLES OF THE ARM (DEEP LAYER), POSTERIOR VIEW

Fig. 4

Joint capsule

Triceps muscle (lateral head) (cut across)

Triceps muscle (long head)

Brachialis muscle

Triceps muscle (lateral head) (cut across)

Tendinous area

Extensor carpi radialis longus muscle

Anconeus muscle

Extensor carpi radialis brevis muscle

Extensor digitorum communis muscle

Teres major muscle

Triceps muscle (medial head)

Medial epicondyle

Flexor carpi ulnaris muscle

THE MUSCLES OF THE ARM

PLATE 53

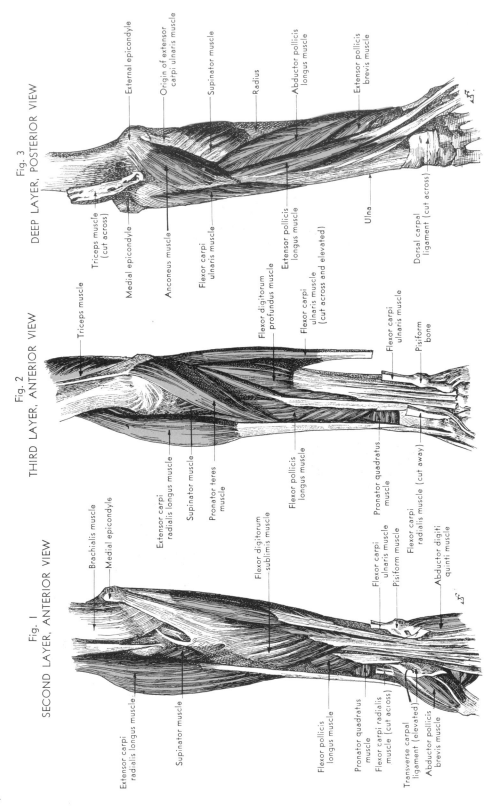

PLATE 54

Fig. 1

SECOND LAYER, ANTERIOR VIEW

Fig. 2

THIRD LAYER, ANTERIOR VIEW

Fig. 3

DEEP LAYER, POSTERIOR VIEW

THE MUSCLES OF THE FOREARM

Fig. 1 labels:

Extensor carpi radialis longus muscle

Supinator muscle

Flexor pollicis longus muscle

Pronator quadratus muscle

Flexor carpi radialis muscle (cut across)

Transverse carpal ligament (elevated)

Abductor pollicis brevis muscle

Brachialis muscle

Medial epicondyle

Flexor digitorum sublimis muscle

Flexor carpi ulnaris muscle

Pisiform muscle

Flexor carpi radialis muscle

Abductor digiti quinti muscle

Fig. 2 labels:

Triceps muscle

Extensor carpi radialis longus muscle

Supinator muscle

Pronator teres muscle

Flexor pollicis longus muscle

Flexor digitorum profundus muscle

Flexor carpi ulnaris muscle (cut across and elevated)

Pronator quadratus muscle

Flexor carpi ulnaris muscle

Pisiform bone

Fig. 3 labels:

Triceps muscle (cut across)

Medial epicondyle

Anconeus muscle

Flexor carpi ulnaris muscle

External epicondyle

Origin of extensor carpi ulnaris muscle

Supinator muscle

Radius

Abductor pollicis longus muscle

Extensor pollicis brevis muscle

Extensor pollicis longus muscle

Ulna

Dorsal carpal ligament (cut across)

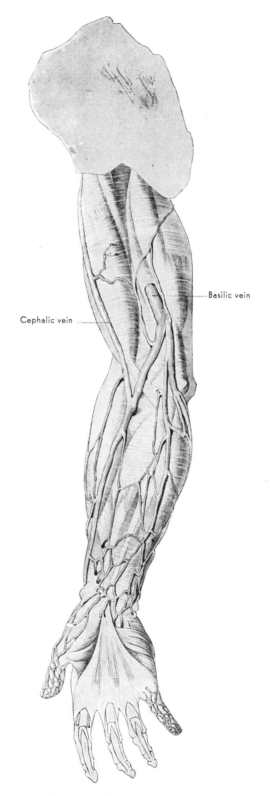

Basilic vein

Cephalic vein

SUPERFICIAL VEINS OF THE UPPER EXTREMITY PLATE 55

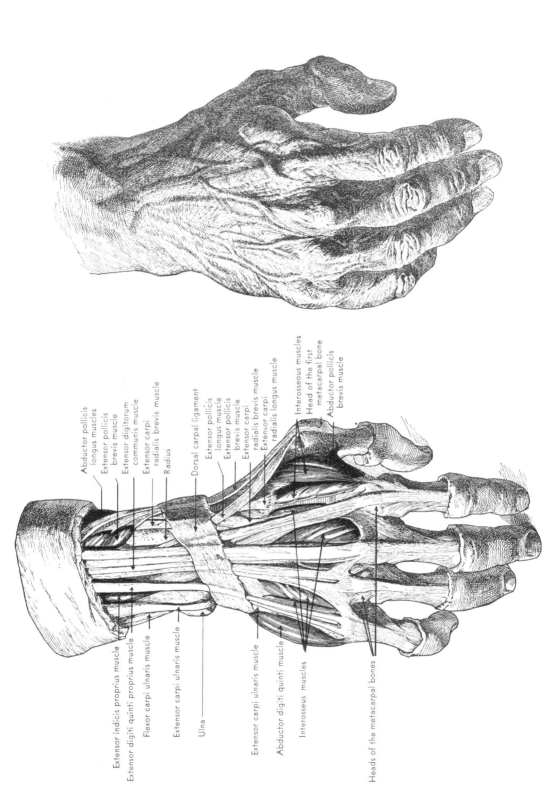

Abductor pollicis longus muscles
Extensor pollicis brevis muscle
Extensor digitorum communis muscle
Extensor carpi radialis brevis muscle
Radius
Dorsal carpal ligament
Extensor pollicis longus muscle
Extensor pollicis brevis muscle
Extensor carpi radialis brevis muscle
Extensor carpi radialis longus muscle
Interosseous muscles
Head of the first metacarpal bone
Abductor pollicis brevis muscle

Extensor indicis proprius muscle
Extensor digiti quinti proprius muscle
Flexor carpi ulnaris muscle
Extensor carpi ulnaris muscle
Ulna
Extensor carpi ulnaris muscle
Abductor digiti quinti muscle
Interosseus muscles
Heads of the metacarpal bones

THE MUSCLES OF THE HAND, POSTERIOR VIEW WITH SURFACE ANATOMY FOR COMPARISON

PLATE 56

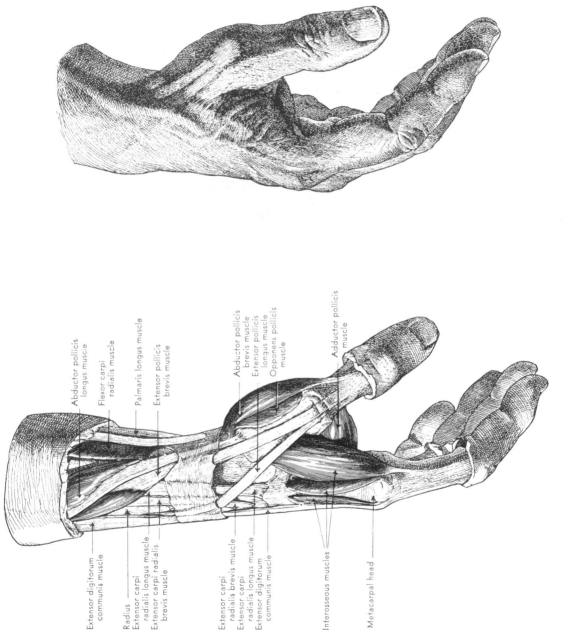

Abductor pollicis
longus muscle

Flexor carpi
radialis muscle

Palmaris longus muscle

Extensor pollicis
brevis muscle

Abductor pollicis
brevis muscle
Extensor pollicis
longus muscle
Opponens pollicis
muscle

Adductor pollicis
muscle

Extensor digitorum
communis muscle

Radius
Extensor carpi
radialis longus muscle
Extensor carpi radialis
brevis muscle

Extensor carpi
radialis brevis muscle
Extensor carpi
radialis longus muscle
Extensor digitorum
communis muscle

Interosseous muscles

Metacarpal head

THE MUSCLES OF THE HAND, LATERAL VIEW WITH SURFACE ANATOMY FOR COMPARISON

PLATE 57

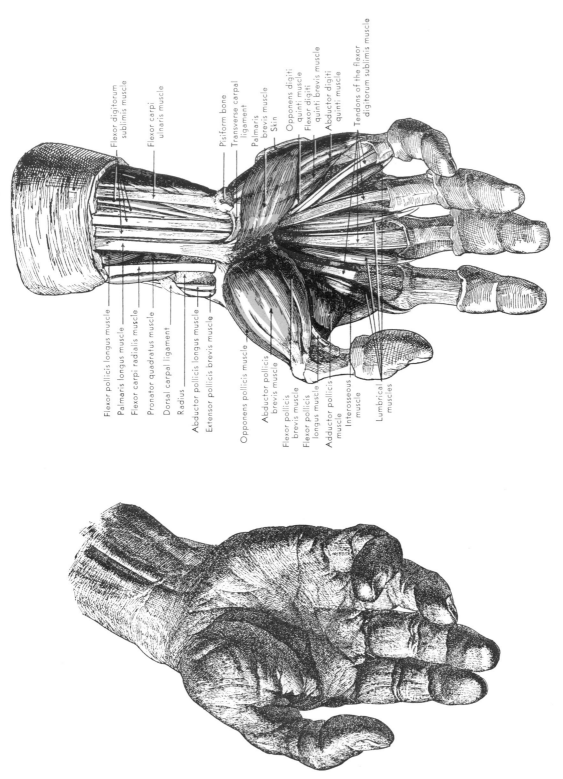

Flexor digitorum sublimis muscle

Flexor carpi ulnaris muscle

Pisiform bone

Transverse carpal ligament

Palmaris brevis muscle

Skin

Opponens digiti quinti muscle

Flexor digiti quinti brevis muscle

Abductor digiti quinti muscle

Tendons of the flexor digitorum sublimis muscle

Flexor pollicis longus muscle

Palmaris longus muscle

Flexor carpi radialis muscle

Pronator quadratus muscle

Dorsal carpal ligament

Radius

Abductor pollicis longus muscle

Extensor pollicis brevis muscle

Opponens pollicis muscle

Abductor pollicis brevis muscle

Flexor pollicis brevis muscle

Flexor pollicis longus muscle

Adductor pollicis muscle

Interosseous muscle

Lumbrical muscles

THE MUSCLES OF THE HAND, ANTERIOR VIEW WITH SURFACE ANATOMY FOR COMPARISON

PLATE 58

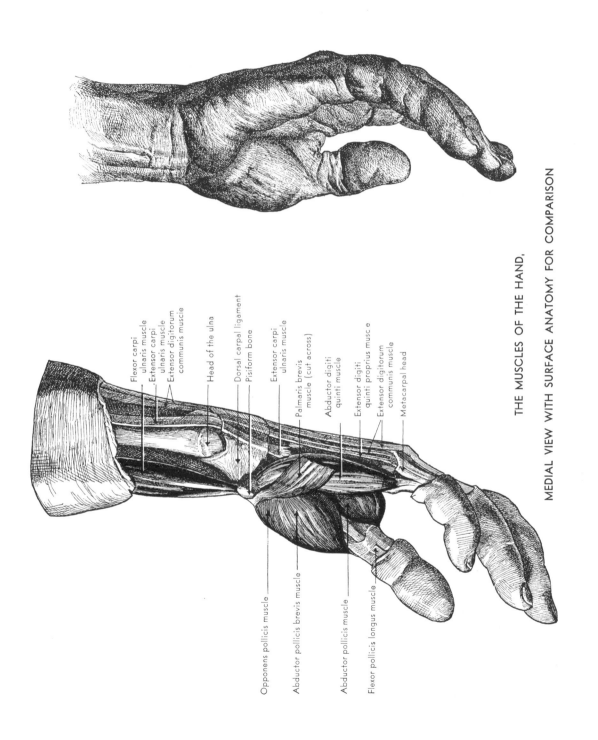

Flexor carpi
ulnaris muscle
Extensor carpi
ulnaris muscle
Extensor digitorum
communis muscle

Head of the ulna

Dorsal carpal ligament
Pisiform bone

Extensor carpi
ulnaris muscle

Palmaris brevis
muscle (cut across)

Abductor digiti
quinti muscle

Extensor digiti
quinti proprius muscle
Extensor digitorum
communis muscle

Metacarpal head

Opponens pollicis muscle

Abductor pollicis brevis muscle

Abductor pollicis muscle

Flexor pollicis longus muscle

THE MUSCLES OF THE HAND,

MEDIAL VIEW WITH SURFACE ANATOMY FOR COMPARISON

PLATE 59

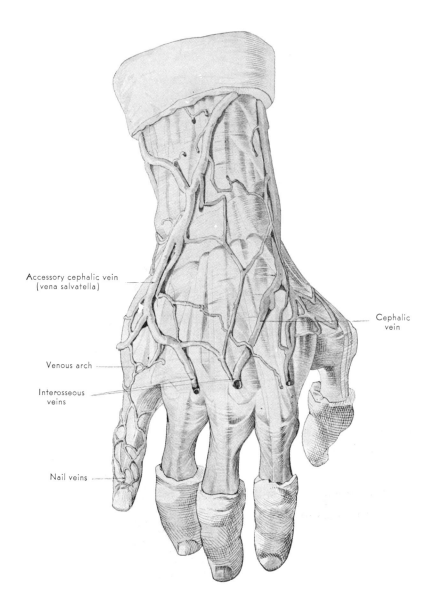

Accessory cephalic vein
(vena salvatella)

Cephalic
vein

Venous arch

Interosseous
veins

Nail veins

THE SUPERFICIAL VEINS OF THE HAND

PLATE 60

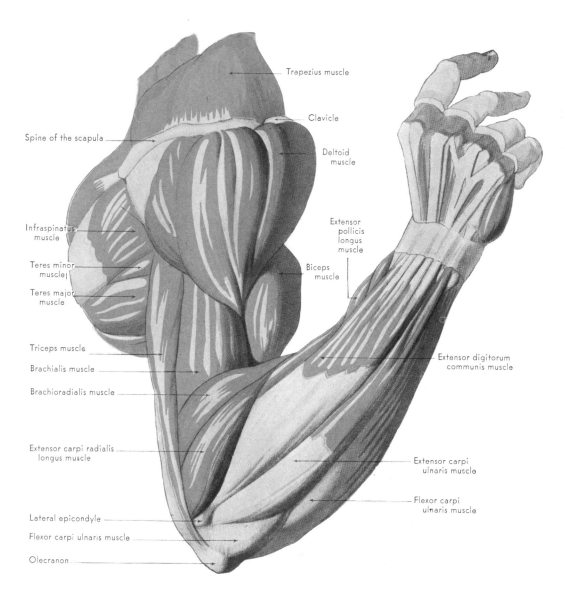

Trapezius muscle

Clavicle

Spine of the scapula

Deltoid muscle

Infraspinatus muscle

Extensor pollicis longus muscle

Teres minor muscle

Biceps muscle

Teres major muscle

Triceps muscle

Brachialis muscle

Extensor digitorum communis muscle

Brachioradialis muscle

Extensor carpi radialis longus muscle

Extensor carpi ulnaris muscle

Flexor carpi ulnaris muscle

Lateral epicondyle

Flexor carpi ulnaris muscle

Olecranon

THE MUSCLES OF THE FLEXED UPPER EXTREMITY,

LATERAL VIEW WITH FOREARM PARTIALLY PRONATED

PLATE 61

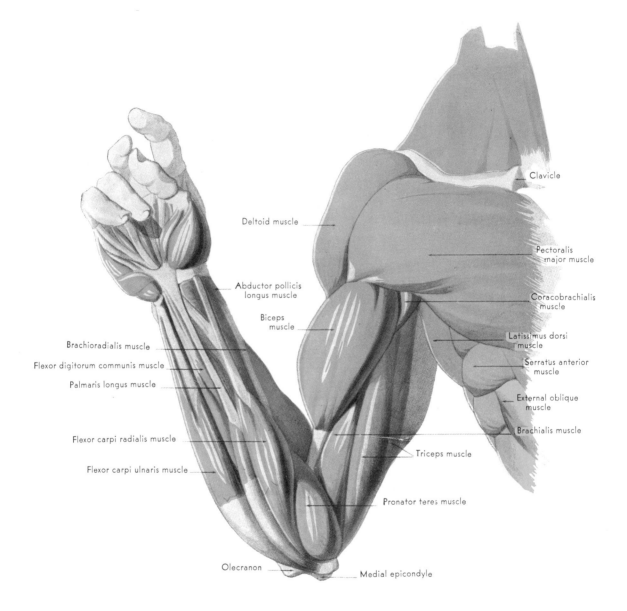

Clavicle

Deltoid muscle

Pectoralis
major muscle

Abductor pollicis
longus muscle

Coracobrachialis
muscle

Biceps
muscle

Latissimus dorsi
muscle

Brachioradialis muscle

Serratus anterior
muscle

Flexor digitorum communis muscle

Palmaris longus muscle

External oblique
muscle

Brachialis muscle

Flexor carpi radialis muscle

Triceps muscle

Flexor carpi ulnaris muscle

Pronator teres muscle

Olecranon

Medial epicondyle

THE MUSCLES OF THE FLEXED UPPER EXTREMITY,

MEDIAL VIEW, FOREARM PARTIALLY PRONATED

PLATE 62

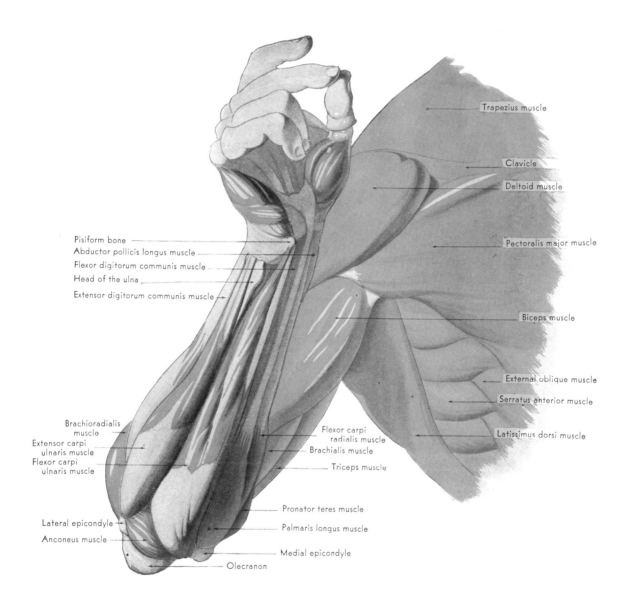

Trapezius muscle

Clavicle

Deltoid muscle

Pectoralis major muscle

Pisiform bone
Abductor pollicis longus muscle
Flexor digitorum communis muscle
Head of the ulna
Extensor digitorum communis muscle

Biceps muscle

External oblique muscle

Serratus anterior muscle

Brachioradialis
muscle

Extensor carpi
ulnaris muscle

Flexor carpi
ulnaris muscle

Flexor carpi
radialis muscle

Brachialis muscle

Triceps muscle

Latissimus dorsi muscle

Lateral epicondyle

Anconeus muscle

Pronator teres muscle

Palmaris longus muscle

Medial epicondyle

Olecranon

THE MUSCLES OF THE FLEXED UPPER EXTREMITY, ANTERIOR VIEW

PLATE 63

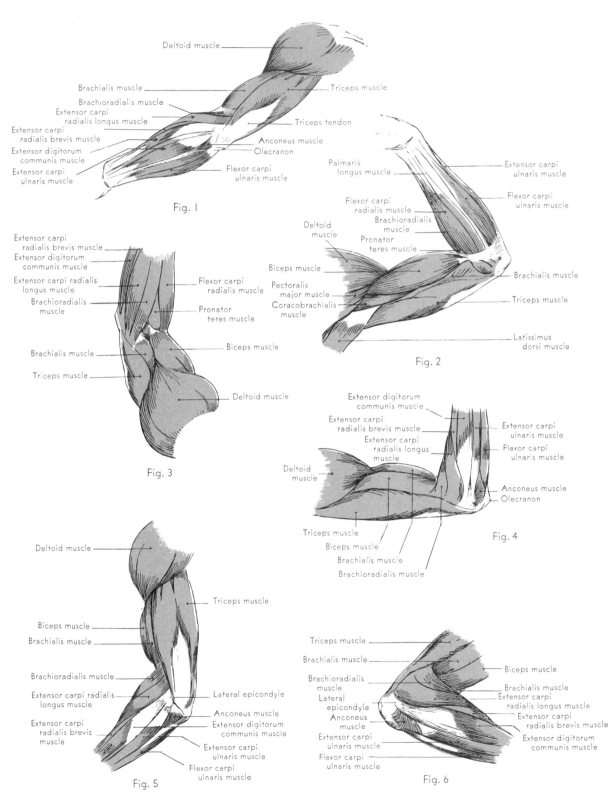

Deltoid muscle

Brachialis muscle
Brachioradialis muscle
Extensor carpi
radialis longus muscle
Extensor carpi
radialis brevis muscle
Extensor digitorum
communis muscle
Extensor carpi
ulnaris muscle

Triceps muscle
Triceps tendon
Anconeus muscle
Olecranon
Flexor carpi
ulnaris muscle

Fig. 1

Palmaris
longus muscle
Flexor carpi
radialis muscle
Deltoid
muscle
Pronator
teres muscle
Biceps muscle
Pectoralis
major muscle
Coracobrachialis
muscle

Extensor carpi
ulnaris muscle
Flexor carpi
ulnaris muscle
Brachioradialis
muscle
Brachialis muscle
Triceps muscle
Latissimus
dorsi muscle

Fig. 2

Extensor carpi
radialis brevis muscle
Extensor digitorum
communis muscle
Extensor carpi radialis
longus muscle
Brachioradialis
muscle
Brachialis muscle
Triceps muscle

Flexor carpi
radialis muscle
Pronator
teres muscle
Biceps muscle
Deltoid muscle

Fig. 3

Extensor digitorum
communis muscle
Extensor carpi
radialis brevis muscle
Extensor carpi
radialis longus
muscle
Deltoid
muscle

Extensor carpi
ulnaris muscle
Flexor carpi
ulnaris muscle
Anconeus muscle
Olecranon

Triceps muscle
Biceps muscle
Brachialis muscle
Brachioradialis muscle

Fig. 4

Deltoid muscle

Triceps muscle

Biceps muscle
Brachialis muscle
Brachioradialis muscle
Extensor carpi radialis
longus muscle
Extensor carpi
radialis brevis
muscle

Lateral epicondyle
Anconeus muscle
Extensor digitorum
communis muscle
Extensor carpi
ulnaris muscle
Flexor carpi
ulnaris muscle

Fig. 5

Triceps muscle
Brachialis muscle
Brachioradialis
muscle
Lateral
epicondyle
Anconeus
muscle
Extensor carpi
ulnaris muscle
Flexor carpi
ulnaris muscle

Biceps muscle
Brachialis muscle
Extensor carpi
radialis longus muscle
Extensor carpi
radialis brevis muscle
Extensor digitorum
communis muscle

Fig. 6

PLATE 64

POSITIONS OF THE ARM 1

Fig. 1

Fig. 2

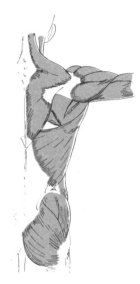

Fig. 3

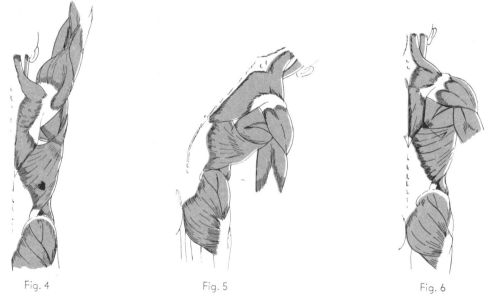

Fig. 4

Fig. 5

Fig. 6

MOTIONS OF THE SHOULDER JOINT I

PLATE 65

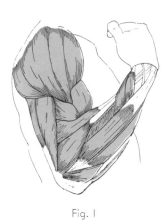

Fig. 1

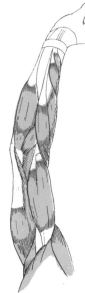

Fig. 2

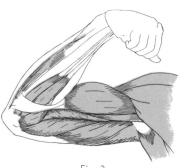

Fig. 3

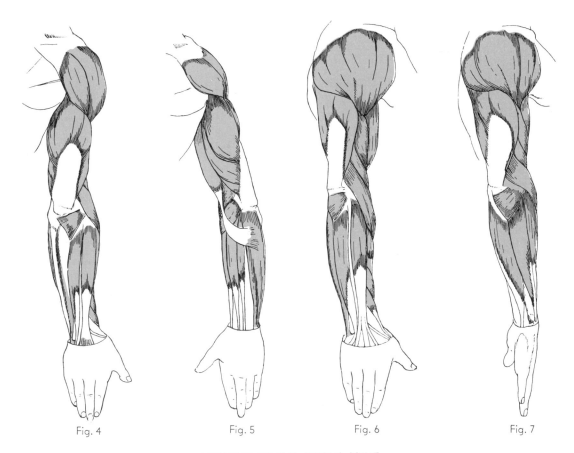

Fig. 4

Fig. 5

Fig. 6

Fig. 7

MOTIONS OF THE ELBOW JOINT
FLEXION, EXTENSION, PRONATION, AND SUPINATION OF FOREARM

PLATE 66

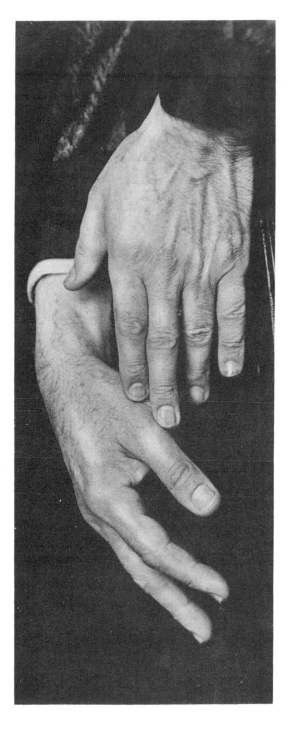

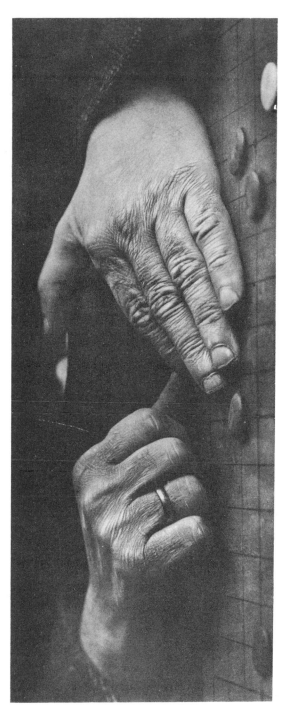

POSITIONS OF THE HAND I

PLATE 67

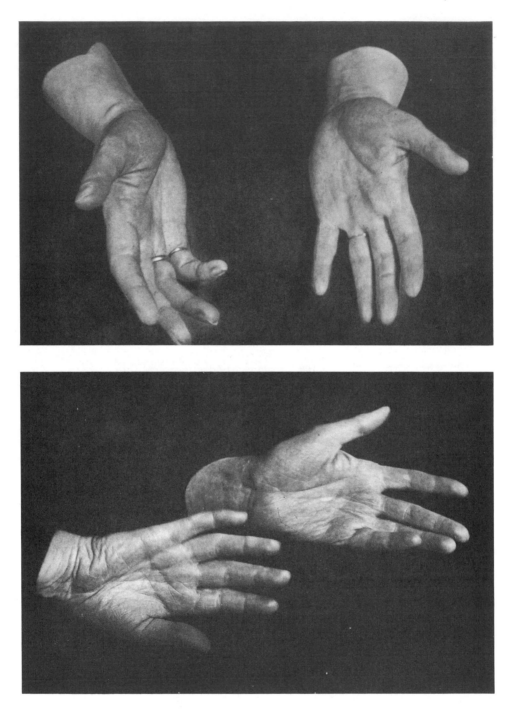

POSITIONS OF THE HAND II

PLATE 68

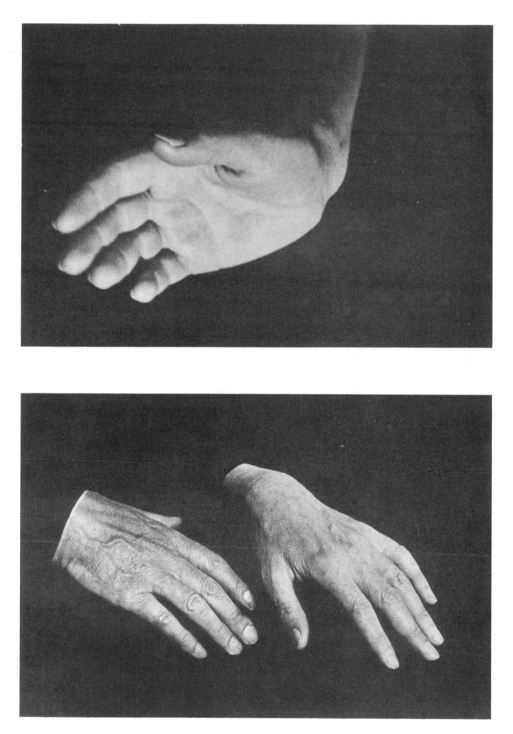

POSITIONS OF THE HAND III

PLATE 69

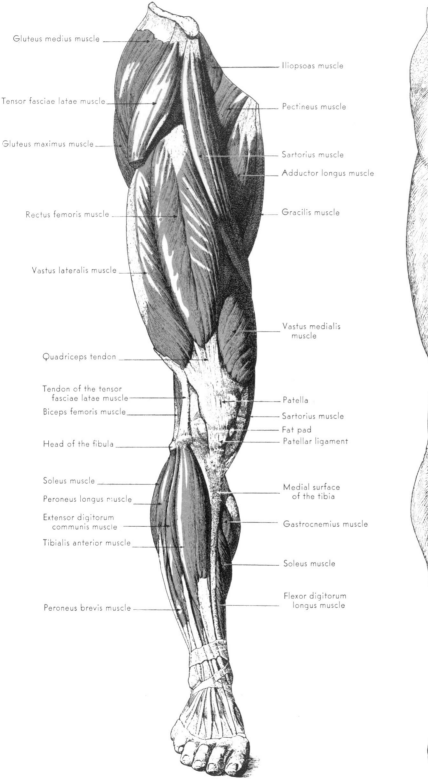

Gluteus medius muscle

Tensor fasciae latae muscle

Gluteus maximus muscle

Rectus femoris muscle

Vastus lateralis muscle

Quadriceps tendon

Tendon of the tensor
fasciae latae muscle

Biceps femoris muscle

Head of the fibula

Soleus muscle

Peroneus longus muscle

Extensor digitorum
communis muscle

Tibialis anterior muscle

Peroneus brevis muscle

Iliopsoas muscle

Pectineus muscle

Sartorius muscle

Adductor longus muscle

Gracilis muscle

Vastus medialis
muscle

Patella

Sartorius muscle

Fat pad

Patellar ligament

Medial surface
of the tibia

Gastrocnemius muscle

Soleus muscle

Flexor digitorum
longus muscle

THE MUSCLES OF THE LOWER EXTREMITY,
ANTERIOR VIEW WITH SURFACE ANATOMY FOR COMPARISON

PLATE 70

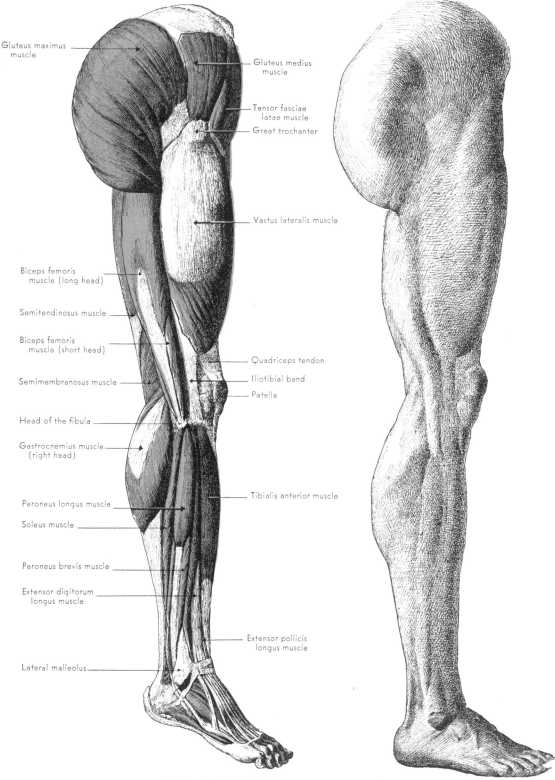

Gluteus maximus muscle

Gluteus medius muscle

Tensor fasciae latae muscle

Great trochanter

Vastus lateralis muscle

Biceps femoris muscle (long head)

Semitendinosus muscle

Biceps femoris muscle (short head)

Quadriceps tendon

Iliotibial band

Semimembranosus muscle

Patella

Head of the fibula

Gastrocnemius muscle (right head)

Tibialis anterior muscle

Peroneus longus muscle

Soleus muscle

Peroneus brevis muscle

Extensor digitorum longus muscle

Extensor pollicis longus muscle

Lateral malleolus

THE MUSCLES OF THE LOWER EXTREMITY,
LATERAL VIEW, WITH SURFACE ANATOMY

PLATE 71

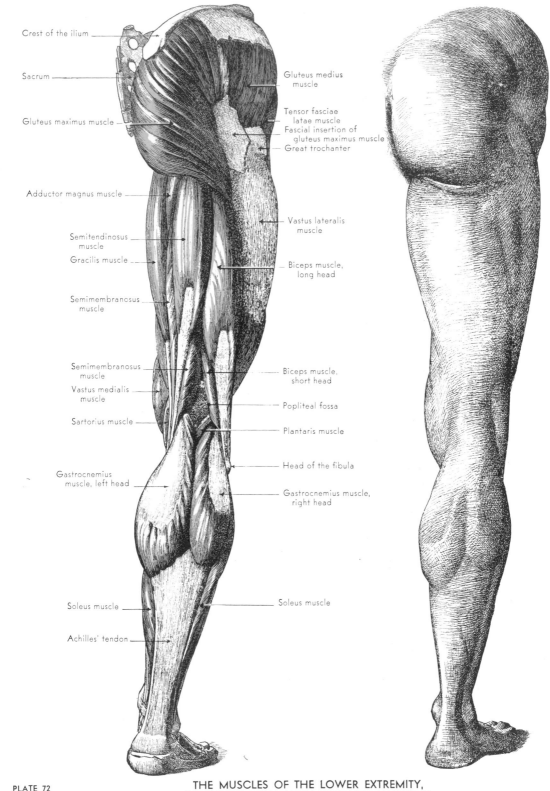

Crest of the ilium

Sacrum

Gluteus maximus muscle

Adductor magnus muscle

Semitendinosus muscle

Gracilis muscle

Semimembranosus muscle

Semimembranosus muscle

Vastus medialis muscle

Sartorius muscle

Gastrocnemius muscle, left head

Soleus muscle

Achilles' tendon

Gluteus medius muscle

Tensor fasciae latae muscle

Fascial insertion of gluteus maximus muscle

Great trochanter

Vastus lateralis muscle

Biceps muscle, long head

Biceps muscle, short head

Popliteal fossa

Plantaris muscle

Head of the fibula

Gastrocnemius muscle, right head

Soleus muscle

PLATE 72

THE MUSCLES OF THE LOWER EXTREMITY,
POSTERIOR VIEW, WITH SURFACE ANATOMY

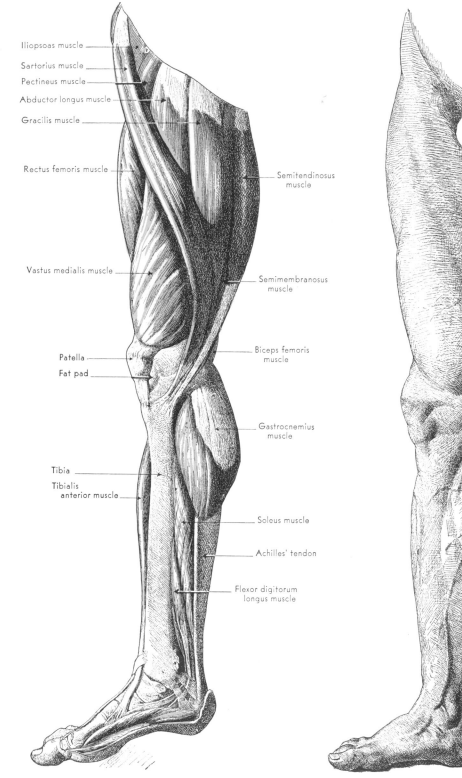

Iliopsoas muscle

Sartorius muscle

Pectineus muscle

Abductor longus muscle

Gracilis muscle

Rectus femoris muscle

Semitendinosus
muscle

Vastus medialis muscle

Semimembranosus
muscle

Patella

Fat pad

Biceps femoris
muscle

Gastrocnemius
muscle

Tibia

Tibialis
anterior muscle

Soleus muscle

Achilles' tendon

Flexor digitorum
longus muscle

THE MUSCLES OF THE LOWER EXTREMITY,
MEDIAL VIEW, WITH SURFACE ANATOMY

PLATE 73

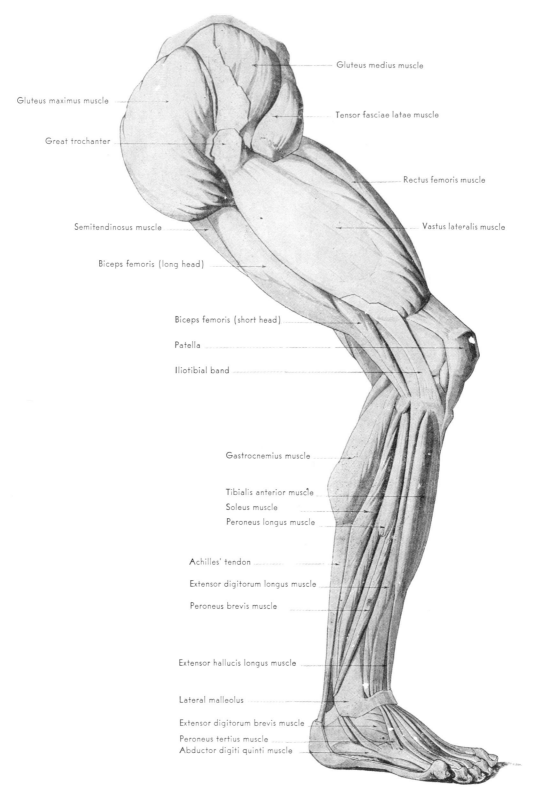

Gluteus medius muscle

Gluteus maximus muscle

Tensor fasciae latae muscle

Great trochanter

Rectus femoris muscle

Semitendinosus muscle

Vastus lateralis muscle

Biceps femoris (long head)

Biceps femoris (short head)

Patella

Iliotibial band

Gastrocnemius muscle

Tibialis anterior muscle

Soleus muscle

Peroneus longus muscle

Achilles' tendon

Extensor digitorum longus muscle

Peroneus brevis muscle

Extensor hallucis longus muscle

Lateral malleolus

Extensor digitorum brevis muscle

Peroneus tertius muscle

Abductor digiti quinti muscle

PLATE 74 THE MUSCLES OF THE FLEXED LOWER EXTREMITY, LATERAL VIEW

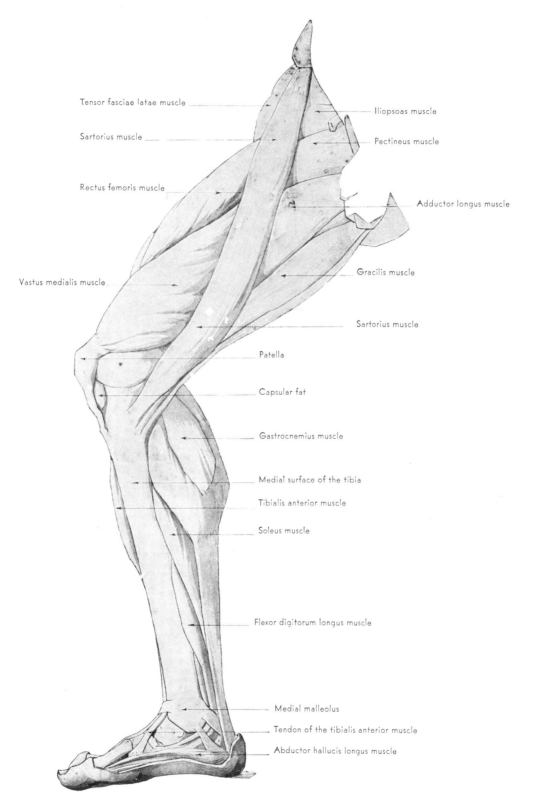

Tensor fasciae latae muscle _____

Sartorius muscle _____

Rectus femoris muscle _____

Vastus medialis muscle _____

_____ Iliopsoas muscle

_____ Pectineus muscle

_____ Adductor longus muscle

_____ Gracilis muscle

_____ Sartorius muscle

_____ Patella

_____ Capsular fat

_____ Gastrocnemius muscle

_____ Medial surface of the tibia

_____ Tibialis anterior muscle

_____ Soleus muscle

_____ Flexor digitorum longus muscle

_____ Medial malleolus

_____ Tendon of the tibialis anterior muscle

_____ Abductor hallucis longus muscle

THE MUSCLES OF THE FLEXED LOWER EXTREMITY, MEDIAL VIEW

PLATE 75

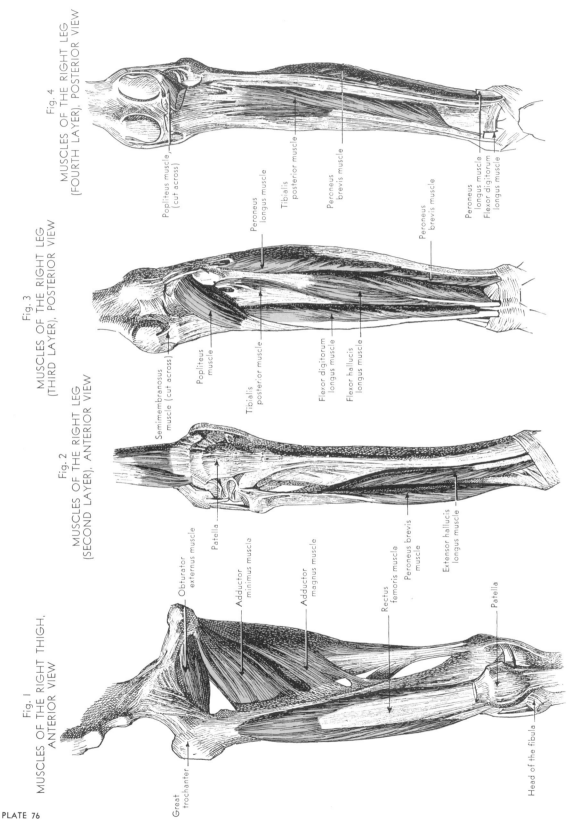

PLATE 76

Fig. 1
MUSCLES OF THE RIGHT THIGH,
ANTERIOR VIEW

Great
trochanter

Obturator
externus muscle

Patella

Adductor
minimus muscle

Adductor
magnus muscle

Rectus
femoris muscle

Peroneus brevis
muscle

Extensor hallucis
longus muscle

Patella

Head of the fibula

Fig. 2
MUSCLES OF THE RIGHT LEG
(SECOND LAYER), ANTERIOR VIEW

Semimembranosus
muscle (cut across)

Popliteus
muscle

Tibialis
posterior muscle

Flexor digitorum
longus muscle

Flexor hallucis
longus muscle

Fig. 3
MUSCLES OF THE RIGHT LEG
(THIRD LAYER), POSTERIOR VIEW

Popliteus muscle
(cut across)

Peroneus
longus muscle

Tibialis
posterior muscle

Peroneus
brevis muscle

Peroneus
brevis muscle

Peroneus
longus muscle
Flexor digitorum
longus muscle

Fig. 4
MUSCLES OF THE RIGHT LEG
(FOURTH LAYER), POSTERIOR VIEW

THE MUSCLE LAYERS OF THE THIGH AND LEG

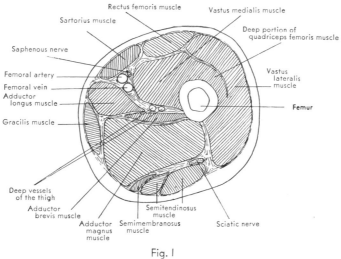

Rectus femoris muscle

Vastus medialis muscle

Sartorius muscle

Deep portion of
quadriceps femoris muscle

Saphenous nerve

Vastus
lateralis
muscle

Femoral artery

Femoral vein

Adductor
longus muscle

Femur

Gracilis muscle

Deep vessels
of the thigh

Adductor
brevis muscle

Adductor
magnus
muscle

Semimembranosus
muscle

Semitendinosus
muscle

Sciatic nerve

Fig. I
CROSS-SECTION THROUGH THE THIGH

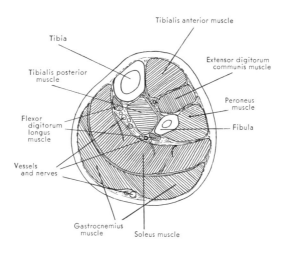

Tibialis anterior muscle

Tibia

Extensor digitorum
communis muscle

Tibialis posterior
muscle

Peroneus
muscle

Flexor
digitorum
longus
muscle

Fibula

Vessels
and nerves

Gastrocnemius
muscle

Soleus muscle

Fig. 2
CROSS-SECTION THROUGH THE LEG

CROSS-SECTIONS ,THROUGH THE LOWER EXTREMITY

PLATE 77

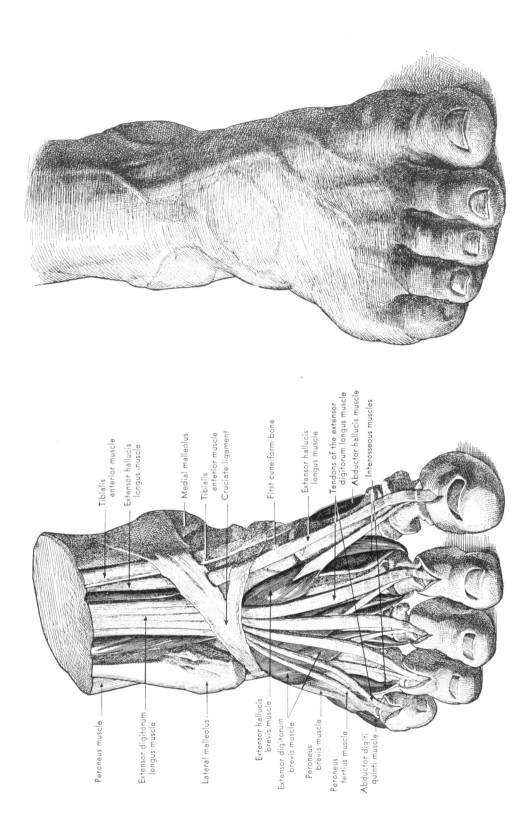

Tibialis
anterior muscle

Extensor hallucis
longus muscle

Medial malleolus

Tibialis
anterior muscle

Cruciate ligament

First cuneiform bone

Extensor hallucis
longus muscle

Tendons of the extensor
digitorum longus muscle

Abductor hallucis muscle

Interosseous muscles

Peroneus muscle

Extensor digitorum
longus muscle

Lateral malleolus

Extensor hallucis
brevis muscle

Extensor digitorum
brevis muscle

Peroneus
brevis muscle

Peroneus
tertius muscle

Abductor digiti
quinti muscle

THE MUSCLES OF THE FOOT, ANTERIOR VIEW, WITH SURFACE ANATOMY

PLATE 78

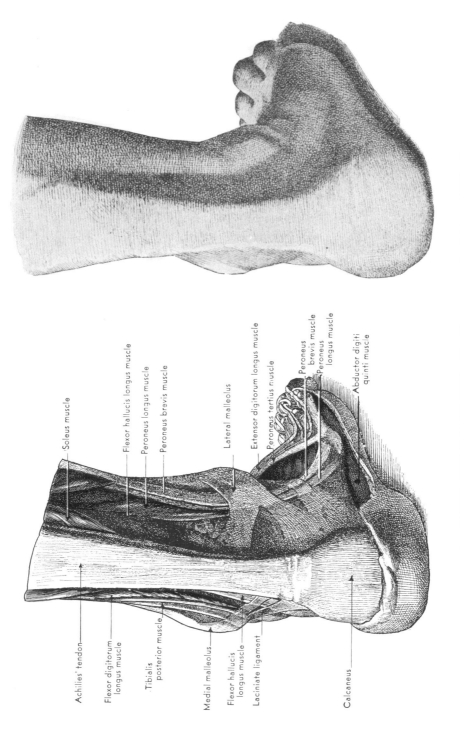

Soleus muscle

Flexor hallucis longus muscle

Peroneus longus muscle

Peroneus brevis muscle

Lateral malleolus

Extensor digitorum longus muscle

Peroneus tertius muscle

Peroneus brevis muscle

Peroneus longus muscle

Abductor digiti quinti muscle

Achilles' tendon

Flexor digitorum longus muscle

Tibialis posterior muscle

Medial malleolus

Flexor hallucis longus muscle

Laciniate ligament

Calcaneus

THE MUSCLES OF THE FOOT, POSTERIOR VIEW, WITH SURFACE ANATOMY

PLATE 79

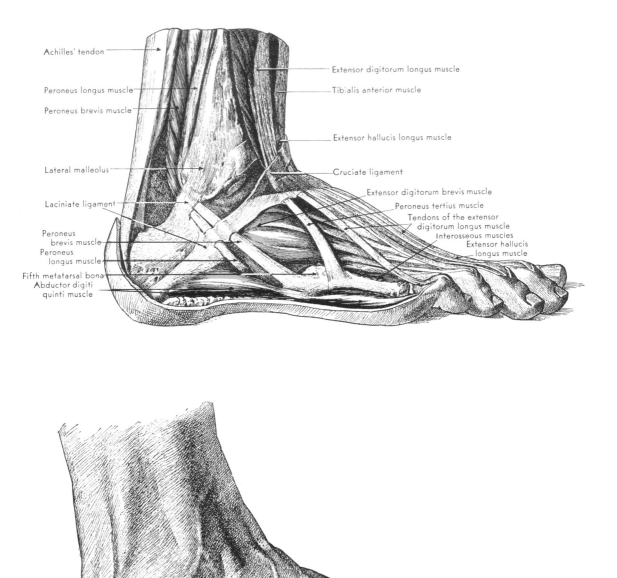

Achilles' tendon

Peroneus longus muscle

Peroneus brevis muscle

Lateral malleolus

Laciniate ligament

Peroneus
brevis muscle
Peroneus
longus muscle

Fifth metatarsal bone
Abductor digiti
quinti muscle

Extensor digitorum longus muscle

Tibialis anterior muscle

Extensor hallucis longus muscle

Cruciate ligament

Extensor digitorum brevis muscle
Peroneus tertius muscle
Tendons of the extensor
digitorum longus muscle
Interosseous muscles
Extensor hallucis
longus muscle

THE MUSCLES OF THE FOOT, LATERAL VIEW, WITH SURFACE ANATOMY

PLATE 80

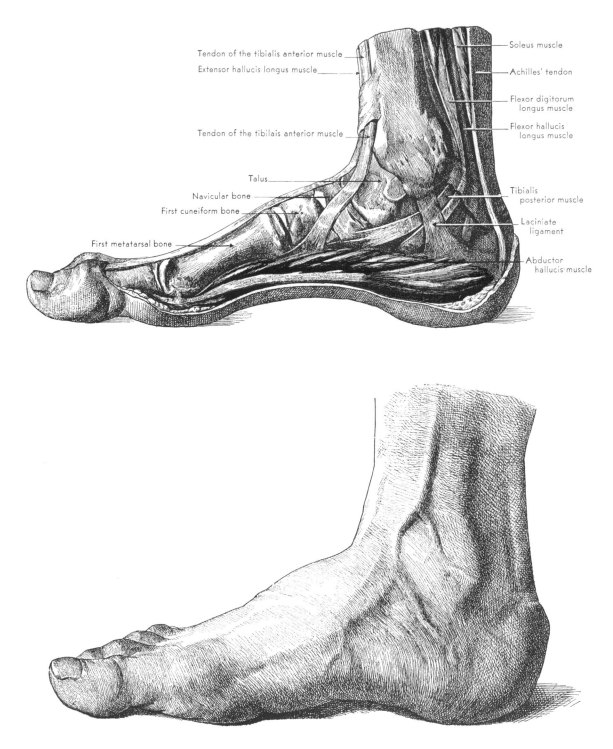

Tendon of the tibialis anterior muscle

Extensor hallucis longus muscle

Tendon of the tibilais anterior muscle

Talus

Navicular bone

First cuneiform bone

First metatarsal bone

Soleus muscle

Achilles' tendon

Flexor digitorum longus muscle

Flexor hallucis longus muscle

Tibialis posterior muscle

Laciniate ligament

Abductor hallucis muscle

THE MUSCLES OF THE FOOT, MEDIAL VIEW, WITH SURFACE ANATOMY

PLATE 81

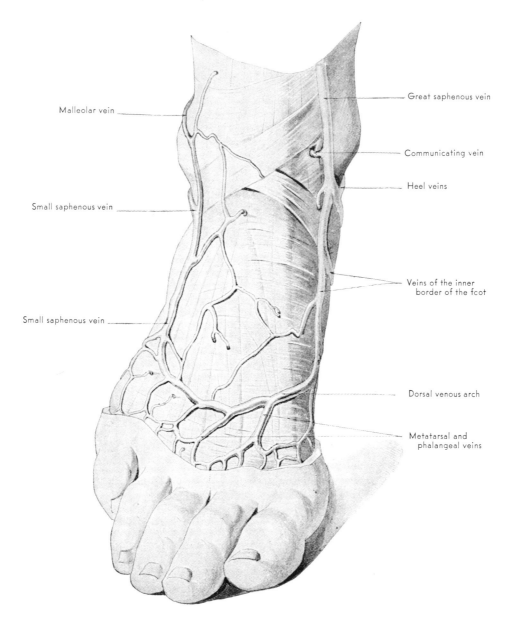

Malleolar vein

Small saphenous vein

Small saphenous vein

Great saphenous vein

Communicating vein

Heel veins

Veins of the inner
border of the foot

Dorsal venous arch

Metatarsal and
phalangeal veins

SUPERFICIAL VEINS OF THE FOOT

PLATE 82

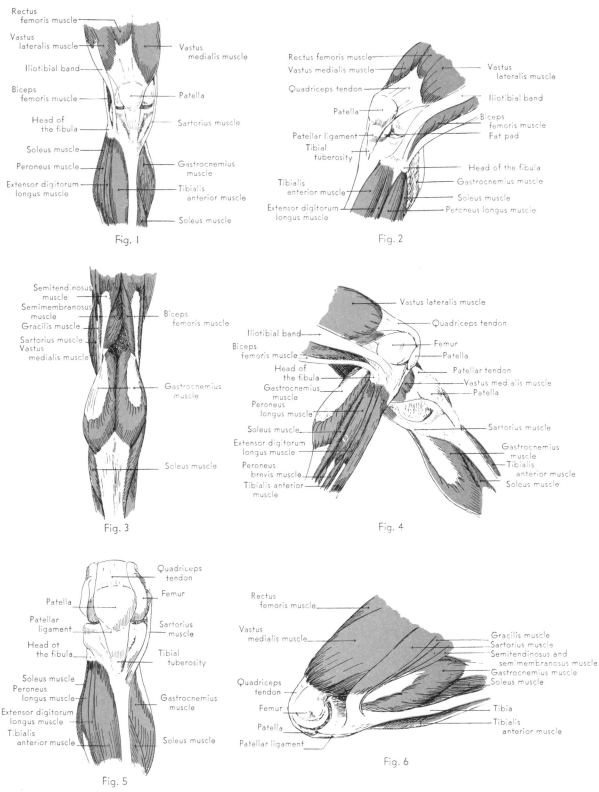

Fig. 1

Rectus femoris muscle
Vastus lateralis muscle
Iliotibial band
Biceps femoris muscle
Head of the fibula
Soleus muscle
Peroneus muscle
Extensor digitorum longus muscle
Vastus medialis muscle
Patella
Sartorius muscle
Gastrocnemius muscle
Tibialis anterior muscle
Soleus muscle

Fig. 2

Rectus femoris muscle
Vastus medialis muscle
Quadriceps tendon
Patella
Patellar ligament
Tibial tuberosity
Tibialis anterior muscle
Extensor digitorum longus muscle
Vastus lateralis muscle
Iliotibial band
Biceps femoris muscle
Fat pad
Head of the fibula
Gastrocnemius muscle
Soleus muscle
Peroneus longus muscle

Fig. 3

Semitendinosus muscle
Semimembranosus muscle
Gracilis muscle
Sartorius muscle
Vastus medialis muscle
Biceps femoris muscle
Gastrocnemius muscle
Soleus muscle

Fig. 4

Iliotibial band
Biceps femoris muscle
Head of the fibula
Gastrocnemius muscle
Peroneus longus muscle
Soleus muscle
Extensor digitorum longus muscle
Peroneus brevis muscle
Tibialis anterior muscle
Vastus lateralis muscle
Quadriceps tendon
Femur
Patella
Patellar tendon
Vastus medialis muscle
Patella
Sartorius muscle
Gastrocnemius muscle
Tibialis anterior muscle
Soleus muscle

Fig. 5

Quadriceps tendon
Femur
Patella
Patellar ligament
Head of the fibula
Soleus muscle
Peroneus longus muscle
Extensor digitorum longus muscle
Tibialis anterior muscle
Sartorius muscle
Tibial tuberosity
Gastrocnemius muscle
Soleus muscle

Fig. 6

Rectus femoris muscle
Vastus medialis muscle
Quadriceps tendon
Femur
Patella
Patellar ligament
Gracilis muscle
Sartorius muscle
Semitendinosus and semimembranosus muscle
Gastrocnemius muscle
Soleus muscle
Tibia
Tibialis anterior muscle

POSITIONS OF THE KNEE JOINT

PLATE 83

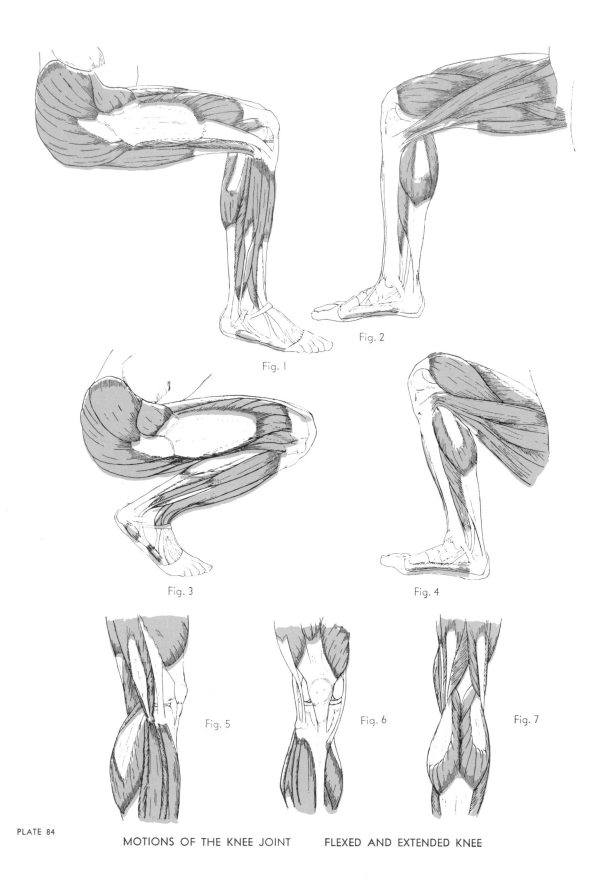

Fig. 2

Fig. 1

Fig. 3

Fig. 4

Fig. 5

Fig. 6

Fig. 7

PLATE 84

MOTIONS OF THE KNEE JOINT FLEXED AND EXTENDED KNEE

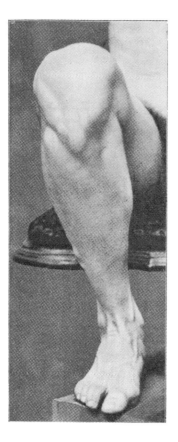

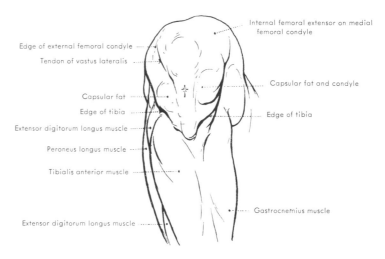

Internal femoral extensor on medial femoral condyle

Edge of external femoral condyle

Tendon of vastus lateralis

Capsular fat and condyle

Capsular fat

Edge of tibia

Edge of tibia

Extensor digitorum longus muscle

Peroneus longus muscle

Tibialis anterior muscle

Gastrocnemius muscle

Extensor digitorum longus muscle

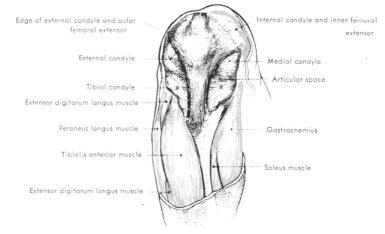

Edge of external condyle and outer femoral extensor

Internal condyle and inner femoral extensor

External condyle

Medial condyle

Articular space

Tibial condyle

Extensor digitorum longus muscle

Peroneus longus muscle

Gastrocnemius

Tibialis anterior muscle

Soleus muscle

Extensor digitorum longus muscle

KOLLMANN, ANATOMY OF THE KNEE, EXTREME ANGLE OF BEND

PLATE 85

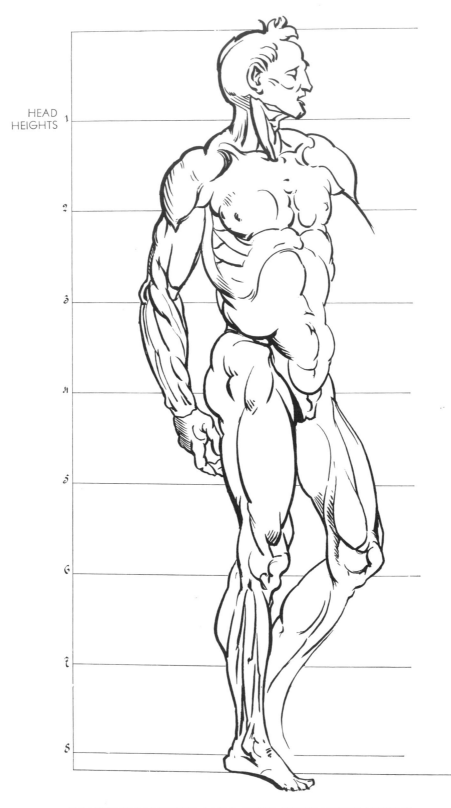

HEAD
HEIGHTS

1

2

3

4

5

6

7

8

PLATE 86 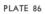 RELATIVE PROPORTIONS, MALE ADULT (AFTER MICHELANGELO)

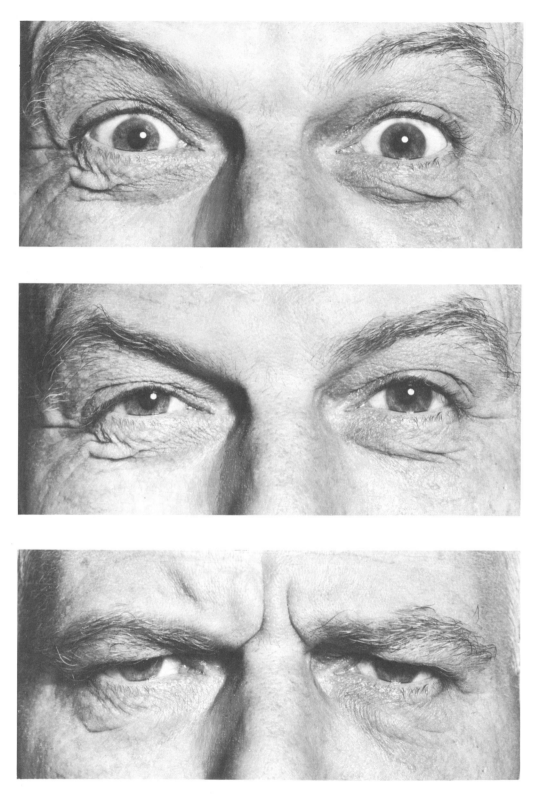

PHOTOGRAPHS SHOWING FOLDS AROUND THE EYES

PLATE 93

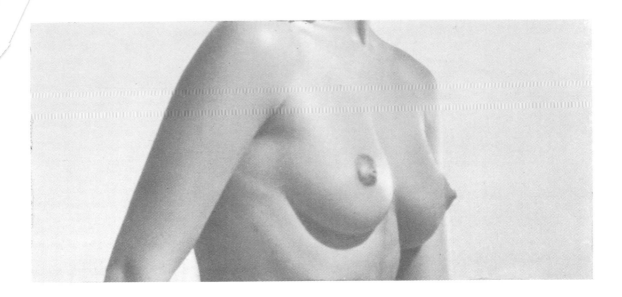

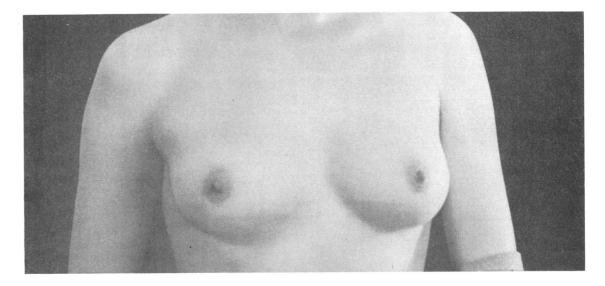

BREASTS I

PLATE 94

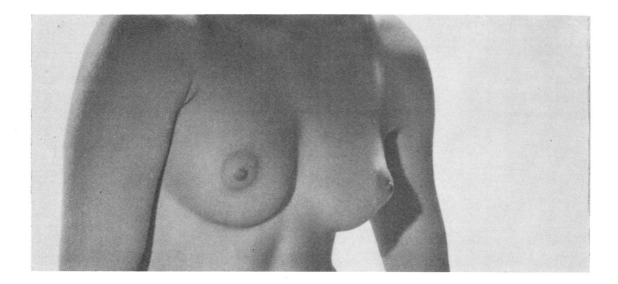

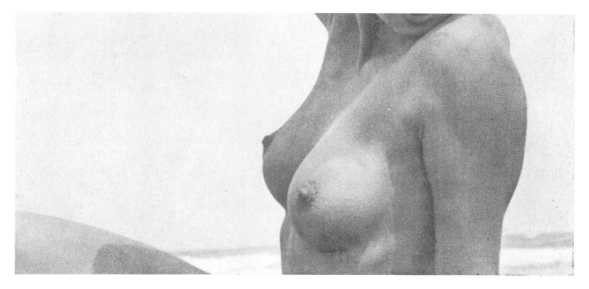

BREASTS II

PLATE 95

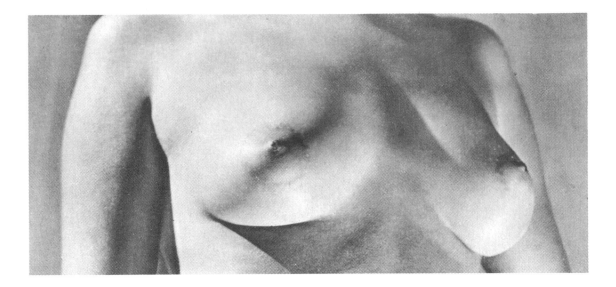

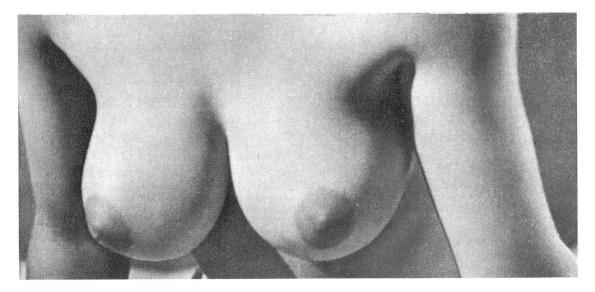

BREASTS III

PLATE 96

A Selection of Hands
By
Heidi Lenssen

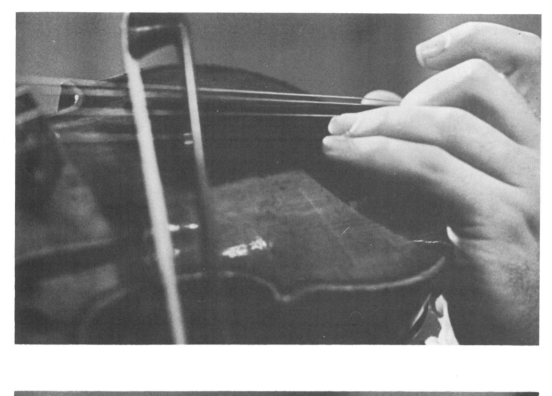

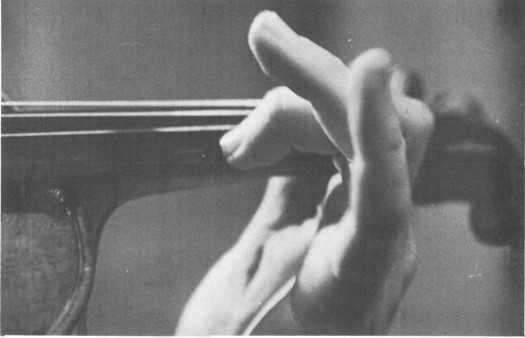

HANDS OF THE VIOLINIST ISAAC STERN

PLATE 97

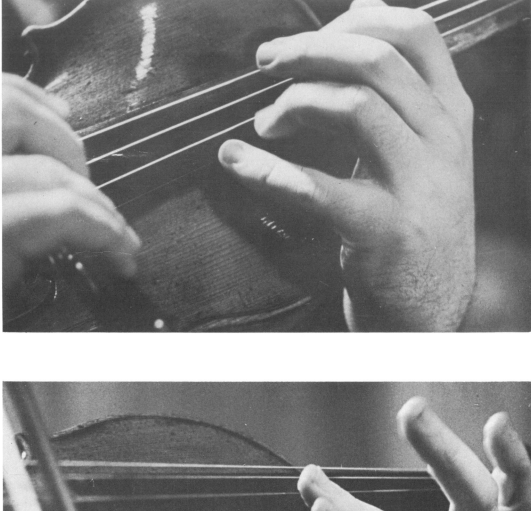

Courtesy of S. Hurok

HANDS OF THE VIOLINIST ISAAC STERN

PLATE 98

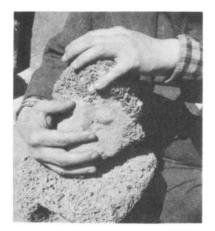 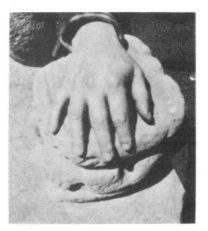

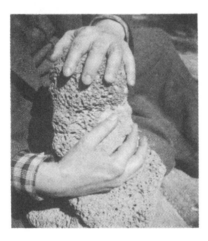 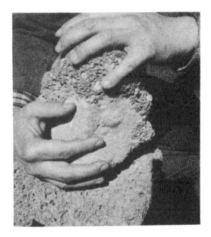

Photo by Fritz Henle

HANDS OF DIEGO RIVERA

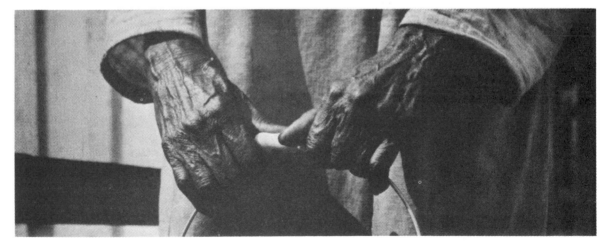

Photo by Fritz Henle

HANDS OF AN OLD LABORER (ONE OF THE LAST SURVIVING SLAVES)

PLATE 99

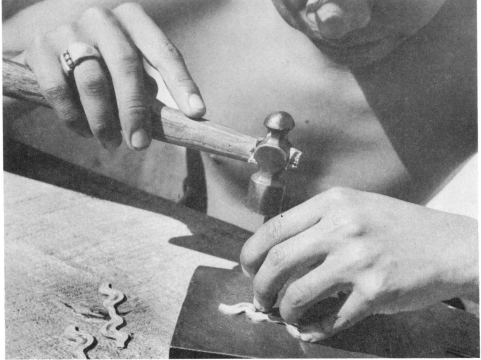

Photo by Fritz Henle

HANDS OF A SILVERSMITH

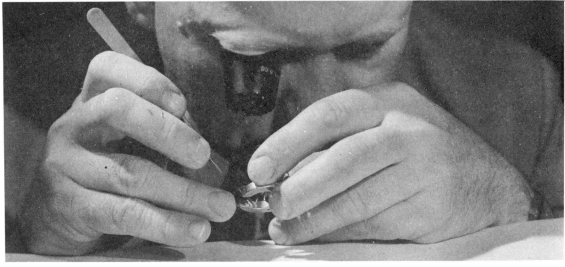

Photo by Fritz Henle

FINE MECHANIC AT WORK

PLATE 100

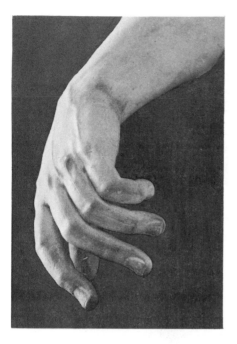
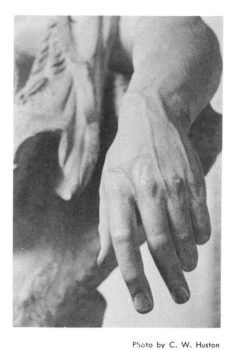

Photo by C. W. Huston

HANDS OF A YOUNG MAN, GREEK (c. 350 B.C.)

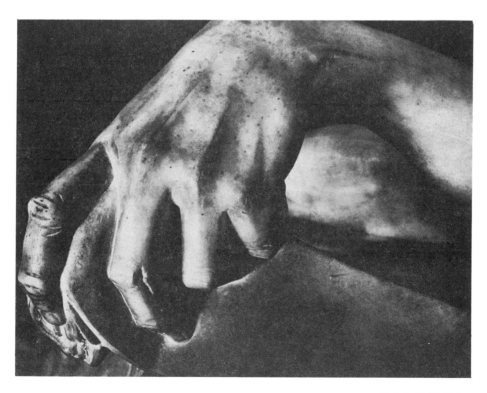

Photo by C. W. Huston

DONATELLO, "ST. JOHN" (DETAIL)

PLATE 101

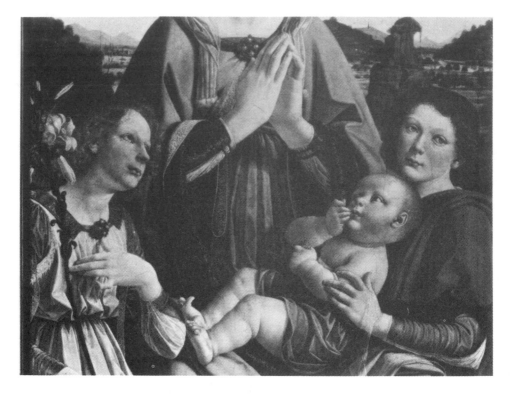

VERROCCHIO, "MARIA AND CHILD" (DETAIL)

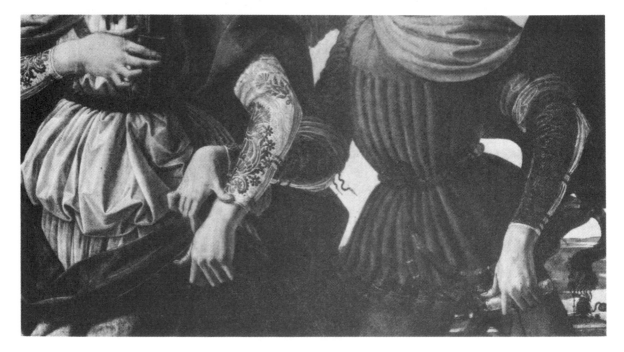

VERROCCHIO, "ST. JOHN AND AN ANGEL" (DETAIL)

PLATE 102

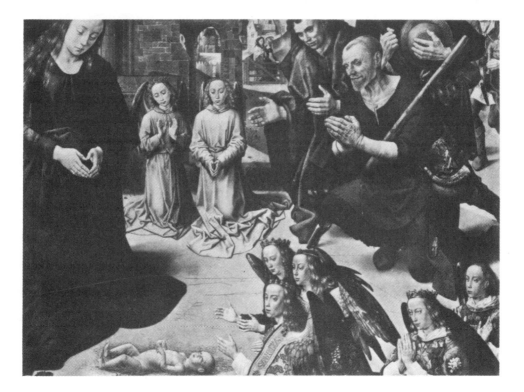

VAN DER GOES, "ADORATION OF JESUS" (DETAIL)

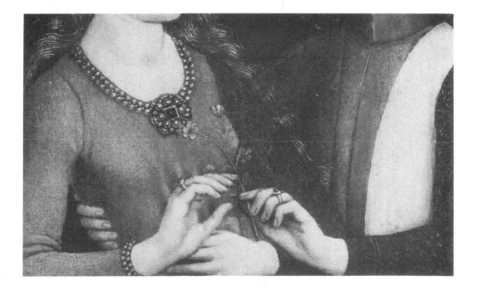

SOUTH GERMAN (c. 1470) (DETAIL)

PLATE 103

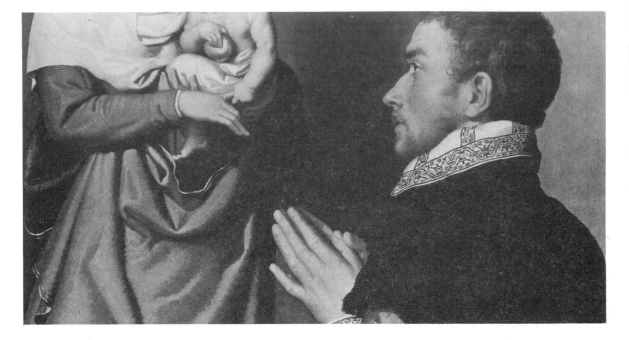

MORONI, "GENTLEMAN IN ADORATION" (DETAIL)

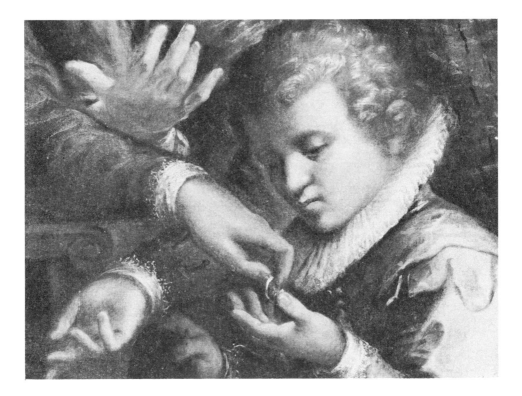

BASSANO (DETAIL)

PLATE 104

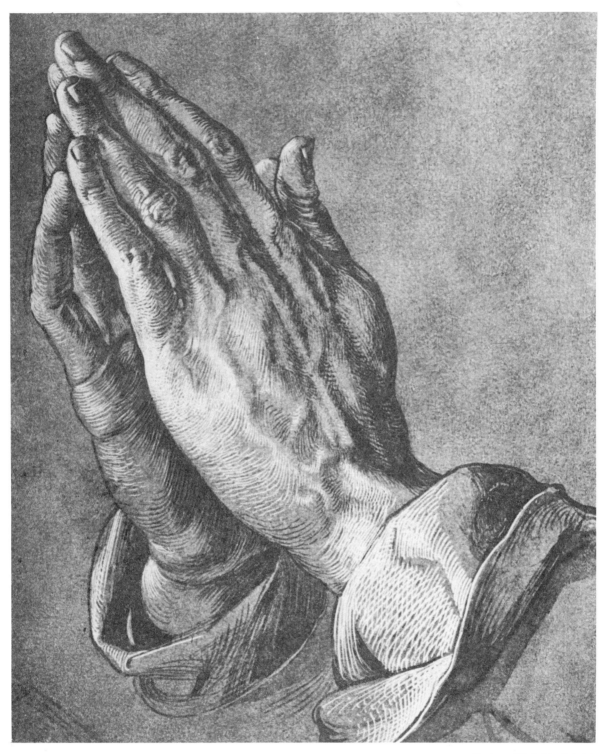

DURER, "PRAYING HANDS"

PLATE 105

EL GRECO, "INCOGNITO" (DETAIL)

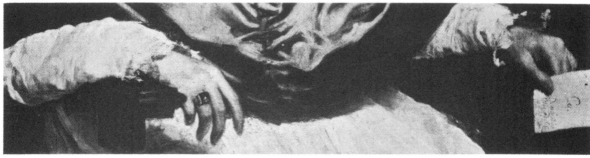

VELASQUEZ, "PORTRAIT OF INNOCENTIUS POPE" (DETAIL)

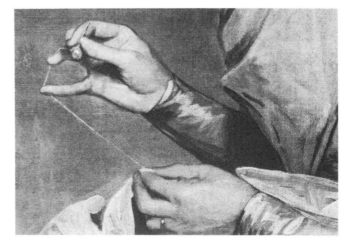

STUART, PORTRAIT (DETAIL)

PLATE 106

A Selection of Illustrations from the Old Masters
And Historical Sources

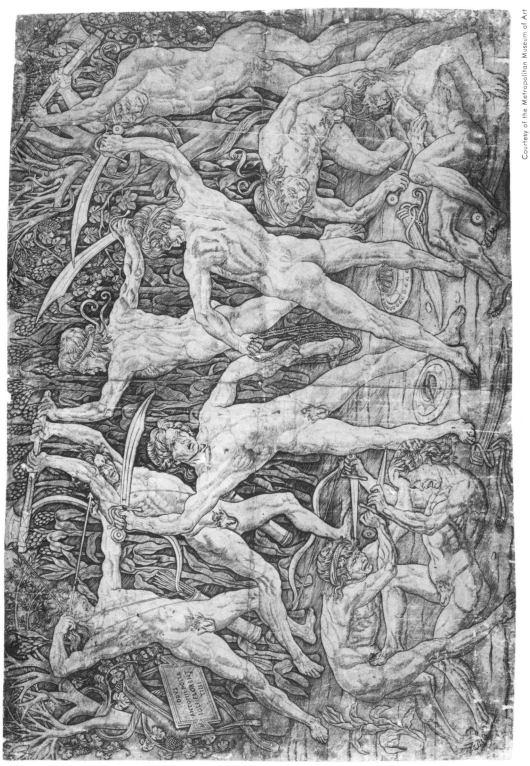

POLLAIUOLO, "BATTLE OF THE NAKED MEN"

PLATE 107

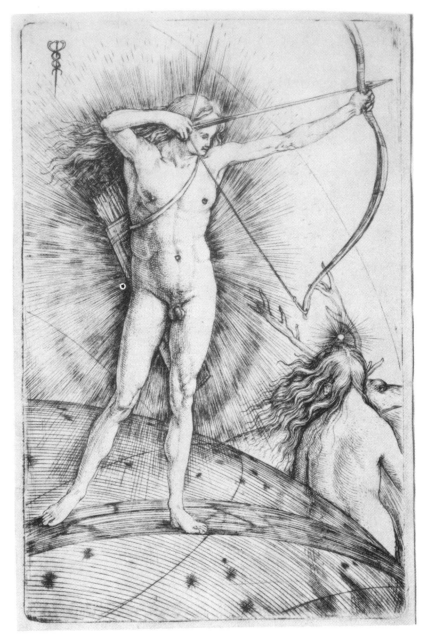

BARBARI, "APOLLO AND DIANA"

PLATE 108

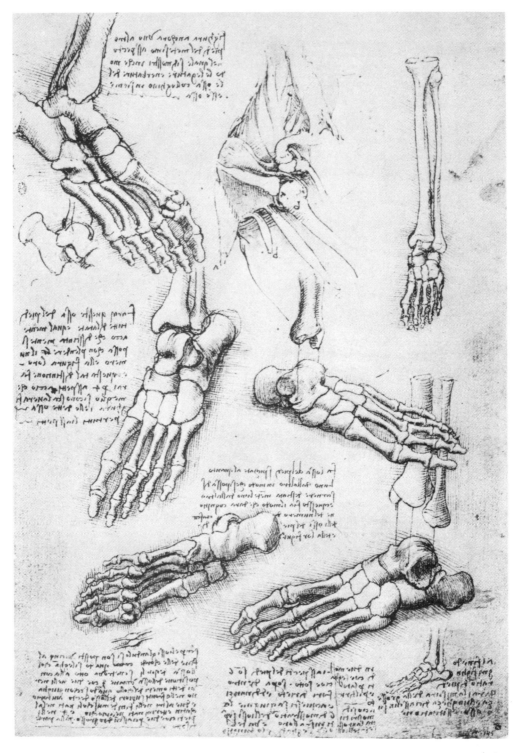

LEONARDO DA VINCI, BONES OF THE FOOT AND DISSECTION OF THE
SHOULDER JOINT.

PLATE 109

LEONARDO DA VINCI, MUSCLES OF THE TRUNK

PLATE 110

LEONARDO DA VINCI, MUSCLES OF THE TRUNK AND LEG

PLATE 111

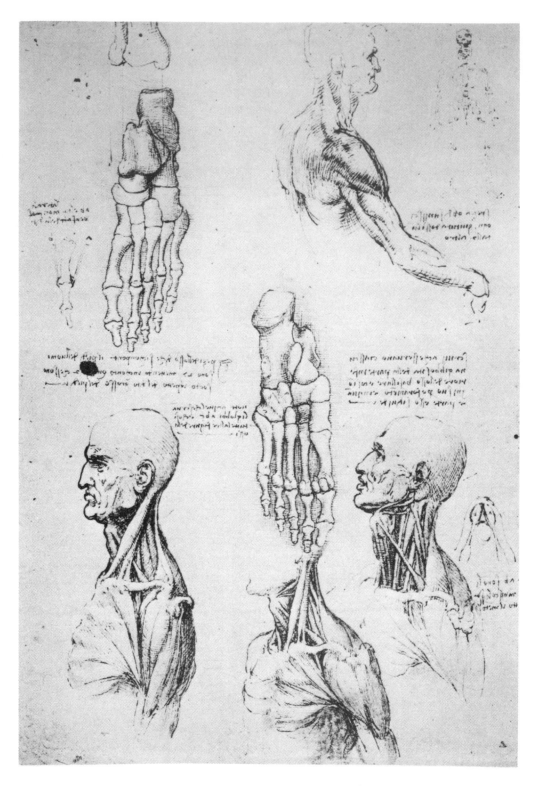

PLATE 112 LEONARDO DA VINCI, BONES OF THE FOOT AND MUSCLES OF THE
HEAD, NECK, AND SHOULDER

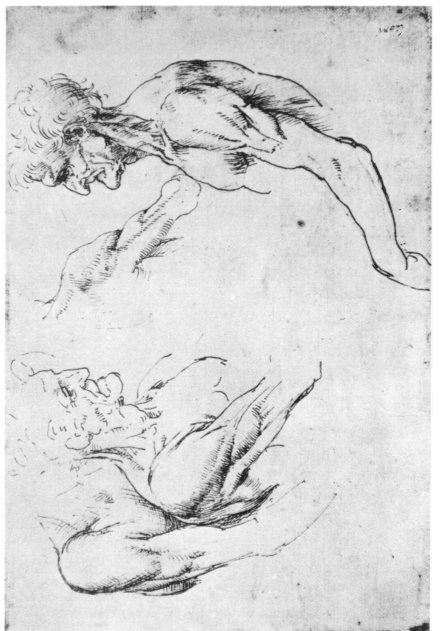

LEONARDO DA VINCI, SURFACE ANATOMY OF THE SHOULDER

PLATE 113

PLATE 114 LEONARDO DA VINCI, MUSCLES OF THE SHOULDER I

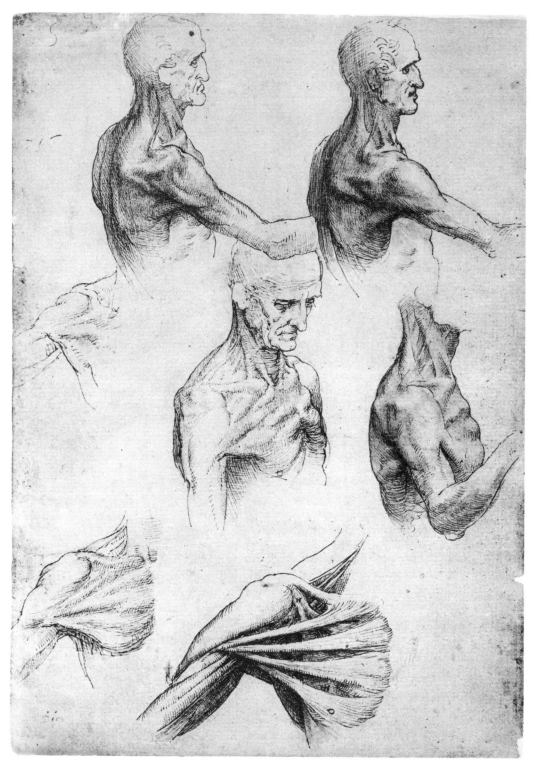

LEONARDO DA VINCI, MUSCLES OF THE SHOULDER II

PLATE 115

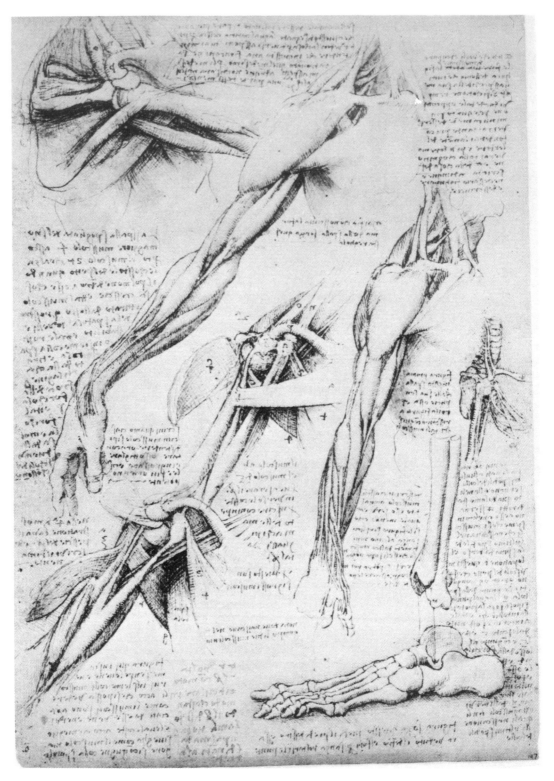

LEONARDO DA VINCI, MUSCLES OF THE SHOULDER III

PLATE 116

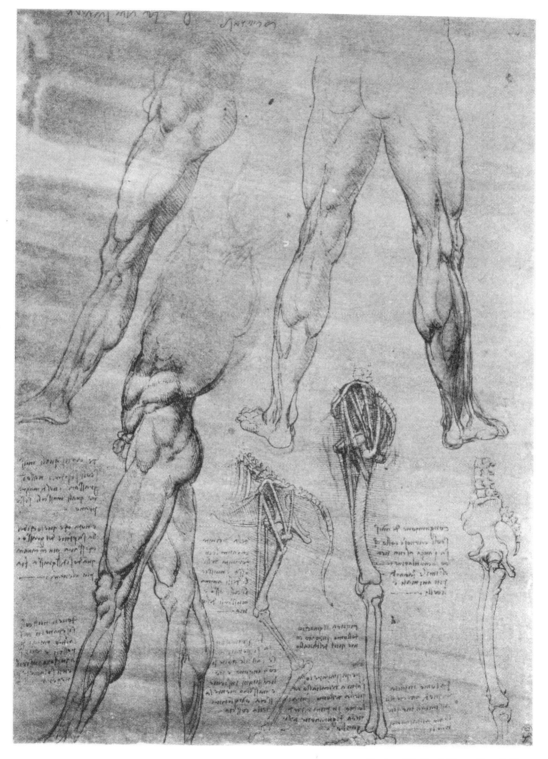

LEONARDO DA VINCI, SURFACE ANATOMY OF THE LOWER EXTREMITY

PLATE 117

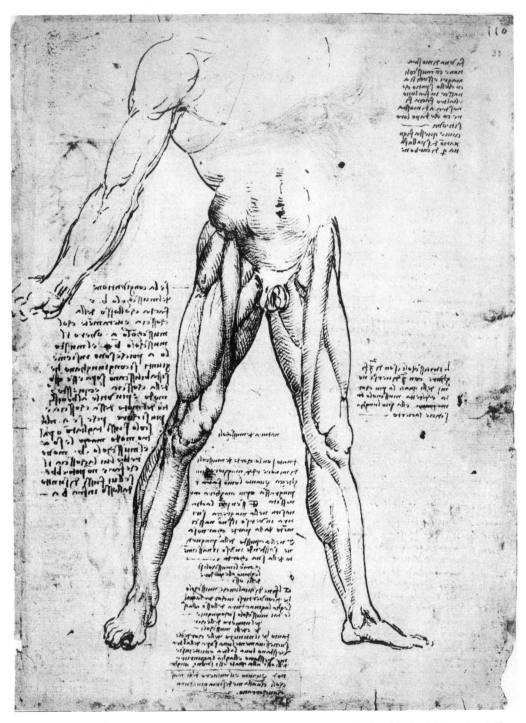

LEONARDO DA VINCI, MUSCLES OF THE LOWER EXTREMITY I

PLATE 118

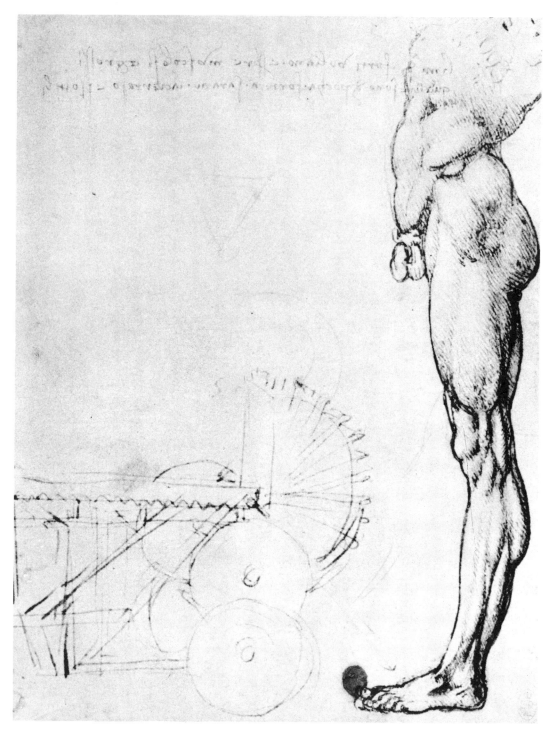

LEONARDO DA VINCI, MUSCLES OF THE LOWER EXTREMITY II

PLATE 119

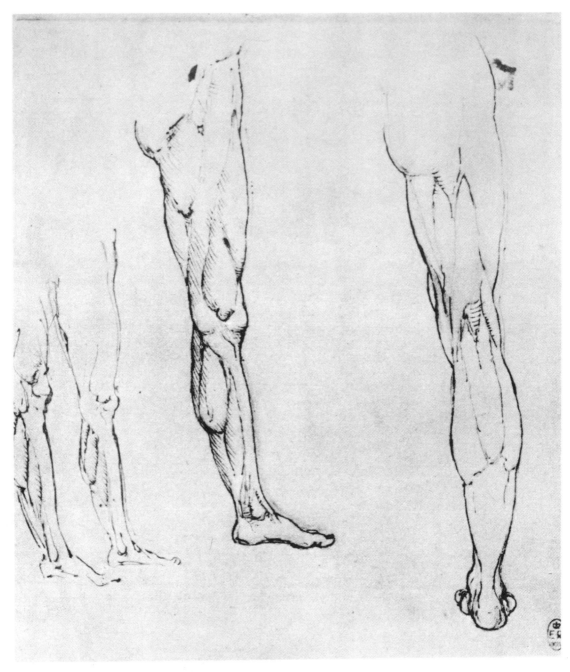

LEONARDO DA VINCI, MUSCLES OF THE LOWER EXTREMITY III

PLATE 120

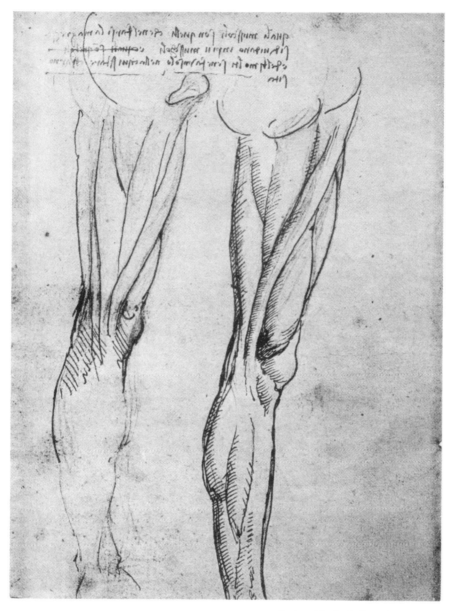

LEONARDO DA VINCI, MUSCLES OF THE LOWER EXTREMITY IV

PLATE 121

LEONARDO DA VINCI, MUSCLES OF THE LOWER EXTREMITY V

PLATE 122

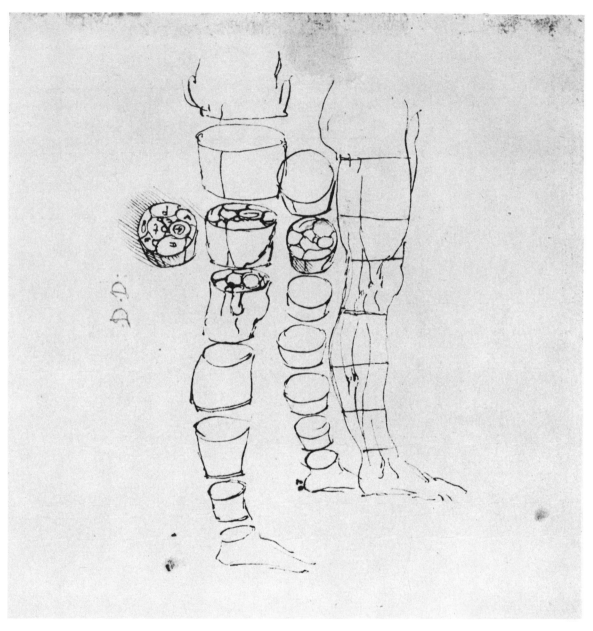

LEONARDO DA VINCI, MUSCLES OF THE LOWER EXTREMITY VI

PLATE 123

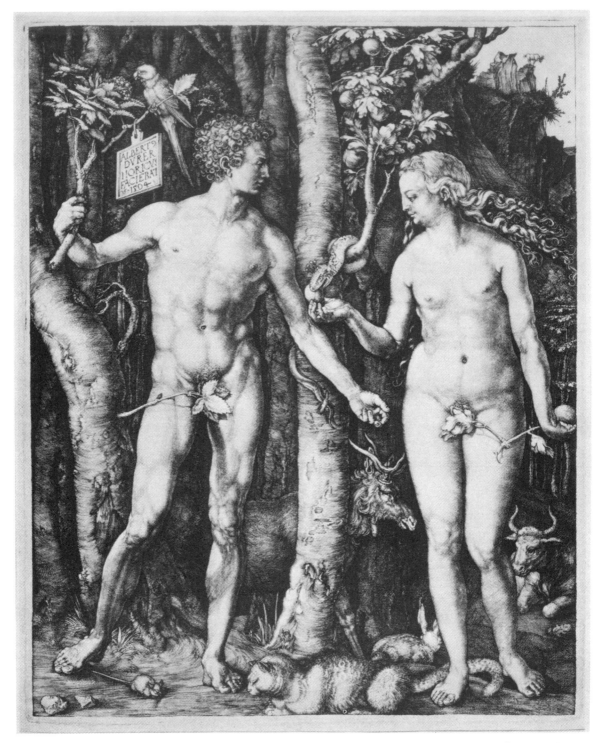

DURER, "ADAM AND EVE"

PLATE 124

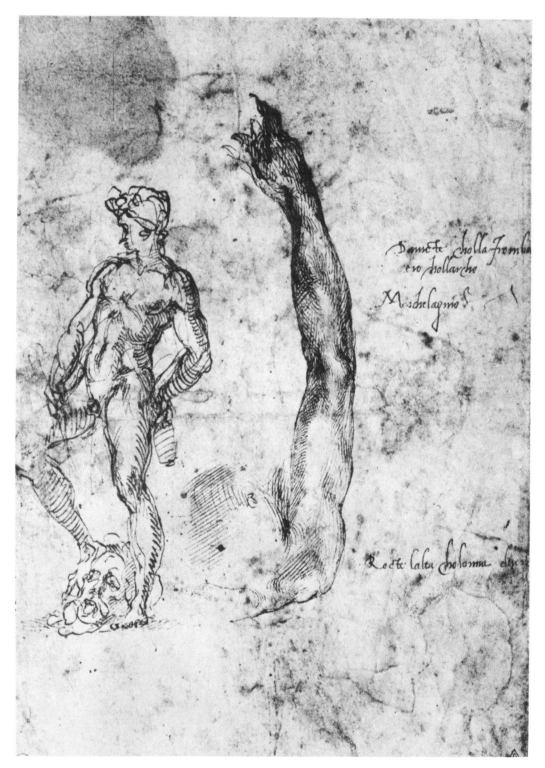

MICHELANGELO, SKETCH FOR THE BRONZE DAVID AND ARM STUDY
FOR THE MARBLE DAVID

PLATE 125

MICHELANGELO, STUDIES OF THE NUDE

PLATE 126

MICHELANGELO, NUDE SEEN FROM THE BACK PLATE 127

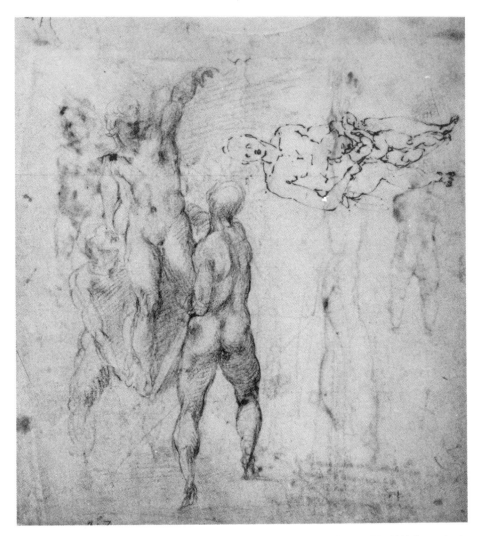

MICHELANGELO, SKETCH FOR THE BRUGES MADONNA, THREE NUDE MEN

PLATE 128

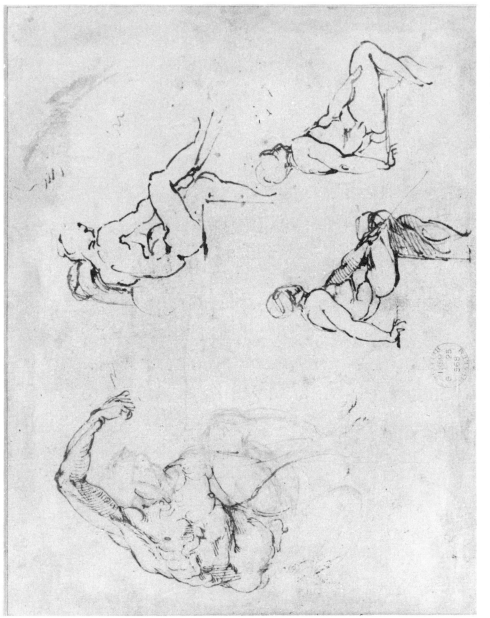

MICHELANGELO, STUDIES FOR THE IGNUDI OF THE
SISTINE CHAPEL CEILING

PLATE 129

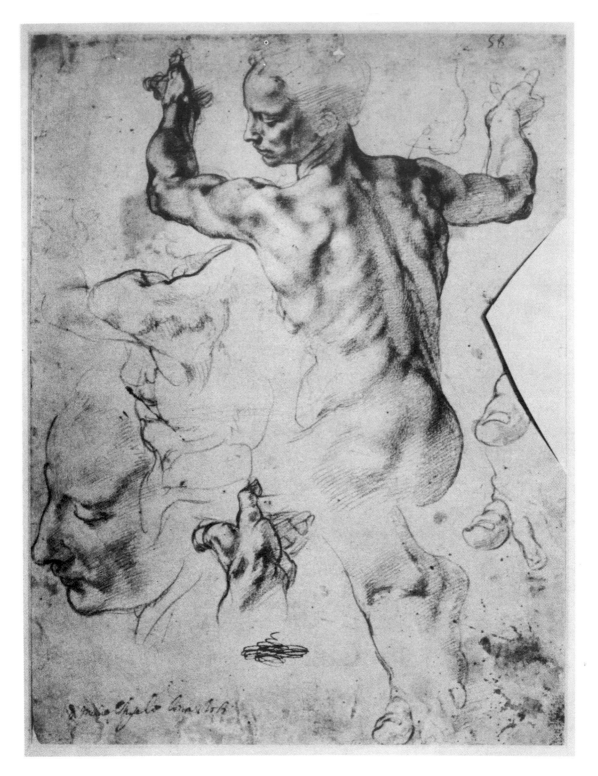

MICHELANGELO, STUDIES FOR THE LIBYAN SIBYL

PLATE 130

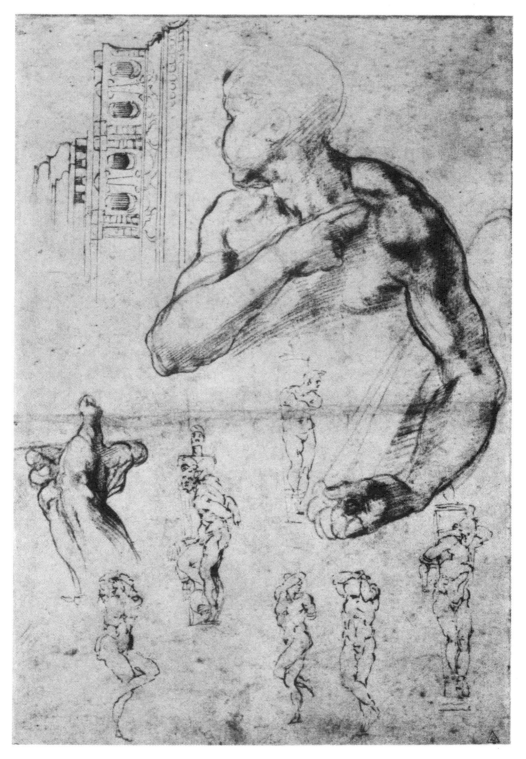

Courtesy of the Ashmolean Museum, Oxford

MICHELANGELO, SKETCHES FOR THE SISTINE CHAPEL CEILING AND THE
TOMB OF JULIUS

PLATE 131

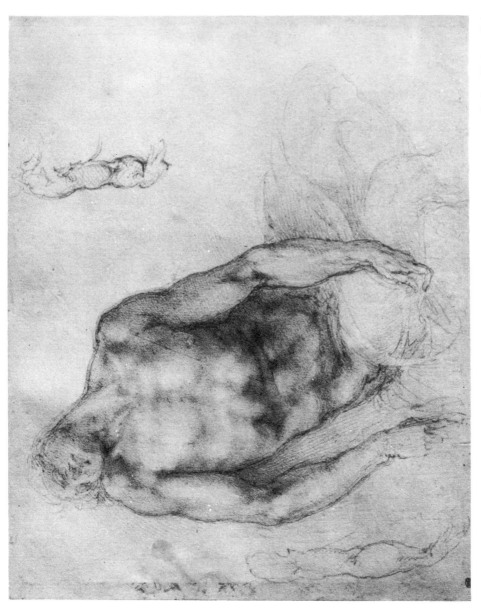

MICHELANGELO, STUDY FOR A PIETA

PLATE 132

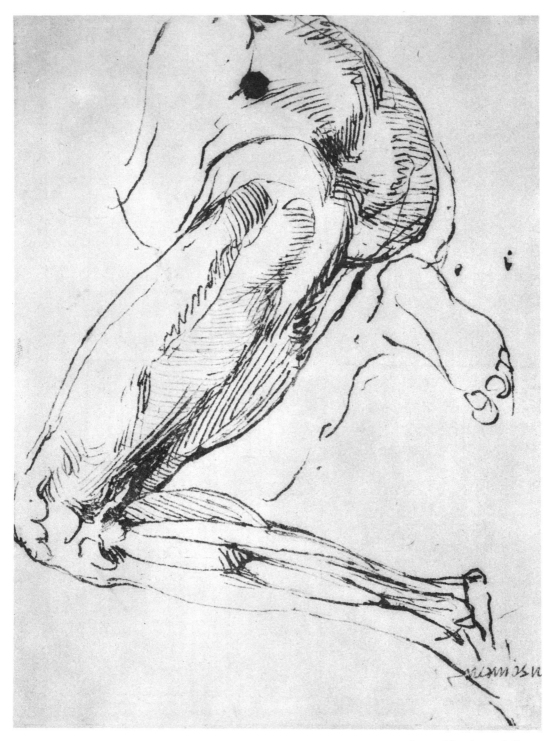

MICHELANGELO, STUDY FOR A RECUMBENT FIGURE
IN THE MEDICI CHAPEL

PLATE 133

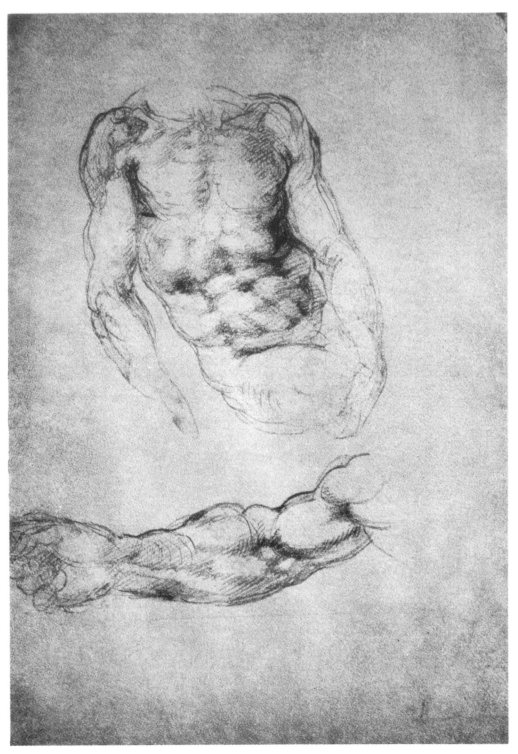

Courtesy of Casa Buonarroti, Florence

MICHELANGELO, ARM AND TORSO STUDY FOR A PIETA

PLATE 134

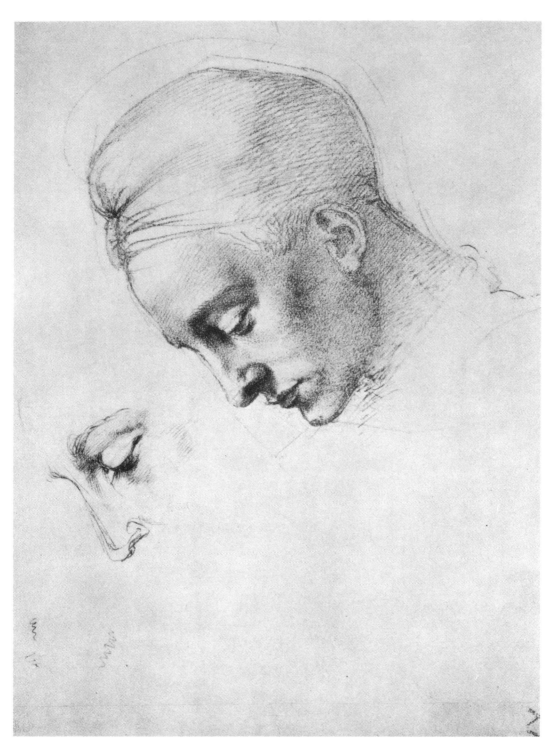

MICHELANGELO, STUDY OF HEADS FOR THE LEDA

PLATE 135

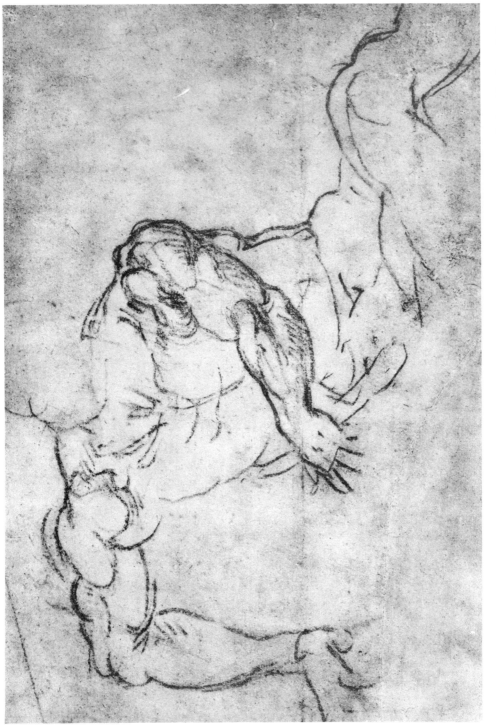

MICHELANGELO, STUDY OF A BACKGROUND FIGURE FOR THE
"RISEN CHRIST"

PLATE 136

MICHELANGELO, STUDY FOR THE "LAST JUDGMENT."

PLATE 137

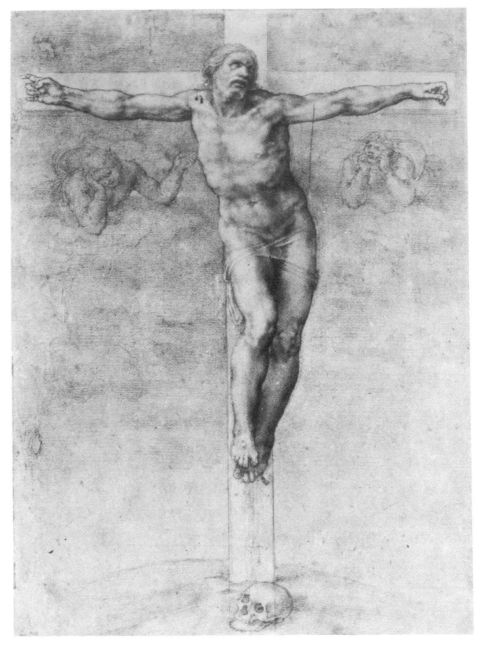

MICHELANGELO, CRUCIFIXION FOR VITTORIA COLONNA

PLATE 138

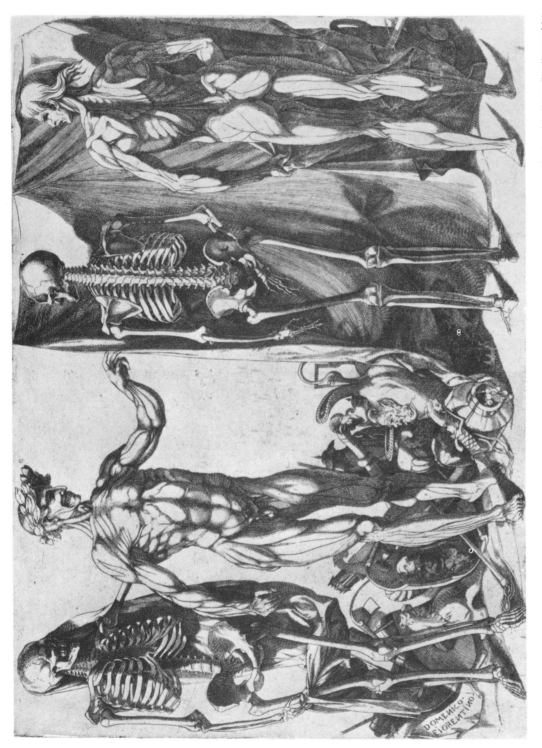

BARBIERI, DESIGN FROM AN ANATOMY BOOK

PLATE 139

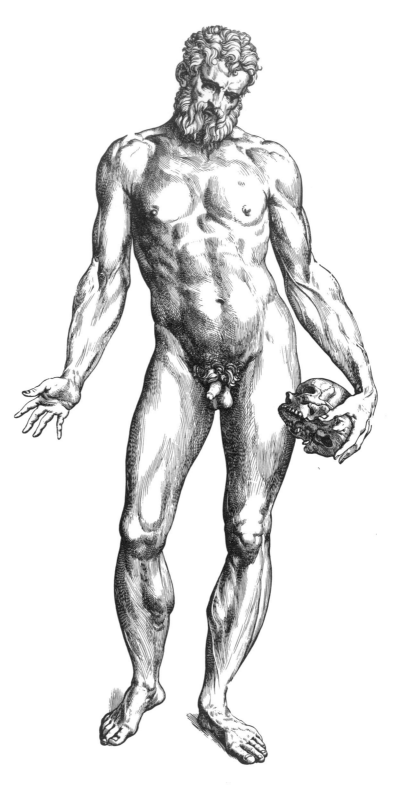

VESALIUS, MALE NUDE

PLATE 140

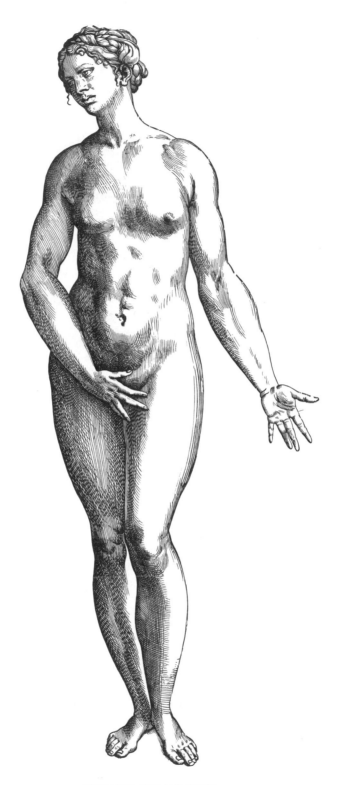

VESALIUS, FEMALE NUDE

PLATE 141

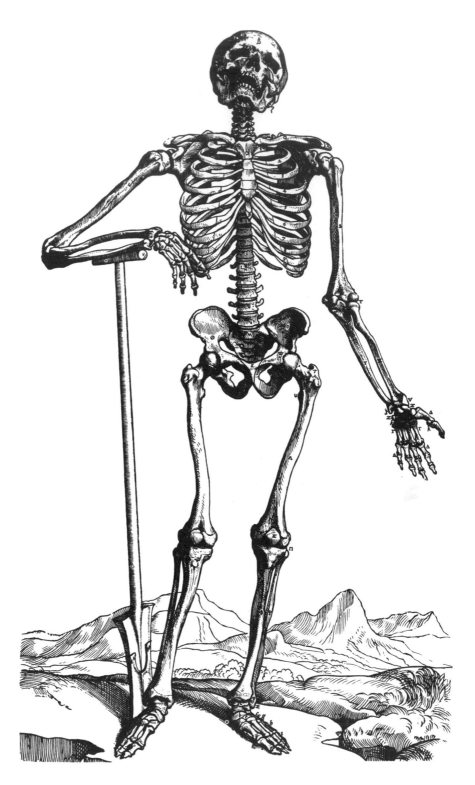

VESALIUS, SKELETON I

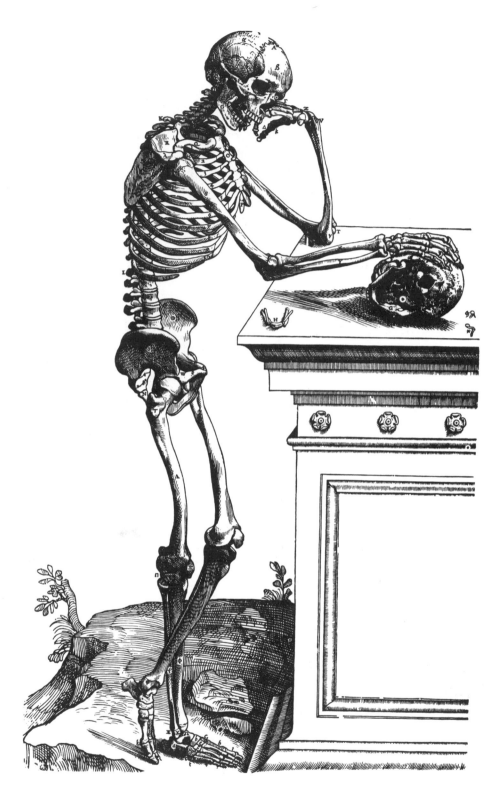

VESALIUS, SKELETON II

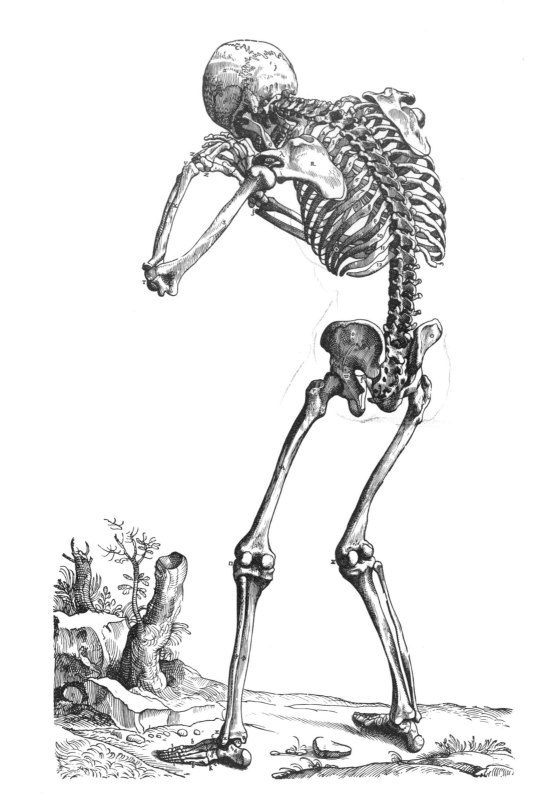

VESALIUS, SKELETON III

PLATE 144

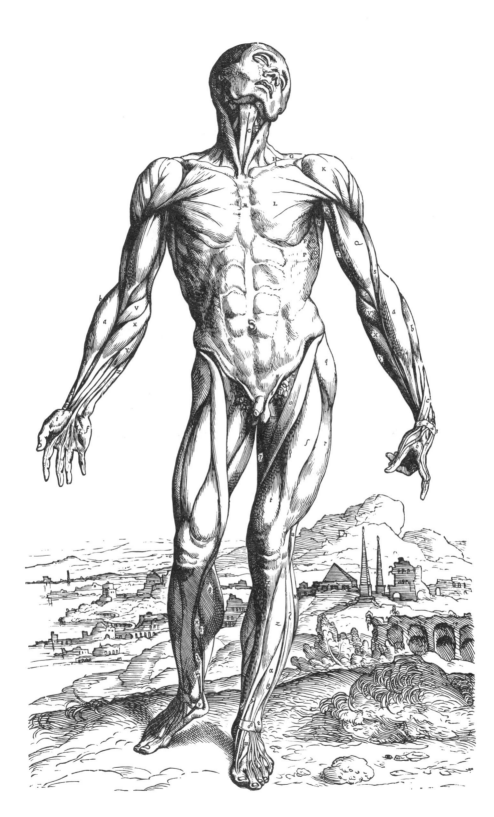

VESALIUS, MUSCLES I

PLATE 145

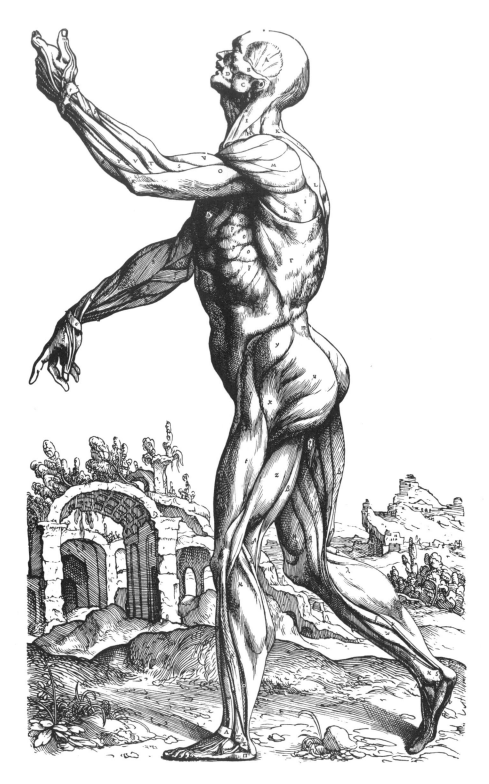

VESALIUS, MUSCLES II

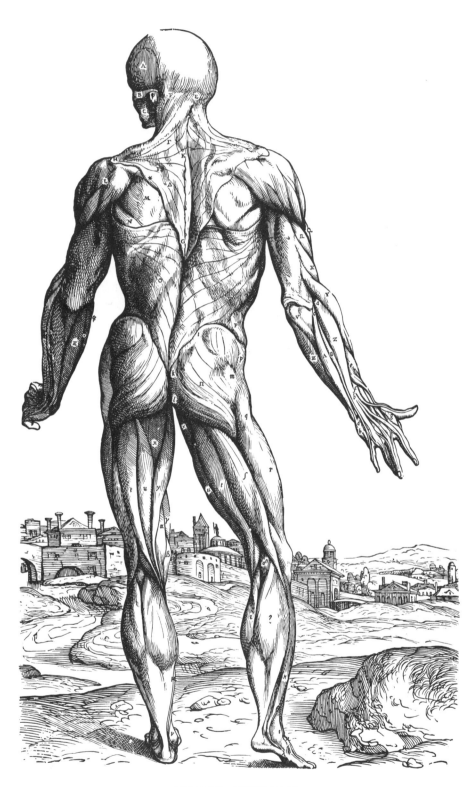

VESALIUS, MUSCLES III

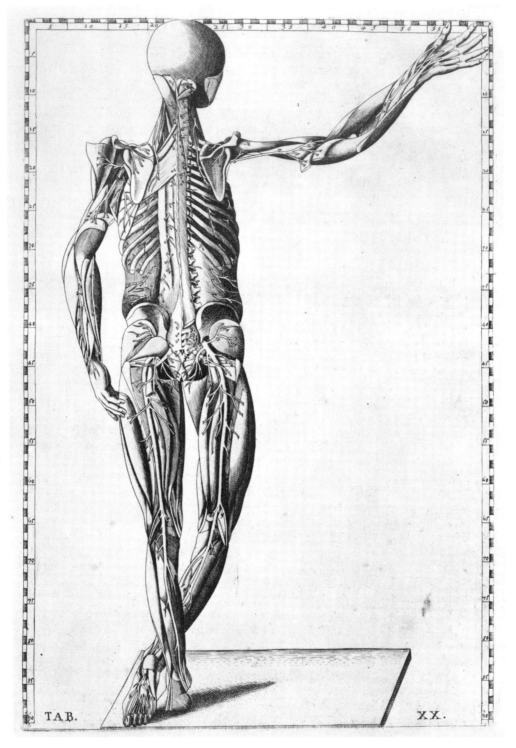

EUSTACHIO, PLATE FROM THE "TABULAÉ ANATOMICAE"

PLATE 148

MEIER, "APOLLO FLAYING MARSYAS"

PLATE 149

BORGIONI, "THE DEAD CHRIST"

PLATE 150

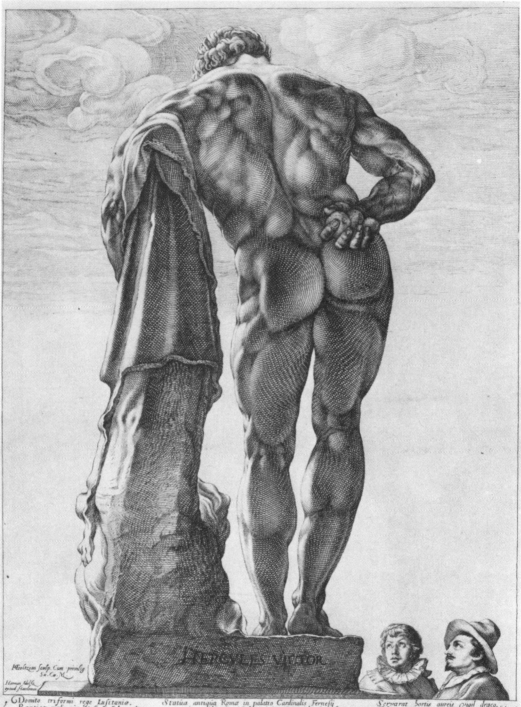

GOLTZIUS, THE "FARNESE" HERCULES

PLATE 151

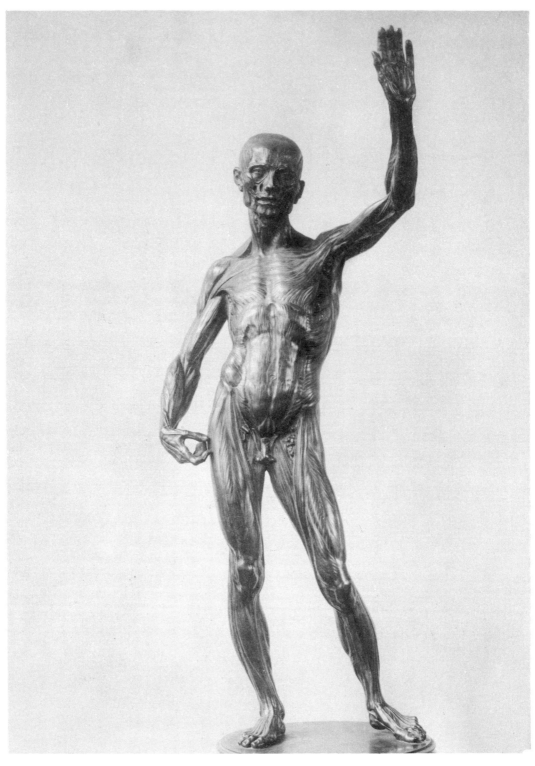

CARDI, ANATOMICAL FIGURE

PLATE 152

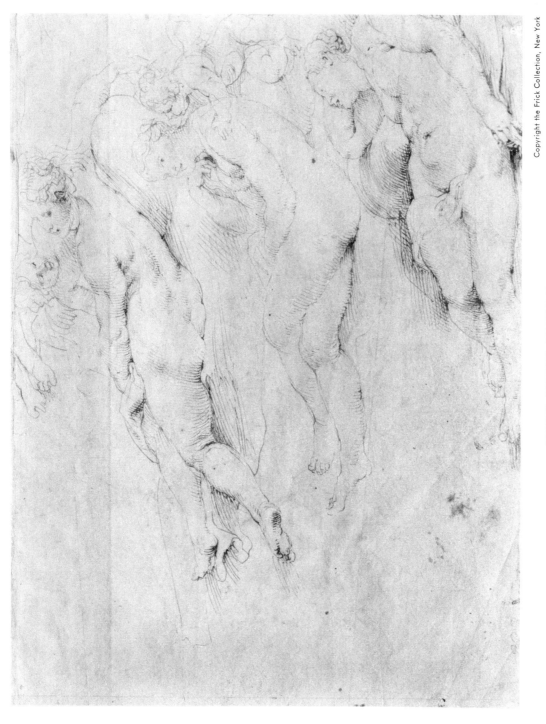

RUBENS, "STUDIES OF VENUS"

PLATE 153

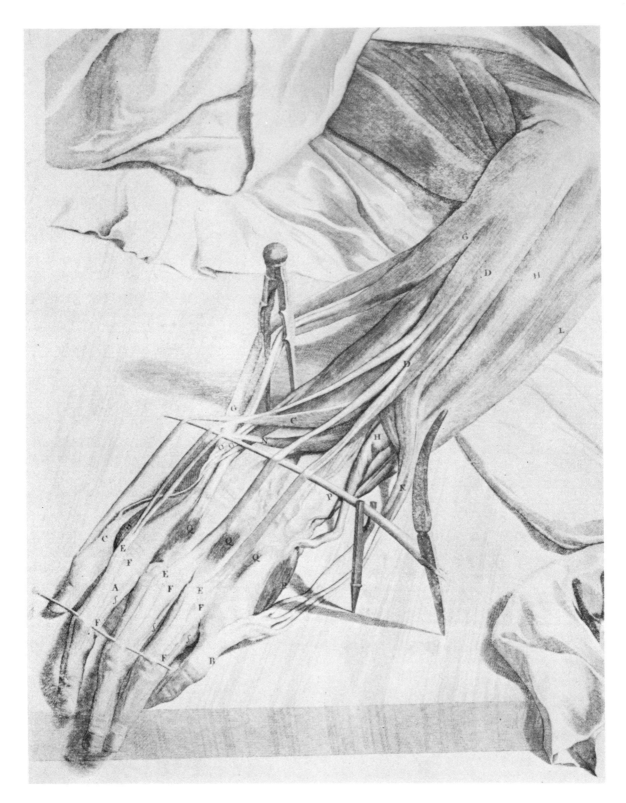

CAMPER, A STUDY OF THE HAND FROM THE ANATOMY OF
HUMANE BODIES

PLATE 154

GOYA, "THE GIANT"

PLATE 155

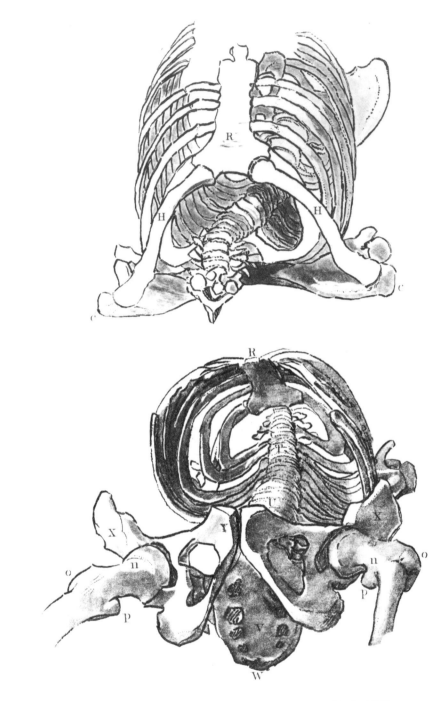

FLAXMAN, VIEWS OF THE THORACIC BASKET

PLATE 156

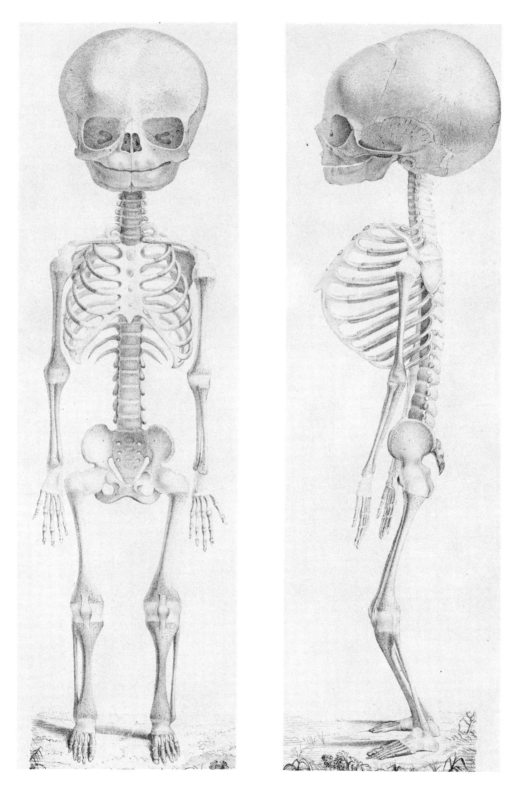

CLOQUET, SKELETON OF INFANT

PLATE 157

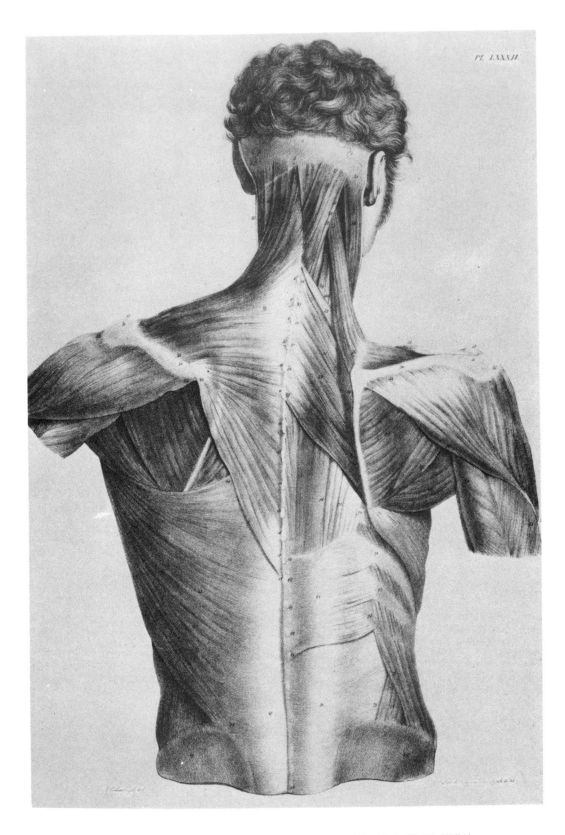

Pl. LXXXII.

CLOQUET, MUSCULATURE OF TORSO AND NECK, POSTERIOR VIEW

PLATE 158

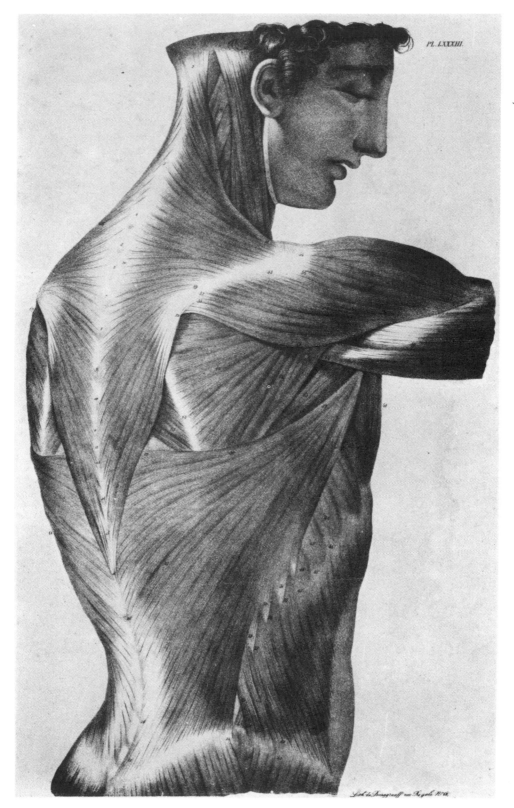

CLOQUET, MUSCULATURE OF TORSO AND NECK, LATERAL VIEW

PLATE 159

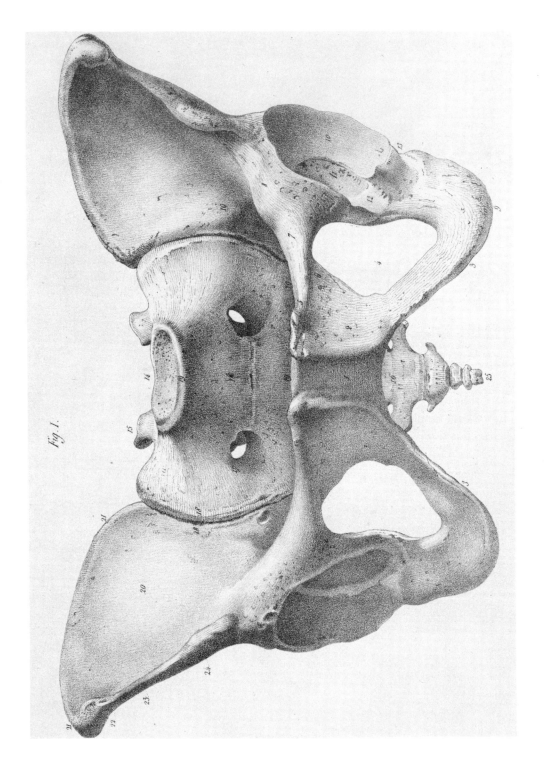

Fig. 1.

CLOQUET, FEMALE PELVIS, ANTERIOR VIEW

PLATE 160

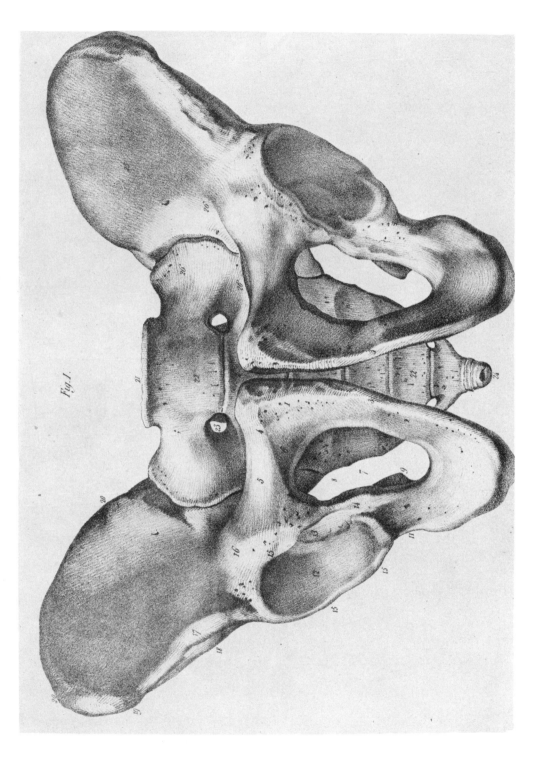

Fig.1.

CLOQUET, FEMALE PELVIS, ANTERIOR VIEW FROM BELOW

PLATE 161

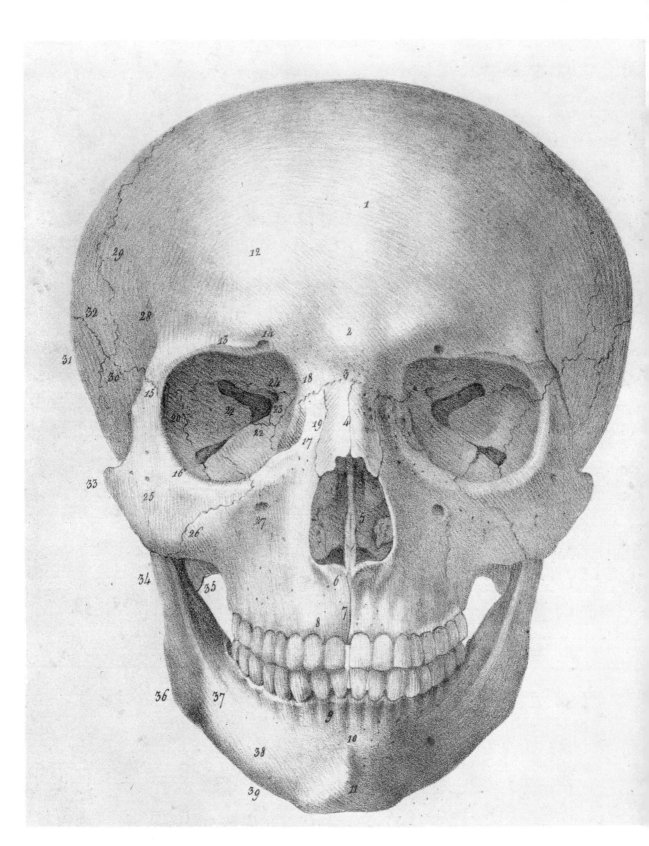

CLOQUET, SKULL, ANTERIOR VIEW

PLATE 162

Fig. 6.

CLOQUET, BONES OF THE SKULL, ANTERIOR VIEW

PLATE 163

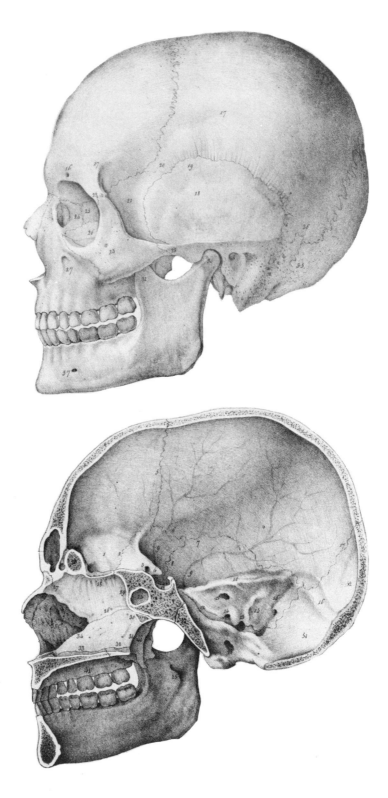

CLOQUET, SKULL, LATERAL VIEW AND SAGITTAL SECTION

PLATE 164

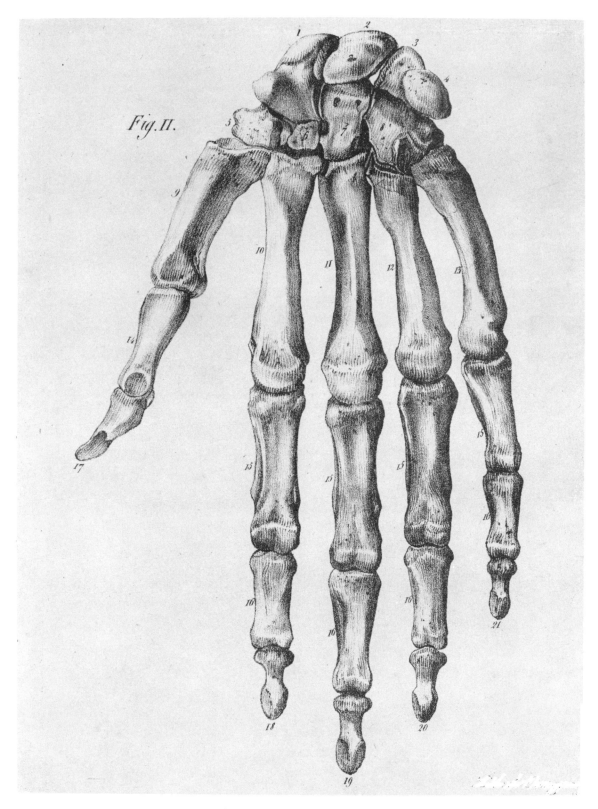

CLOQUET, BONES OF THE HAND

PLATE 165

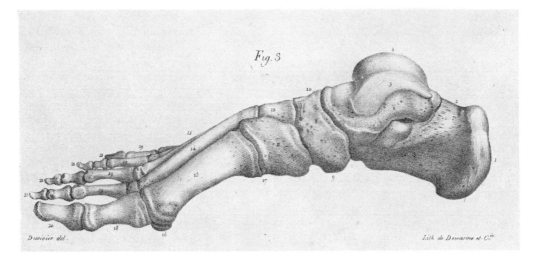

CLOQUET, BONES OF THE FOOT, LATERAL VIEW

PLATE 166

INGRES, "STUDIES FOR THE DEAD BODY OF ACRON"

PLATE 167

RIMMER, MUSCLES OF THE BACK

PLATE 168

RIMMER, MUSCLE OF THE TORSO, SOLID AND UNALTERABLE SECTIONS

PLATE 169

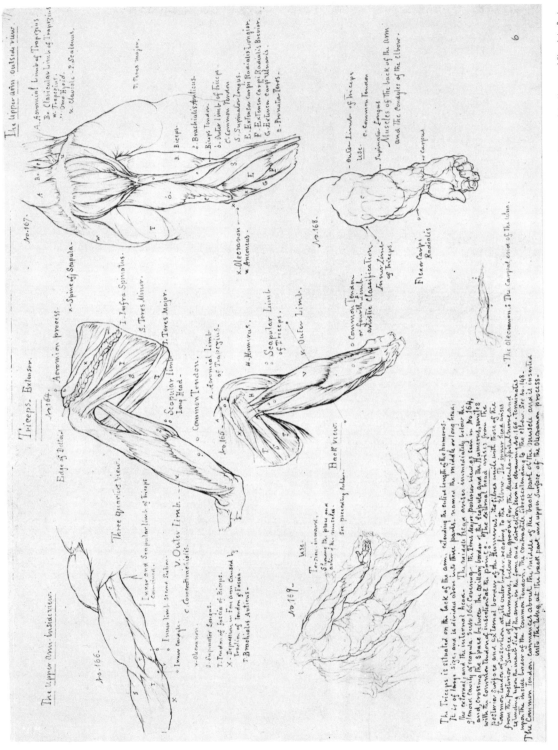

RIMMER, THE TRICEPS AND MUSCLES OF THE ARM

PLATE 170

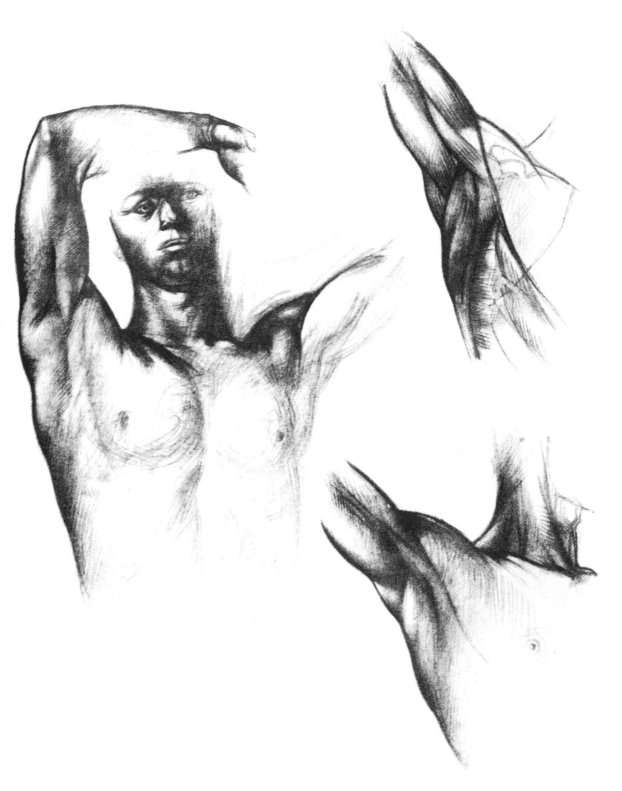

BARCSAY, TRUNK IN MOVEMENT

PLATE 171

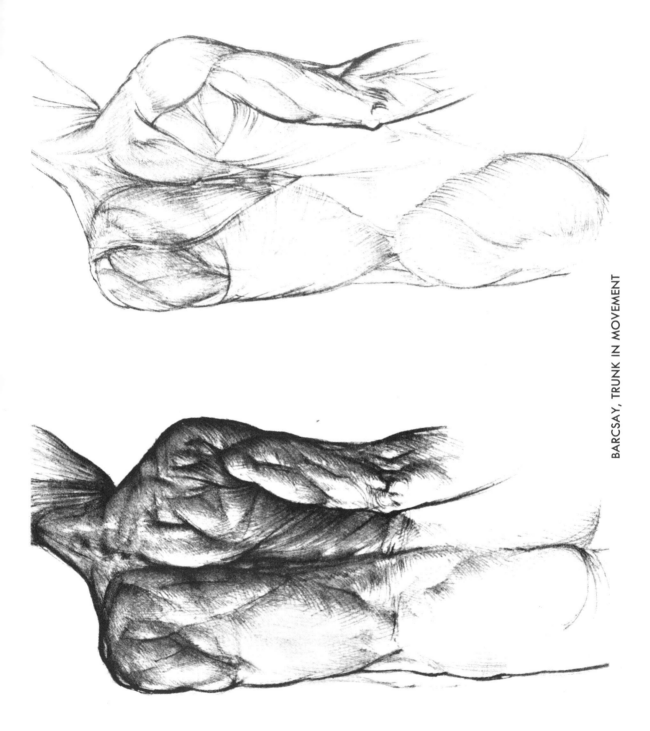

BARCSAY, TRUNK IN MOVEMENT

PLATE 172

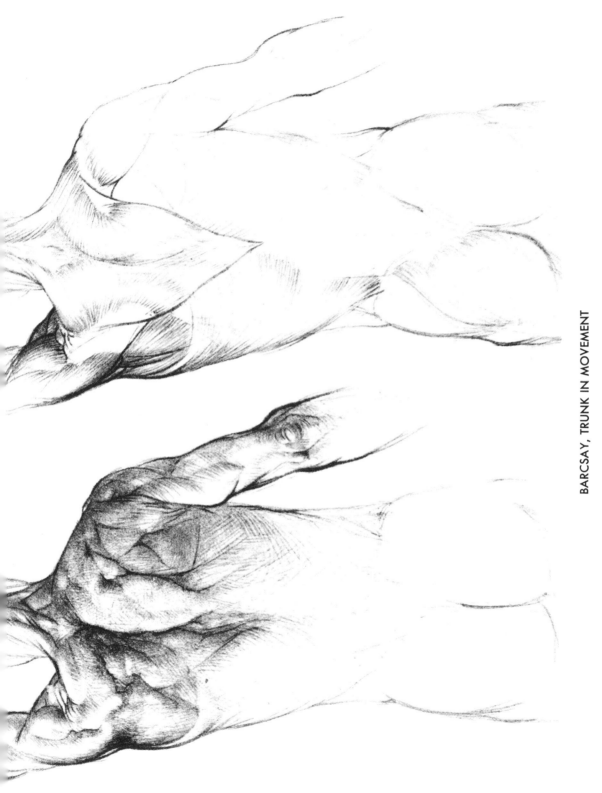

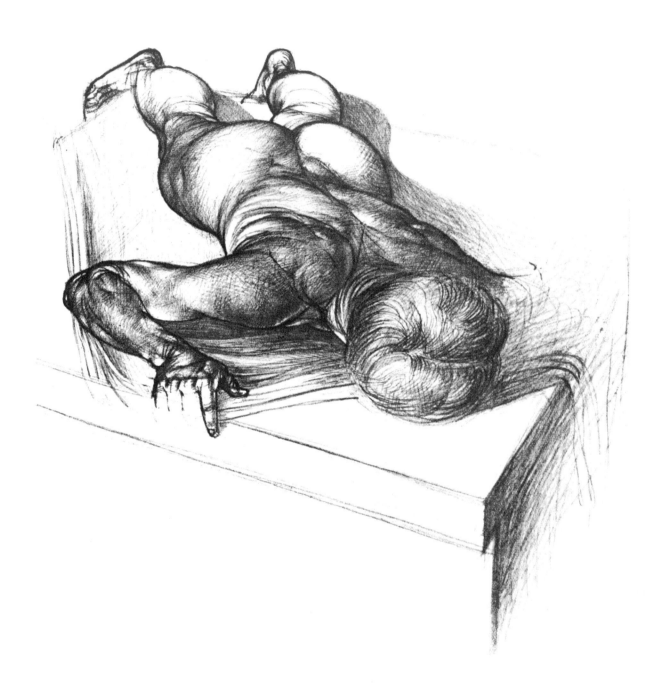

BARCSAY, FORESHORTENED BODY

PLATE 174

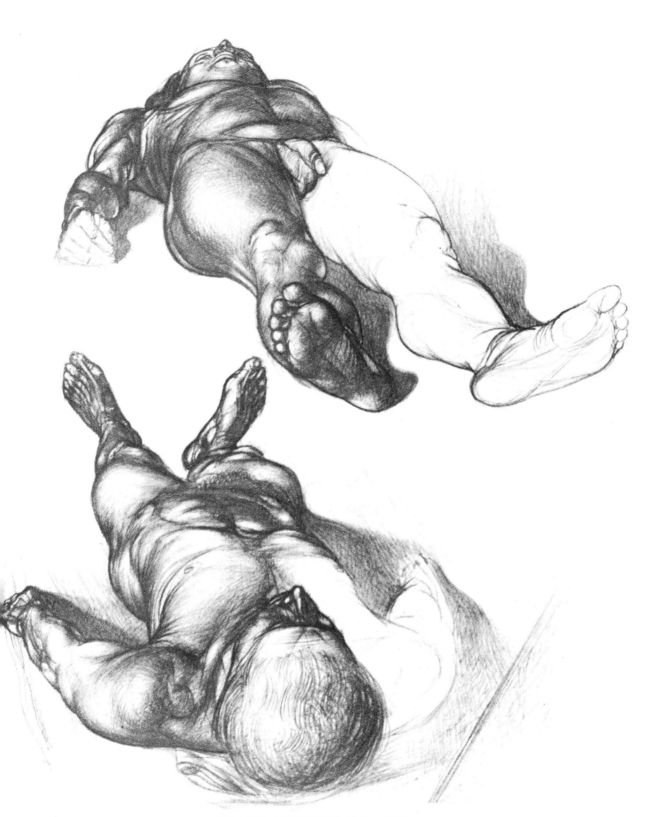

BARCSAY, FORESHORTENED BODY

PLATE 175

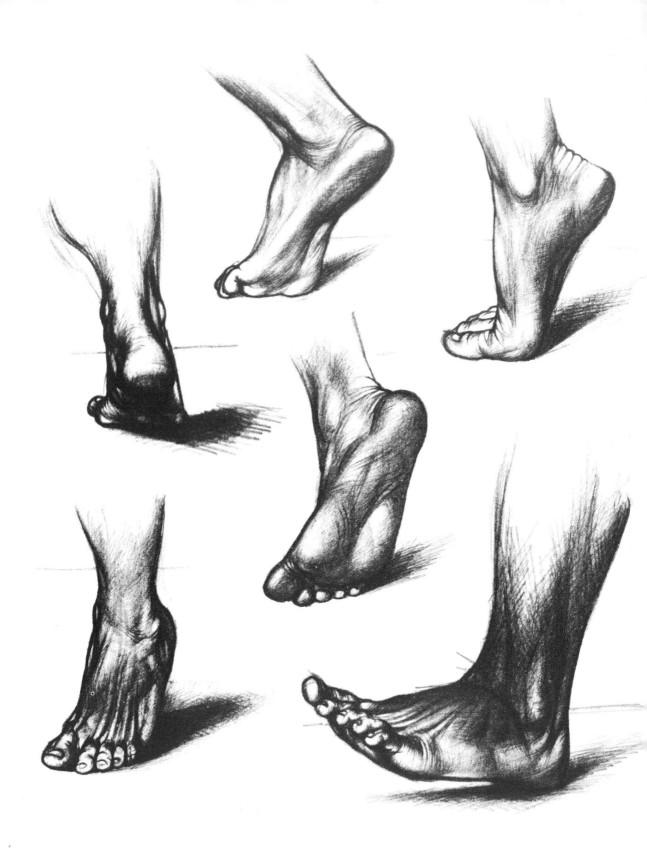

BARCSAY, THE FOOT IN MOVEMENT

PLATE 176

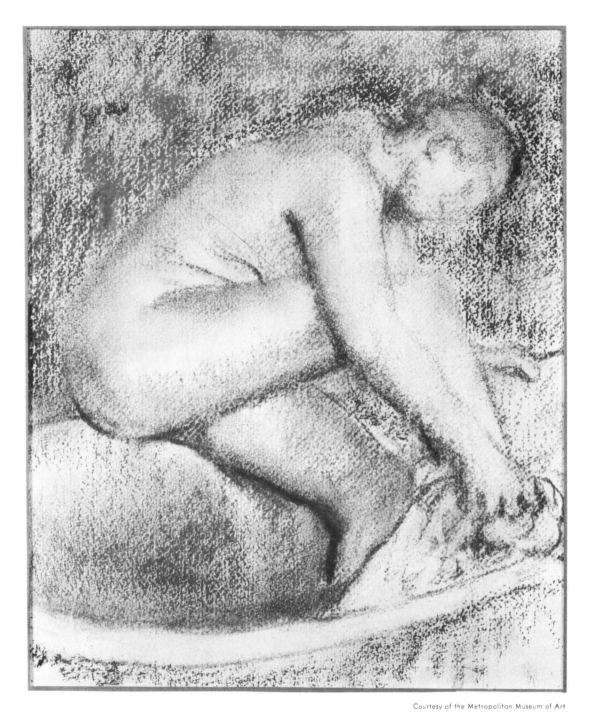

DEGAS, "THE BATH"

PLATE 177

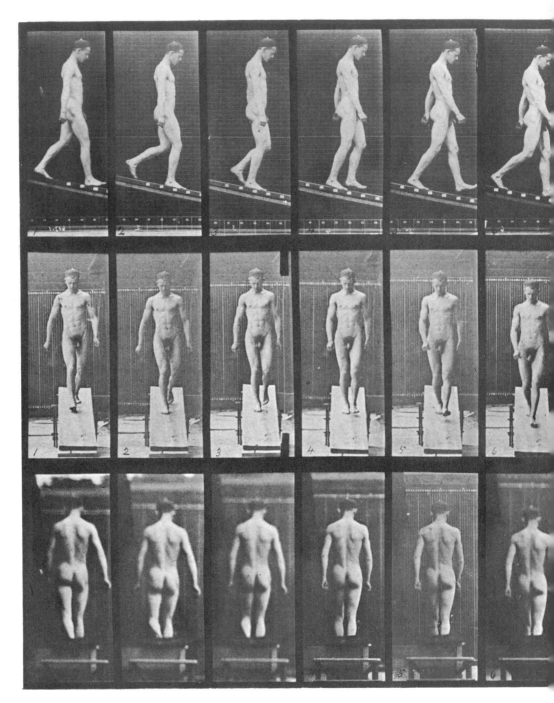

MUYBRIDGE, ATHLETE, WALKING

PLATE 178

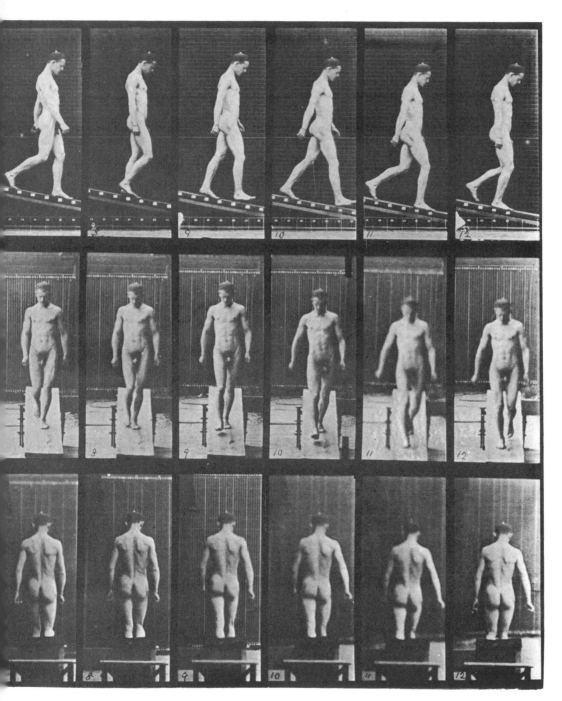

MUYBRIDGE, ATHLETE, WALKING

PLATE 179

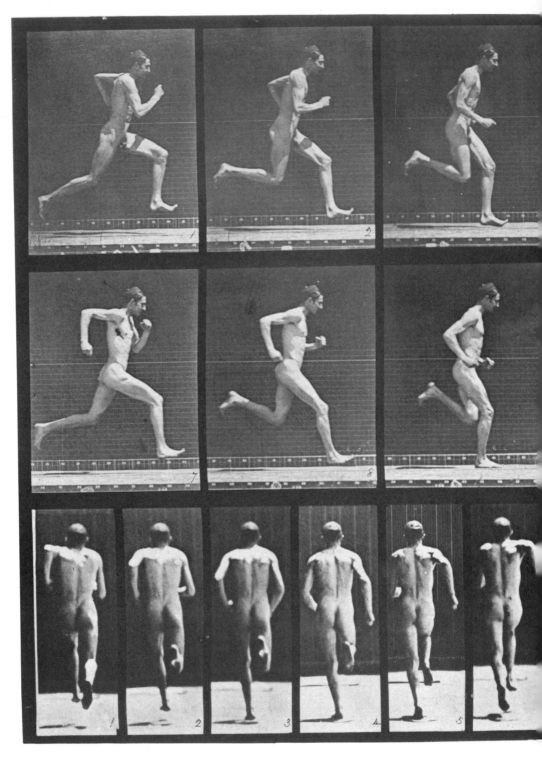

MUYBRIDGE, ATHLETE, RUNNING

PLATE 180

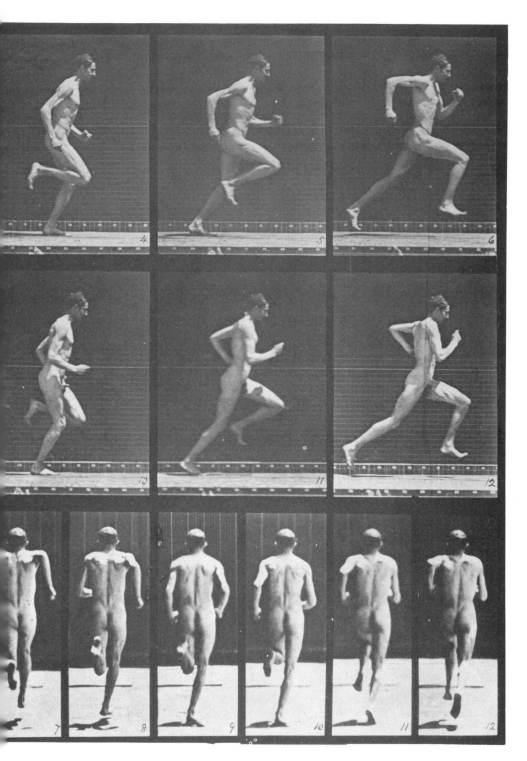

MUYBRIDGE, ATHLETE, RUNNING

PLATE 181

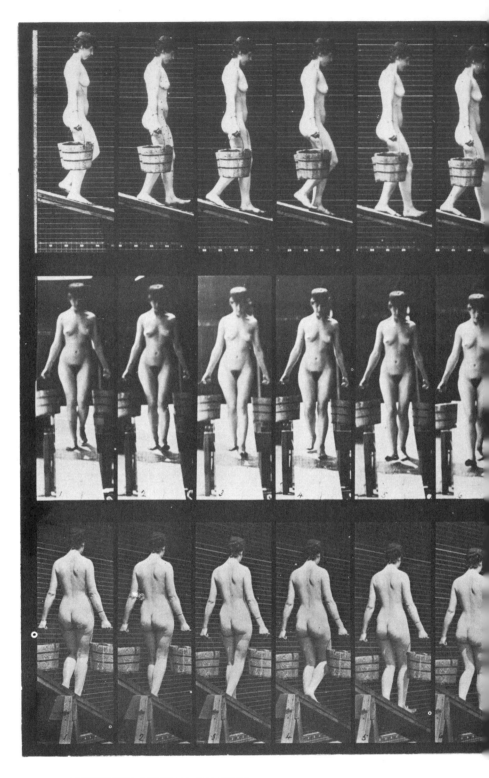

MUYBRIDGE, WOMAN, WALKING

PLATE 182

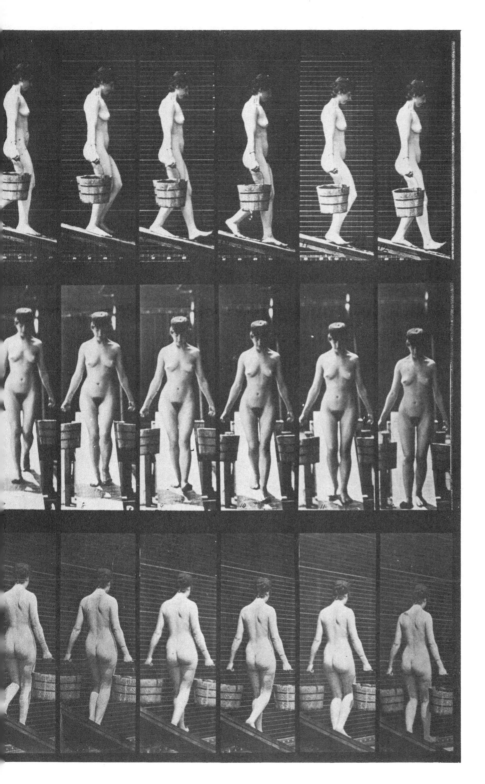

MUYBRIDGE, WOMAN, WALKING

PLATE 183

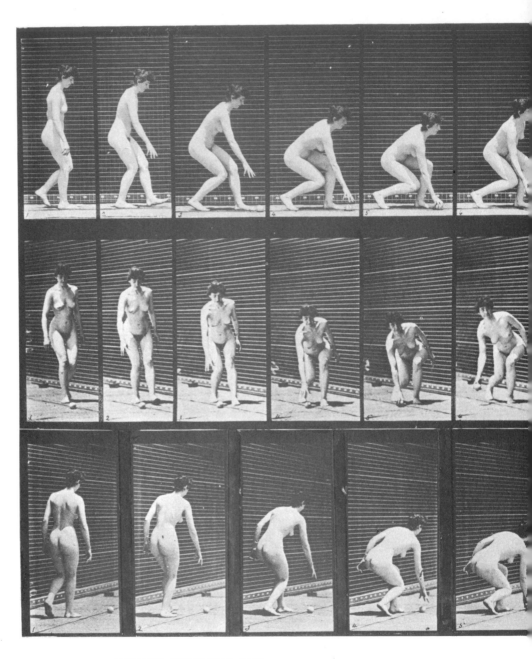

WOMAN, THROWING BALL

PLATE 184

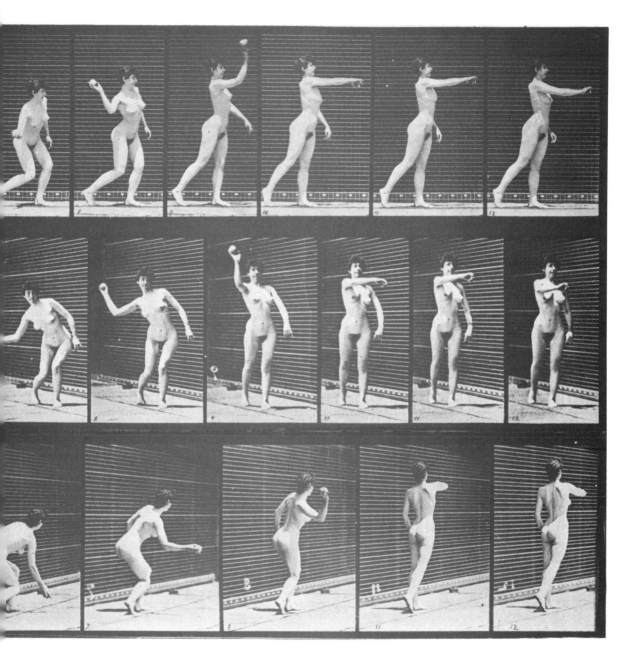

WOMAN, THROWING BALL

PLATE 185

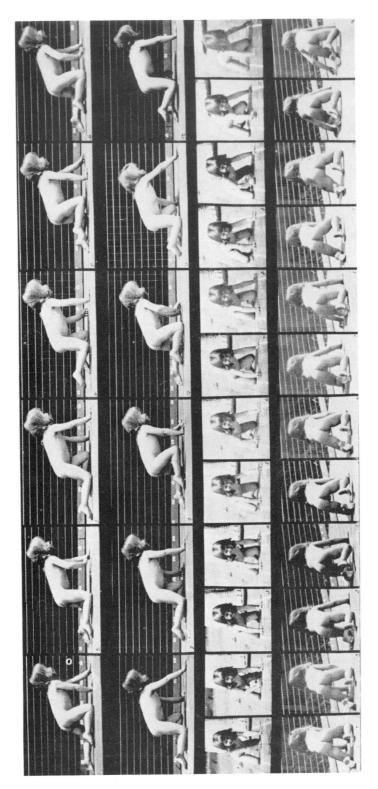

MUYBRIDGE, CHILD, CRAWLING

PLATE 186

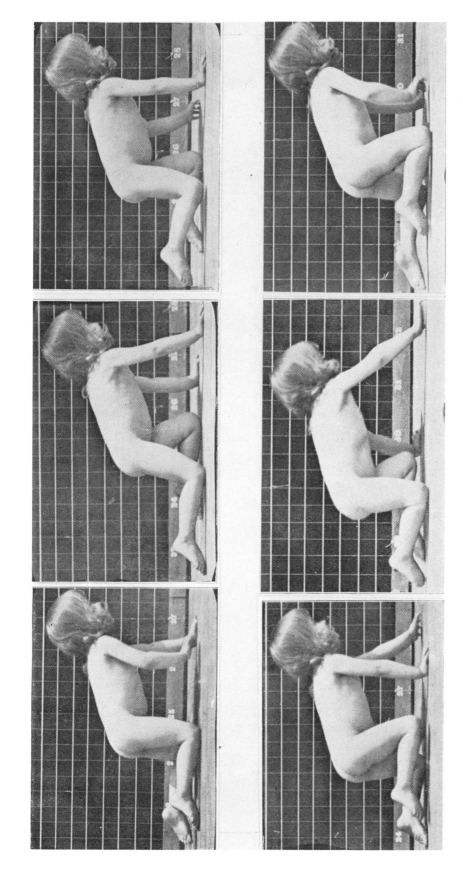

MUYBRIDGE, CHILD, CRAWLING: SELECTED PHASES

PLATE 187

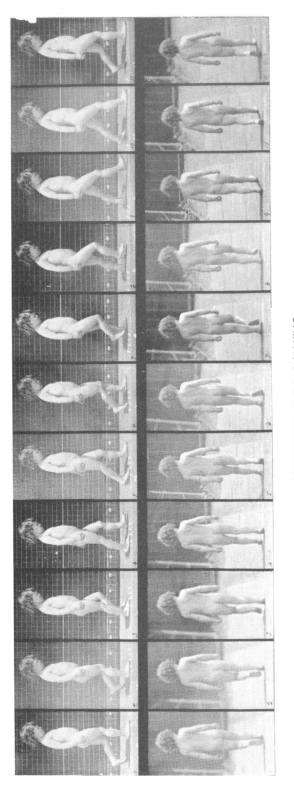

MUYBRIDGE, CHILD, WALKING

PLATE 188

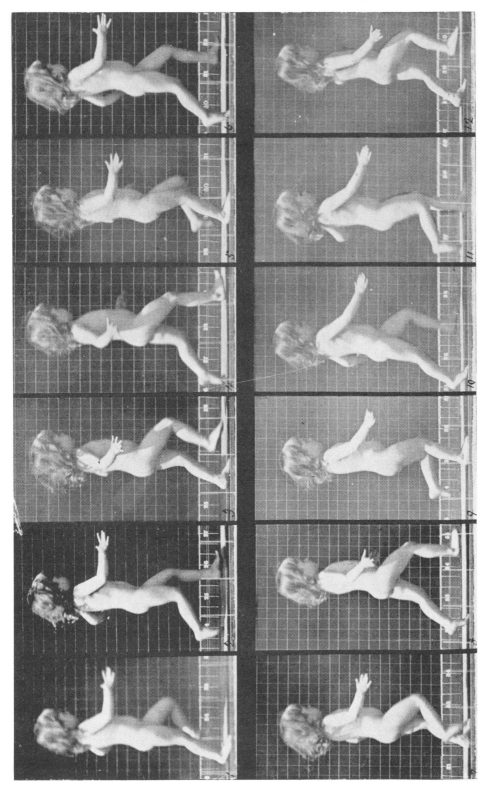

MUYBRIDGE, CHILD, RUNNING

PLATE 189

AN ANNOTATED

BIBLIOGRAPHY
OF BOOKS ON HUMAN ANATOMY
OF INTEREST TO ARTISTS

By Adolf K. Placzek

This bibliography does not pretend to be complete but aims to suggest, in the various categories it covers, the most important avenues for further study and the wide variety of anatomical material available at different levels of instruction. A visit to one of the more important libraries, such as the New York Public Library, the Metropolitan Museum of Art, or the Columbia University Library, and a review of the books catalogued under Art Anatomy is a rewarding and enriching experience that is strongly recommended to the student. It is hoped that this bibliography will serve as a guide to such individual study.

1. ATLASES AND MEDICAL WORKS

Frohse, Franz. *Atlas of human anatomy,* by Franz Frohse, Max Brödel and Leon Schlossberg. Explanatory text by Jesse Feiring Williams. New York, Barnes and Noble, Inc. 1942.

Convenient small book of descriptive anatomy. Colored plates. No surface description.

Gray, Henry. *Anatomy of the human body* . . . Philadelphia, Lea and Febiger. 1942.

Compact medical textbook for advanced study.

Peck, Stephen Rogers. *Atlas of human anatomy.* New York, Oxford University Press. 1951.

A manual with good photography and clear, concise drawings.

Pfeiffer, L. *Handbuch der angewandten Anatomie* . . . Leipzig, Spamer. 1899.

Interesting for its study of medical proportions and irregularities of the human body.

Sobotta, Johannes. *Atlas of human anatomy* . . . New York, Stechert. 1930-39.

One of the great works. For the art student, only volume 1 (bones, ligaments, joints, muscles, and regions) of particular use.

Spalteholz, Werner. *Hand-atlas of human anatomy.* Philadelphia, J. B. Lippincott. 192-.

Used by generations of medical students. Three volumes of clear and detailed presentations, of which the first two are of use to the art student.

Toldt, Carl. *An atlas of human anatomy.* New York, Macmillan Company. 1926.

"For students and physicians." Of limited use for artists.

Wolff, Eugene. *Anatomy for artists* . . . London, H. K. Lewis and Co. 1933.

Detailed anatomy, good description of surface form, functions and movements.

2. WORKS OF HISTORICAL INTEREST

Albinus, Bernhard Siegfried (1697-1770). *Tabulae anatomicae sceleti et musculorum hominis.* Lugdunae Batavorum. 1747.

Exquisite engravings. Text in Latin and English. Muscles and bones of the male body.

Audran, Gérard (1640-1703). *Des menschlichen leibes Proportionen* . . . Nuremberg, Sandrart. 1686.

Many editions. Proportions and measurements, influenced by Dürer. Based mainly on ancient sculpture.

Buonarroti, Michelangelo (1475-1564). *Michelangelo drawings,* by Ludwig Goldscheider. London, The Phaidon Press. 1951.

Michelangelo, unlike Leonardo, was no scientist; nor did he try, like Dürer, to arrive at set proportions. However, in their perception of form, plasticity and motion of the body, his drawings are unsurpassed.

Camper, Petrus (1722-1789). *Dissertation physique* . . . Autrecht, B. Wild and J. Altherr. 1791.

Proportions, national characteristics and expressions of the human face and head. Good engravings.

Dürer, Albrecht (1471-1528). *Hierinn sind begriffen vier bücher von menschlicher proportion* . . . Nuremberg. 1528.

Many later editions. The great master strove for a "canon" of types—not altogether successful from the classic point of view.

Genga, B. *Anatomia per uso et intelligenza del disegna* . . . Rome, Rossi. 1691.

Large engravings of the male athletic body, based on ancient sculpture.

Jombert, Charles Antoine (1712-1784). *Méthode pour apprendre le dessein* . . . *représentant différentes parties du corps humain* . . . Paris, L'auteur. 1755.

Engravings, based on the great Renaissance painters. Heads. Surface proportions.

Leonardo da Vinci (1452-1519). *The drawings of Leonardo da Vinci.* With an introduction and notes by A. E. Popham. New York, Reynal and Hitchcock. 1945.

Searching medical analysis of the human body, by the pen of one of the greatest artists—in fact, the almost unique merger of the creative and the scientific mind.

Leonardo da Vinci. *Leonardo da Vinci on the human body; the anatomical, physiological and embryological drawings of Leonardo da Vinci,* by Charles D. O'Malley and J. B. de C. M. Saunders. New York, H. Schuman. 1952.

A reproduction and emendation of Leonardo's research notes and drawings, system by system and region by

region, of the human body.

McMurrich, James Playfair. *Leonardo da Vinci, the anatomist* . . . Baltimore, Williams and Wilkins. 1930.

A full report on Leonardo's achievements as anatomist.

Rubens, Peter Paul (1577-1640). *Die Handzeichnungen von Peter Paul Rubens.* Herausgegeben von Gustav Glück und Franz Martin Haberditzl. Berlin, Bardverlag. 1928.

Details of figures and studies of dramatic motion, with a complete mastery of technique and a perfect understanding of anatomy.

Rubens, Peter Paul. *Théorie de la figure humaine considerée dans ses principes soit en repos ou en mouvement* . . . Paris, C. A. Jombert. 1773.

Engraved by Pierre Aveline, 1702-1760, based on Rubens drawings.

Schadow, Johann Gottfried (1764-1850). *Polyclète; ou théorie des mesures de l'homme* . . . Berlin, The author. 1834.

Based on Petrus Camper. Continued by Physionomie Nationale, 1835. Polyclète contains beautiful plates on proportion of the body, Physionomie Nationale concerns itself with national characteristics, proportions, and expressions of face and head.

Vesalius, Andreas (1514-1564). *The Epitome of Andreas Vesalius* . . . New York, The Macmillan Company. 1949.

A modern translation of the writings of the great Flemish pioneer in anatomy. The original Latin text and the plates are reproduced.

Vesalius, Andreas. *The illustrations from the works* . . . by J. B. de C. M. Saunders and Charles D. O'Malley. Cleveland, The World Publishing Company. 1950.

Excellent reproduction of the plates; translations and annotations.

3. OLDER WORKS ON ANATOMY FOR ARTISTS

Bell, Sir Charles. *The anatomy and philosophy of expression.* London, Henry G. Bohn. 1865 (Fifth edition).

Concerned with the facial expression. Much used and several times reprinted in its time.

Braun, Adolphe Armand. *Hieroglyphic or Greek method of life drawing* . . . London, Postal University. 1918.

Presentation of an individual method, supposedly based on the Greeks. Emphasis on the female body. The photographs of only historical interest.

Duval, Mathias Marie. *Artistic anatomy* . . . translated by Frederick E. Fenton. London, Paris, Cassell and Co. 1848.

Based on lectures delivered at the Ecole des Beaux-arts. A thorough description, little illustration.

Ellwood, George and Yerbury, F. R. *Studies of the human figure, with some notes on drawing and anatomy* . . . London, B. T. Batsford. 1918.

Good descriptive text. The photographs reflect the change of taste.

Hay, David Ramsey. *The geometric beauty of the human figure defined* . . . *Edinburgh, Blackwood and Sons.* 1851.

An elaborate system of proportion. Little on the human body itself.

Fau, Julien. *The anatomy of the external forms of man, issued for the use of artists, painters and sculptors* . . . London, Hippolyte Ballière. 1849.

Translated from the French edition of· 1845. Description of the male body; plates after ancient sculpture (e.g. Laocoön).

Flaxman, John (1775-1826). *Anatomical studies of the bones and muscles, for the use of artists* . . . London, M. A. Nattali. 1833.

Engraved by Henry Landseer after the artist's death. Beautiful large plates of the limbs and parts of the body.

Fripp, Sir Alfred Downing, and Thompson, Ralph R. *Human anatomy for art students . . . and an appendix on comparative anatomy* . . . London, Sealey, Service and Co. 1917.

Good descriptive anatomy, with few illustrations.

Hartley, Jonathan Scott. *Anatomy in art. A practical text book for the art student* . . . New York, Press of Styles and Cash. 1891.

A detailed descriptive analysis of bones and muscles, well illustrated.

Marshall, John. *Anatomy for artists; illustrated by two hundred original drawings by J. S. Cuthbert.* London, Smith, Elder and Co. 1890.

Extensive description, structure as well as surface.

McClellan, George. *Anatomy in its relation to art* . . . Philadelphia, The Author. 1900.

Written by a medical doctor, but with proper emphasis on the visual. Well illustrated. Still very useful, apart from the change in taste with regard to the photographs.

Muybridge, Eadweard. *The human figure in motion. An electro-photographic investigation of the consecutive phases of muscular action.* New York. Dover Publications. Inc. 1955.

Important for the study of motion, consecutive movements, and balance.

Pérard, Victor Semon. *Anatomy and drawing* . . . New York, Pérard. 1928.

Little text. Detailed anatomy, but simplified and clarified for the purposes of sketching.

Richer, Paul Marie Louis Pierre. *Anatomie artistique; description des formes extérieures du corps humain* . . . Paris. 1890.

Line drawings of rare clarity and simplicity, in the classic taste. "The body at rest and in its principal movements." Good text.

Rimmer, William. *Art anatomy.* Dover Pub.Inc. 1962.

Interesting mainly as a record of teaching methods of the 19th century. Plates after sketches of William Rimmer, 1816-1879, sculptor, painter, physician and art teacher, with his remarks.

Roth, Ch. *The student's atlas of artistic anatomy* . . . New York, Westermann. 1891.

The male athlete's body analyzed by muscles and bones. Limited scope.

Smith, John Rubens. *A key to the art of drawing the human figure* . . . Philadelphia, S. M. Stewart, 1831.

An early American art teacher, concerned with proportions and perspective. Good plates.

Thomson, Arthur. *A handbook of anatomy for art students.* New York. Dover Publications, Inc. 1964.

By an art teacher. Few illustrations, but extensive and

valuable textual explanations.

Vanderpoel, John H. *The human figure.* New York. Dover Publications, Inc. 1958.

The parts of the body, visually rather than analytically.

4. RECENT BOOKS

Andrews, Sloan. *Anatomy and figure construction for the fashion and figure artist.* New York, Manhattan Art Studios. 1935.

Barcsay, Jeno. *Anatomy for the Artist.* Budapest, Corvina. 1956.

Based on Greek proportions and Renaissance examples, with modern instruction for quick sketching.

Best Maugard, Adolfo. *The simplified human figure. Intuitional expression.* New York, Alfred A. Knopf. 1936.

Geometrical-schematic approach. Stress on simplification.

Bradbury, Charles Earl. *Anatomy and construction of the human figure.* New York, McGraw-Hill Co. 1949.

Equally concerned with structure and representation. Competent text. Well illustrated.

Bridgman, George B. *Constructive anatomy.* New York, Bridgman Publishers. 1936.

Sketches of the various parts of the body, from the structural-mechanic point of view. "Man as machine."

Bridgman, George B. *. . . Complete guide to drawing from life.* New York, Sterling Publishing Co. 1952.

The new, broader edition. Added information on drawing techniques.

Cox, George James. *Art and "the life"; a book on the human figure, its drawing and design.* Garden City, N. Y., Doubleday, Doran and Co. 1933.

Main value: the stimulating text. Techniques for the artist rather than analysis of the body. A good chapter on books about anatomy.

Dobkin, Alexander. *Principles of figure drawing.* Cleveland, World Publishing Co. 1948.

Different techniques with illustrations from old and modern painters and master draftsmen.

Doust, Len A. *A manual on drawing the human figure.* London and New York, F. Warne and Co. 1936.

Simple, with emphasis on the visual, primarily for pencil sketching.

Dunlop, James M. *Anatomical diagrams for the use of art students . . .* New York, Macmillan Co. 1946.

Clear and precise colored diagrams, with short descriptions; useful for structural perception.

Eisele, Louis A. *Figure drawing for fashion and costume designers . . .* Pelham, N. Y. Bridgman Publishers. 1939.

Simplified schemes of the female body.

Giusti, George. *Drawing figures . . .* New York and London, The Studio Publishing Co. 1944.

Touching on many aspects—historical, technical, anatomical.

Farris, Edmond J. *Art students' anatomy.* New York. Dover Publications, Inc. 1961.

A thorough introduction. Photographs, anatomical drawings, roentgenograms.

Hurley, Faye. *Simplified anatomy of the human figure . . .* New York, Library Associates. 1945.

Elementary handbook for beginners.

Lenssen, Heidi. *Art and anatomy.* New York, J. J. Augustin. 1944.

"Studies of the human figure by masters of the Middle Ages and the Renaissance, together with anatomical drawings by contemporary American artists."

Loomis, Andrew. *Figure drawing for all it's worth.* New York, The Viking Press. 1946.

A textbook for art students, instructive on technique. Visual approach.

Marsh, Reginald. *Anatomy for artists.* New York, American Artists Group. 1945.

Based on older sources. Useful illustrations. Visual approach.

Meyner, Friedrich. *Künstleranatomie.* Leipzig, E. A. Seemann. 1951.

Sketches and diagrams of muscles, bones and details. Good photographs, also historical reproductions. Emphasis on the male body.

Moses, Walter Farrington. *Artistic anatomy . . .* Los Angeles, Borden Publishing Co. 1939.

A simplified but still thorough presentation. Little text.

Refregier, Anton. *Natural figure drawing, with photos and drawings . . .* New York, Tudor Publishing Co. 1948.

Ranging over a wide field in a light style.

Tomasch, Elmer J. *The ABC's of anatomy . . .* New York, The William-Frederick Press. 1947.

Elementary handbook with stress on the solidity of volumes rather than the linear quality.

5. SOURCES OF BIBLIOGRAPHICAL REFERENCE ON ANATOMY

Choulant, Ludwig. *History and Bibliography of Anatomic Illustration.* (Translated by Mortimer Frank.) Chicago, Illinois, The University of Chicago Press. 1920.

An extensive historical survey of the field.

Cox, George James. *Art and "the life"; a book on the human figure, its drawing and design.* Garden City, N. Y., Doubleday, Doran and Co. 1933.

Contains an excellent chapter on books about anatomy, with extended discussion of several.

Duval, Mathias Marie, and Bical, Albert. *L'anatomie des maîtres.* Paris, A. Quantin. 1890.

Thirty plates of anatomical drawings by Leonardo, Michelangelo, Géricault, and others. Historical introduction and notes.

Duval, Mathias Marie, and Cuyer, Edouard. *Histoire de l'anatomie plastique. Les maîtres, les livres et les écorchés.* Paris, Société française d'éditions d'art. 1898.

Well illustrated and more recent than Choulant, the German edition of which came out in 1852.

Singer, Charles. *A Short History of Anatomy and Physiology; from the Greeks to Harvey.* New York. Dover Publications. Inc. 1957.